Dear Lina,

Your portraits have always been so strong. Keep up the amazing work & let this book inspire you!

With love, Melissa

Christmas 2015

# In Focus

## NATIONAL GEOGRAPHIC GREATEST PORTRAITS

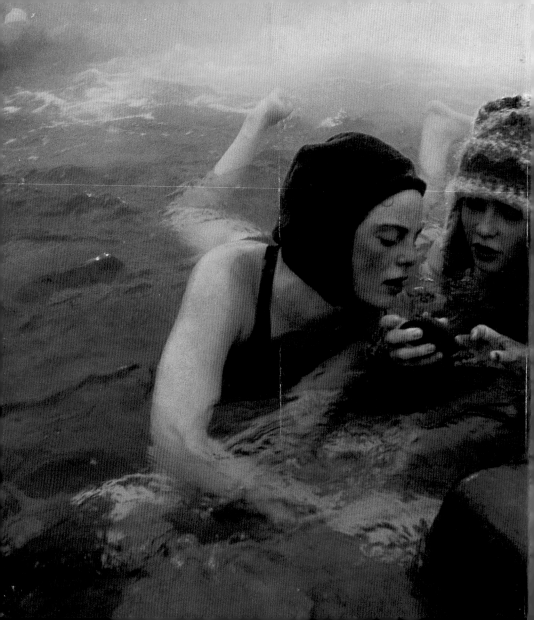

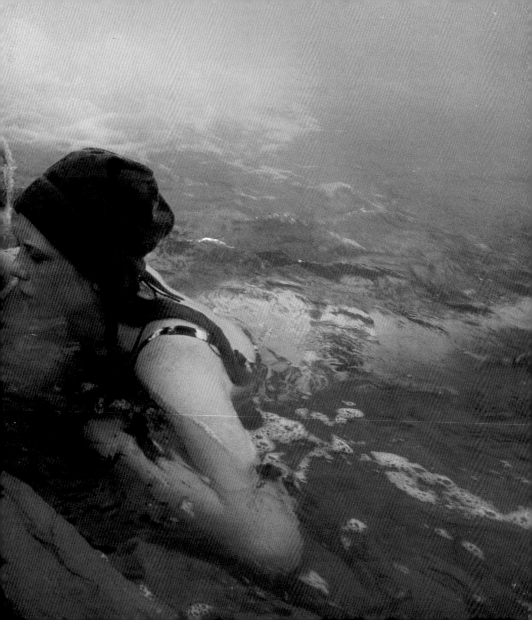

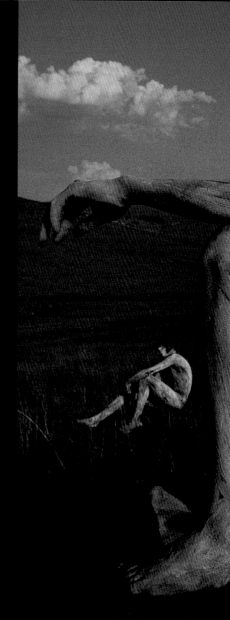

**PRECEDING PAGES:**
**ANNIE GRIFFITHS BELT   1997**
High school friends enjoy thermal springs
despite air temperature of minus 20°F near
Gardiner, Montana.

**JAMES NACHTWEY   1993**
Xhusa youths are covered in clay during a
rite of passage into manhood, South Africa.

**FOLLOWING PAGES:**
**DAVID ALAN HARVEY   1994**
"Commanche John" Keel performs a
Native American traditional dance at
Oklahoma City's Red Earth festival.

4

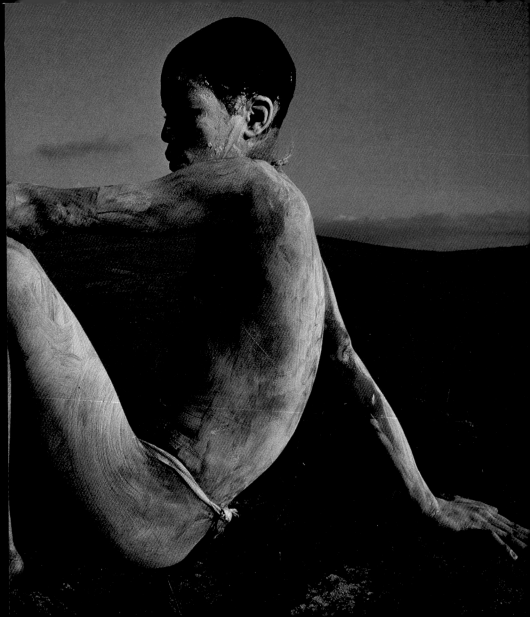

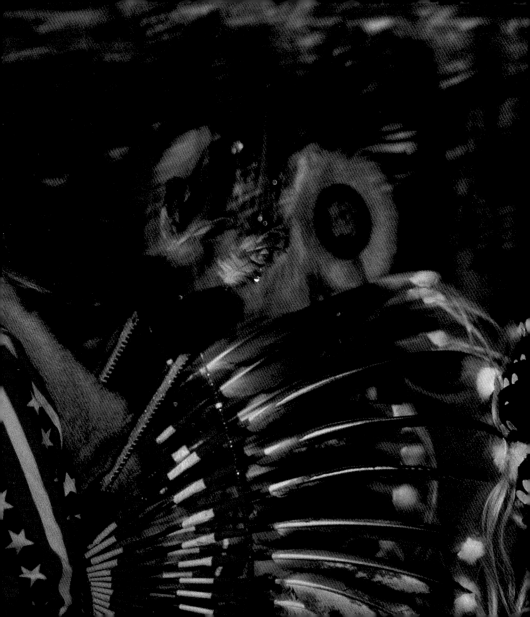

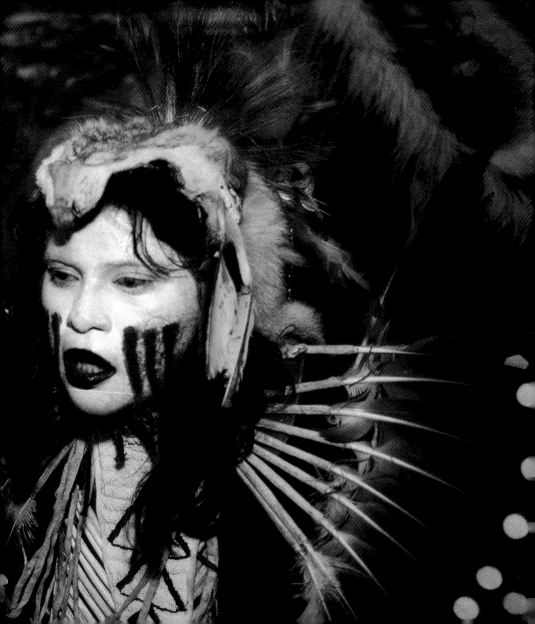

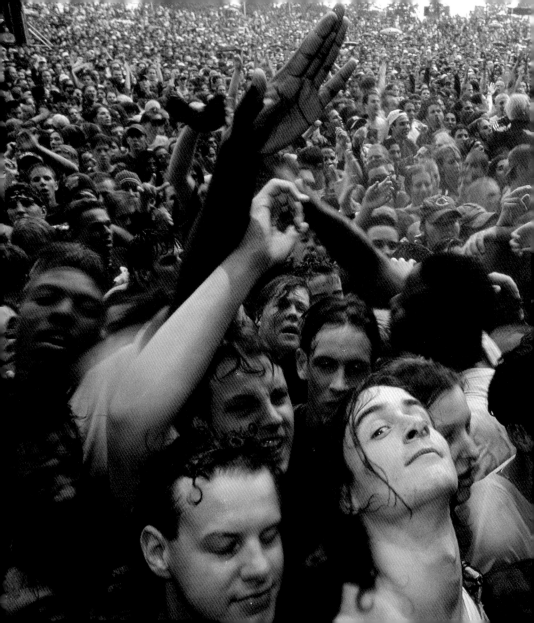

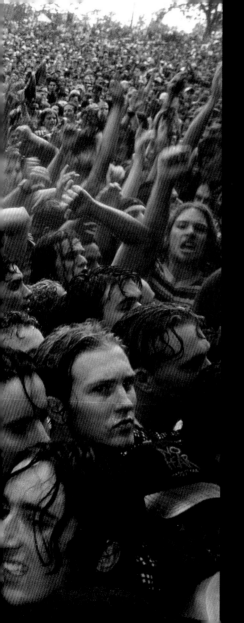

GERD LUDWIG 1994
The youth of Toronto jam into the
mosh pit at the Lollapalooza Festival
in Barrie, Canada.

FOLLOWING PAGES:
JOEL SARTORE 1994
Robert Patrick sits in his truck after a day's
work training horses at the San Pedro Ranch
near Corrizo Springs, Texas.

9

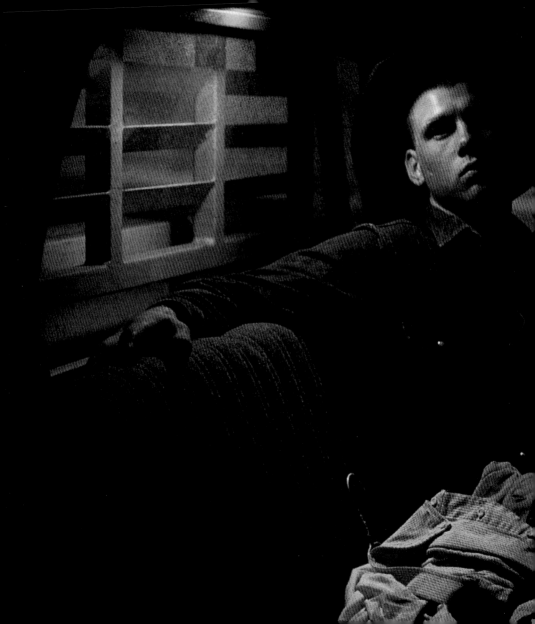

**SAM ABELL   1997**
Mother and daughter, visiting from England,
vacation in tropical northern Australia off
the Cobourg Peninsula.

**FOLLOWING PAGES:**
**◄ DAVID ALAN HARVEY   1975**
An elder of San Atilan in Guatemala

**► DAVID ALAN HARVEY   1988**
The same elder appears little changed
in the years since his 1975 appearance
in an article on the Maya.

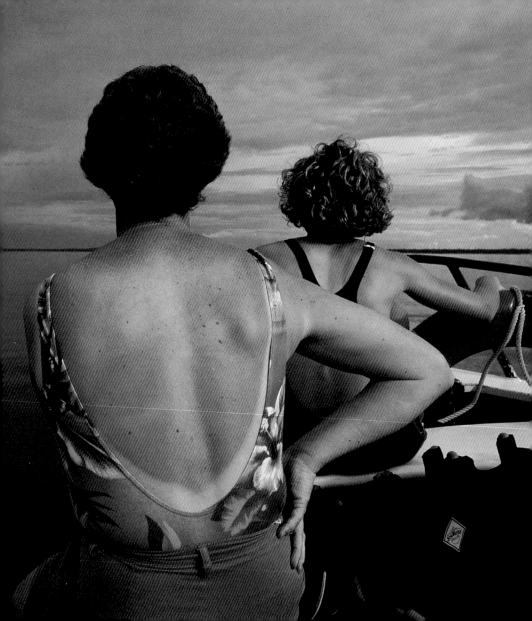

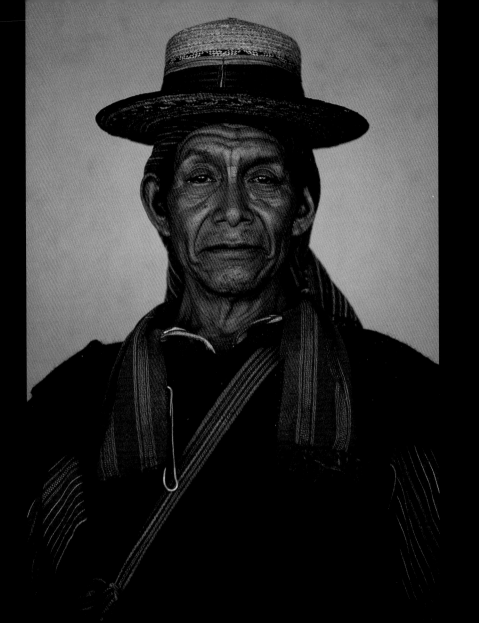

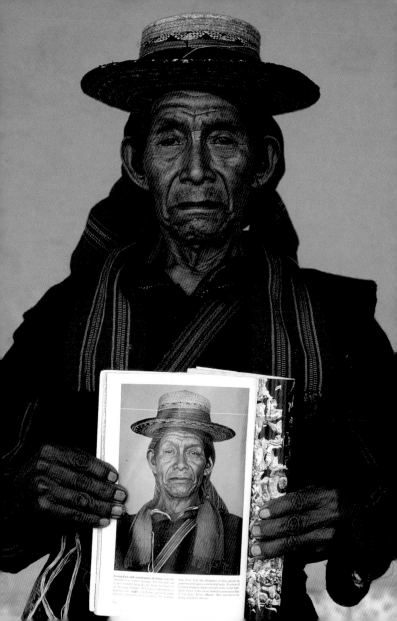

Living face and countenance of those if as the
age-old ... a century heritage. The ritual, and
of their families become the Ameri indians at
all Peruvian In..a... Aymara in Bolivia, a
hundred over eight ... Indies are at d ... same
that ... country by descend live in the Andes

that have held the allegiance of their people by
assuming prestigious ceremonial tasks. A system of
rotating religious duties prevails today in the high-
lands. Some of the men hold institutionalized
in the faces hence, ghosts. Men are hired by
doing voluntary service

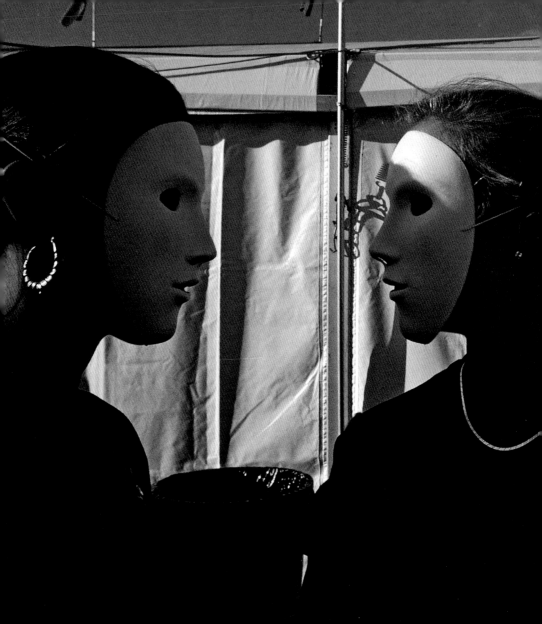

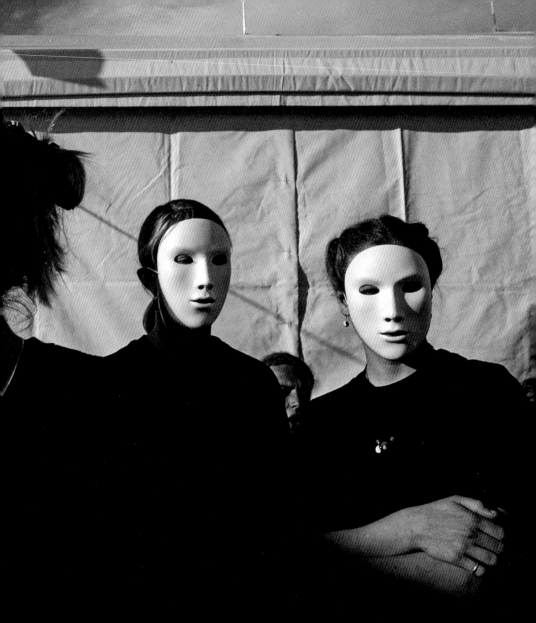

**CHRIS JOHNS    2001**
A boy's silhouette darkens a wall
in Welkom, South Africa, where his
band lived as squatters for 16 years.

**FOLLOWING PAGES:**
**JODI COBB    1980**
Ella Eronen, one of Finland's most beloved
actresses, poses in the costume of "Madame,"
an actress who felt lost unless she had a role

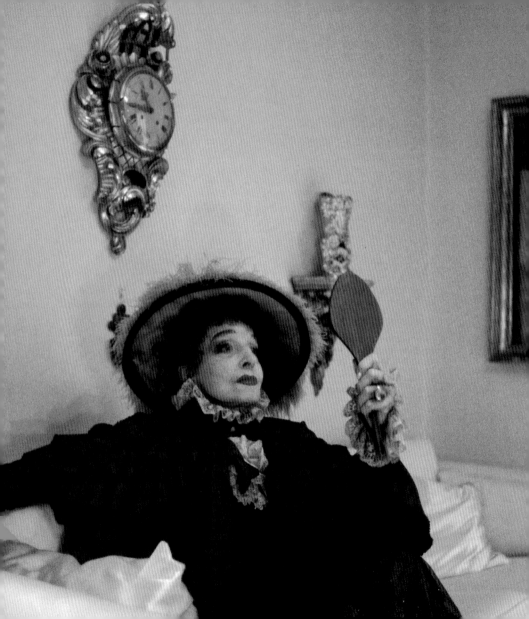

# In Focus

## NATIONAL GEOGRAPHIC
## GREATEST PORTRAITS

NATIONAL GEOGRAPHIC

Washington, D.C.

# Contents

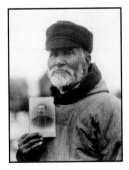

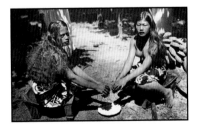

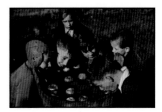

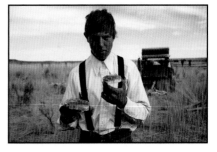
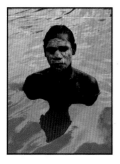

# Foreword

by Chris Johns
Editor in Chief, *National Geographic* magazine

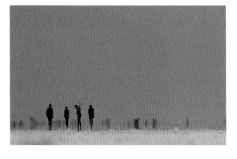

OUT OF A MIRAGE FOUR Bushman hunters stride across a searing white pan in northeastern Namibia. The day is young, but the heat is already so intense that the Bushmen's silhouettes are stretched by simmering heat waves. I'm enthralled by the image. I'm lying on Nyae Nyae pan, squinting as I peer through a long telephoto lens, trying to capture on film what I'd seen recently on rock faces: elegant portraits of thin, elongated, human figures on the move. To capture the spirit and essence of other human beings is a challenge beyond measure, but when it happens, and the photograph comes together, the creation brings joy.

THE PAGES OF THIS BOOK ARE FILLED WITH PORTRAITS that were a joy to create. But make no mistake, it is seldom easy to make a truly memorable portrait. In a photographer's career, the distance between truly satisfying photographs can be immense, measured in weeks, months, years, or in thousands of miles. There are days that stretch over what seems to be an eternity when doubt creeps in, and the photographer begins to wonder if he or she will ever see a picture again. These moments of doubt afflict every field photographer, especially the best ones. And, surprisingly, the doubt doesn't go away with success, because for great photographers the bar keeps getting higher. No picture is ever quite good enough. The photographer stalks the elusive goal of "capturing the spirit and essence of another human being," but falls short because there is so much more to say, there is so much more that is felt. But though doubt is a constant companion, so is the photographer's desire to connect with people—to capture something consequential about another person in a portrait.

Early in a career the notion of constant growth is intimidating, but over time it becomes an accepted reality, even welcomed. The mature photographers whose work is in this book have the advantage of experience. They know how to work themselves out of the dark moods and see the light. For more

than 20 years I've looked at and admired the work of respected colleagues such as Bill Allard, Jodi Cobb, Steve McCurry, Lynn Johnson, Sam Abell, and David Harvey, to name only a few whose photographs appear in this book. They've made me want to keep taking pictures, and even more important, they keep making photographs that inspire me.

Now my career as a photographer has evolved into working as Editor in Chief of *National Geographic* magazine, and I often find myself in a darkened room where my colleagues' photographs transport me to places I want to visit and introduce me to people I want to meet. These photographers continue to put their reputations on the line, taking risks and in turn making the finest photographs of their lives. As I sit in that darkened room, I believe I am seeing profound personal growth fueling the creation of photographs that will endure.

TOO OFTEN A PHOTOGRAPHER'S REAL EXCELLENCE doesn't get due notice in today's fast-paced culture, where celebrity portraiture has given celebrity status to many photographers. Occasionally Allard, Cobb, McCurry, Johnson, or Harvey will photograph a celebrity, and there are a few of those images in this book, but they are the exception.

More often the pages of this book and *National Geographic* magazine are graced with uncommon photographs of common people. Yet to the photographers who took the pictures these subjects are far from common, just as they are not common people to their families, friends, neighbors, and co-workers. In each portrait there is an individual, with a life and a story to tell. And maybe, just maybe, if the connection between photographer and subject is trusting enough, and the photographer's skills and sensitivity are high enough, the portrait will reveal the spirit and essence of the individual.

If and when that happens, and that is a big if, the portrait may stand the test of time. And in turn the creator of the photograph can better answer the questions, "What am I doing here? What drives me to do this hard thing?" Great portraits fill these pages. They span more than a century. They are photographs that have risen to the challenge of portraiture, and they endure.

*Chris Johns*

# National Geographic Portraits

*Leah Bendavid-Val*

EVERYBODY WHO WORKED ON THIS BOOK ASKED THE same question: "What is a portrait?" The dictionary says it is a picture of a person, usually (but not always) "showing his face." But that definition ignores intriguing possibilities. Many of them—people from the back, masked, even half hidden—appear on these pages.

The word "portrait" sometimes calls to mind self-conscious mug shots, but the photographs in this book are anything but that. Take Annie Griffiths Belt's picture of high school girls (pages 2-3) sharing a girlish moment soaking in thermal springs on a sub-zero day in Montana, or James Nachtwey's statuesque South African boy (pages 4-5) engaged in an age-old ritual of passage into manhood—all were unaware their picture was being taken when the camera's shutter clicked.

In Oklahoma City an Indian dancer's trance (pages 6-7) is held in the camera for the tiniest fraction of a second. Turn the page and you'll see thousands of frenzied young people at a rock concert, recorded even faster. It is only in the past several decades that producing such a quick record was even possible. Before that a portrait couldn't physically be made unless there was a time-consuming collaboration between artist and sitter. Cumbersome cameras and slow film just didn't allow it. But since the 1930s, photographers have been able to work the streets and capture fleeting behavior. The skilled documentarian became a combination artist and athlete, seeing and then responding almost simultaneously. Photojournalists made pictures of people that are remarkably affecting, but are they portraits?

The potency of great portraits has been recognized at least since the beginning of history. Egyptian pharaohs and Roman and Chinese emperors had themselves depicted in stone, and later European aristocracy and ordinary people who could afford it had themselves portrayed in paint. Photography democratized the practice, and now portraits of family and friends are displayed in virtually every household.

THE NATIONAL GEOGRAPHIC SOCIETY'S MISSION—TO discover and present the world's unknown places and populations—meant people were at first recorded as ethnic types, not as individuals in one-of-a-kind portraits. Even now Geographic photographs are meant to be about cultures rather than individuals. People are placed in information-rich settings with the purpose of illustrating dress and lifestyle. But National Geographic attracts photographers who want to do more than deliver on their assignments (which in itself is hard enough). The best photographers succeed in seeing their

subjects with fresh eyes, and to do so they may return to them again and again.

On page 14 we showcase a formal portrait of a Maya man. Opposite is a picture of the same man 13 years later. He is holding the magazine's published photograph of himself, and looks, uncannily, only slightly the worse for wear. He is evidence that Geographic photographers took the trouble to know and stay in touch with their subjects.

A few years ago I was sitting on the floor in a narrow aisle in the Geographic's chilly photography archive, and together with archivist Bill Bonner chanced on a forgotten, never published 1925 picture of a Greenlander holding a portrait of Arctic explorer Robert E. Peary, given him by the explorer himself in the 1890s. Magical isn't too strong a word to describe the feeling of stumbling on this long-gone moment, and the feeling returns whenever I take the time to let it.

NATIONAL GEOGRAPHIC'S ARCHIVE, FILLED WITH millions of small treasures, shows that photography here didn't stand still. To say that politics, technology, attitudes, and tastes have changed a lot over the last century is an understatement. The Geographic kept pace, sometimes missing important things, occasionally leading the way, and altogether creating a rather remarkable photographic

record. After all these years of accumulated pictures, one of the greatest pleasures turns out to be looking at people you'd never otherwise know existed.

Artists and critics say a portrait is successful if it reveals character, but this is a tall order. Is it ever really possible to fill it? A person is far too complex to be revealed in any single instant. A suggestive glimpse is probably all we can ever hope for. This book accepts that proposition, removes from the photographs the burden of giving total insight into the people in them, and invites viewers to open their hearts to the truths and fantasies of photography.

WE ASKED FIVE PHOTOGRAPHERS TO WRITE ESSAYS FOR this volume. They consider Geographic portraiture from the standpoint of photographers and also as viewers. My own comments on the photographs appear on the green pages throughout the book.

— LEAH BENDAVID-VAL

**Though** photographic portraits remain physically unchanged over time, their meanings are constantly shifting. These women on a Hawaiian beach, and also the picture of women arranging Goodyear tires destined for Antarctica (pages 32-33), are enjoyed today for their quaintness, a far cry from the photographers' original intentions to be modern.

There are still peoples in the world whose way of life is threatened, and the Geographic continues to offer readers pictures of them. Photographic styles have changed but, as before, the portraits are meant to urge the public to preserve or at least remember cultures such as the Pygmy tribespeople of the Congo (pages 46-47) and the island people of Irian Jaya, Indonesia (pages 44-45).

Photographers and viewers look at pictures more self-consciously now than they did even a decade ago. The picture of a Greenlander proudly displaying a portrait of Robert E. Peary (page 39) and the photograph of Mercedes McKee (pages 34-35), model for her family's pearl button business in 1942, make us think about photography itself, and suggest that all new work is linked to what came before.

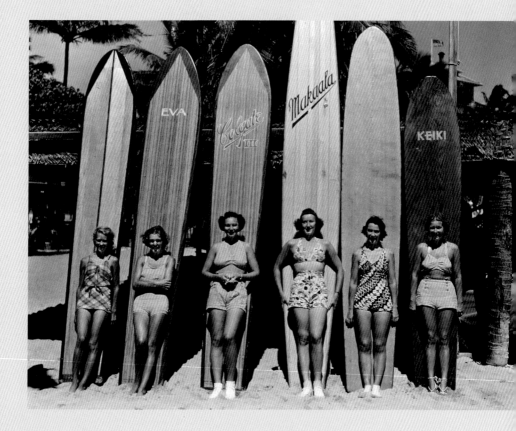

**RICHARD H. STEWART    1938**
Bathing beauties pose in front of surfboards in Waikiki.

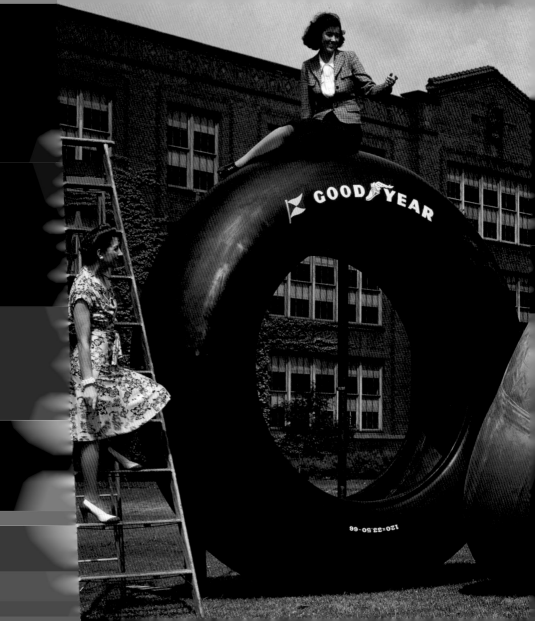

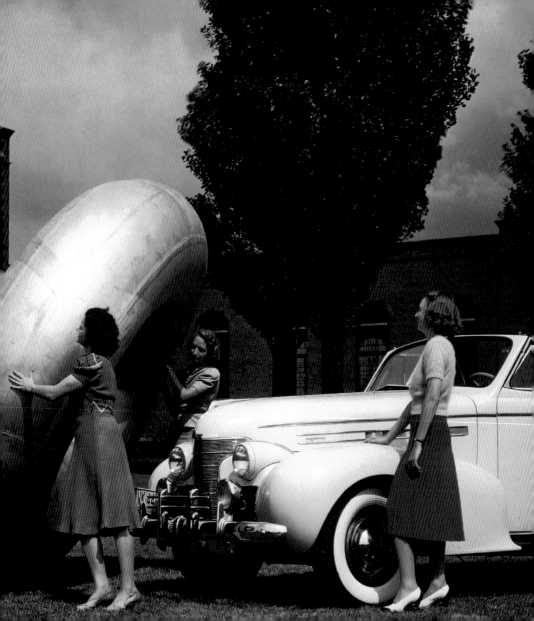

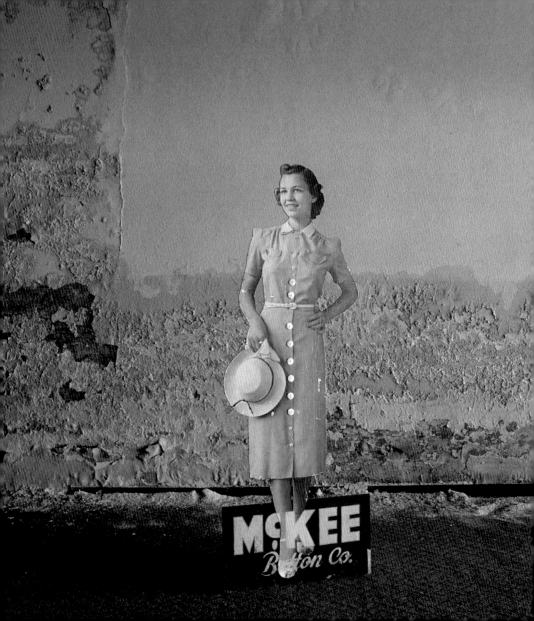

**PRECEDING PAGES:**
**WILLARD R. CULVER 1940**
The largest pneumatic tire ever made at the time,
this 12-ply tire measures ten feet in overall diameter,
and weighs nearly 700 pounds.

**SAM ABELL 2001**
A 1942 advertising photo of Mercedes McKee,
in the shell of a building which later became the
Pearl Button Museum in Muscatine, Iowa, was
re-photographed in 2001.

**FOLLOWING PAGES:**
**◄ PHOTOGRAPHER UNKNOWN 1898**
Dawson, Yukon Territory, Canada

**▶ B. ANTHONY STEWART 1939**
Wearing a gown made from grapefruit peels,
a girl in Weslaco, Texas, celebrates the beginning
of harvest in the fertile Rio Grand Delta.

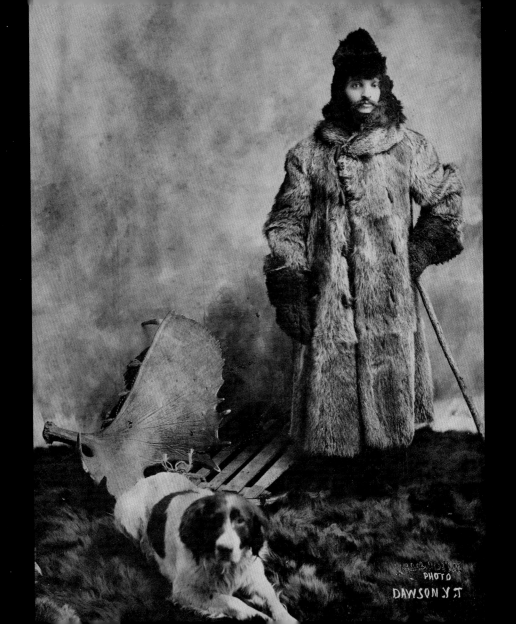

PHOTO
DAWSON Y.T

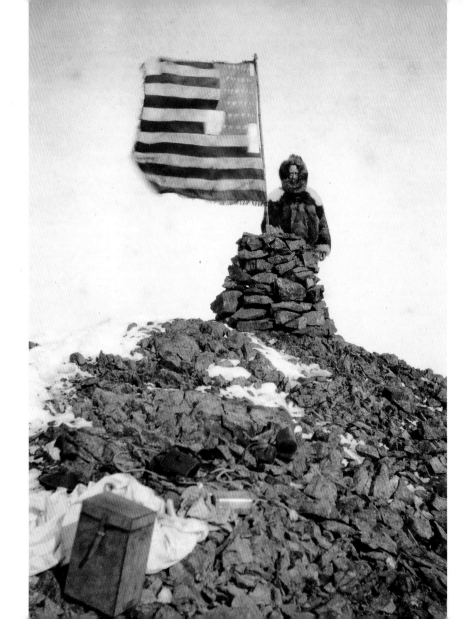

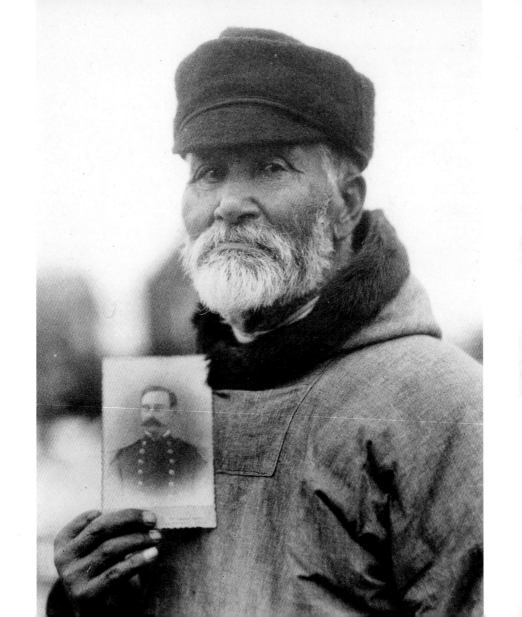

PRECEDING PAGES:

◄ **ROBERT E. PEARY COLLECTION** **1906**
Robert E. Peary on his North Pole Expedition, Cape
Thomas Hubbard, Axel Heiberg Island, Canada

► **MAYNARD OWEN WILLIAMS** **1925**
An elderly Greenlander shows a portrait of Robert E.
Peary given him by the Arctic explorer in the 1890s.

**FROM ALICE BALLANTINE**
**KIRJASSOFF** **1920**
An orchestra of Sing Song girls, the Formosan version
of a jazz band, provides entertainment in a teahouse.

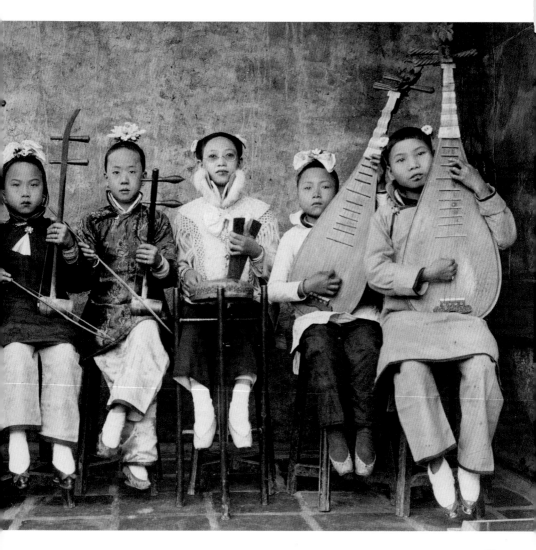

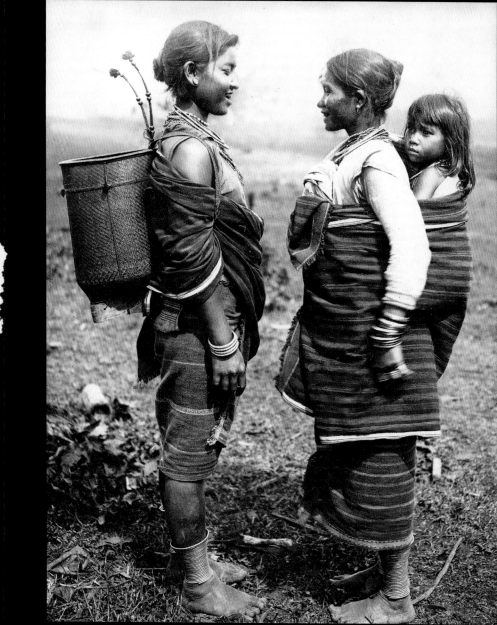

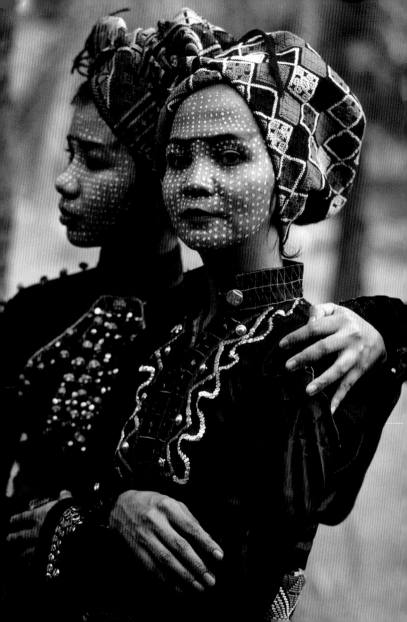

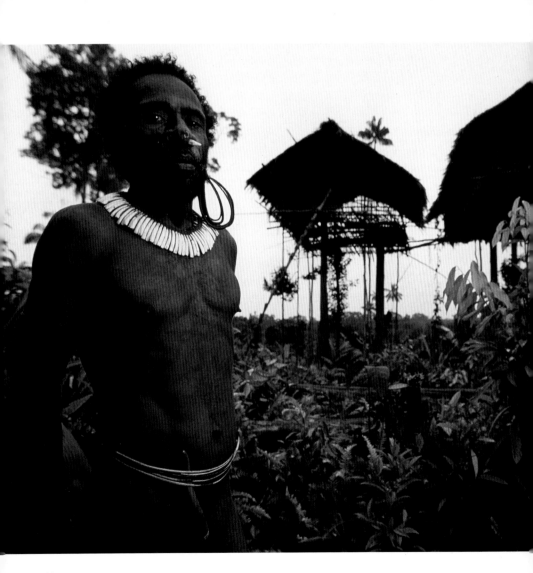

PRECEDING PAGES:
◄ **FROM M. BRANGER & SONS    1921**
A neighborly conversation in French Indochina

▶ **STEVE MCCURRY    1986**
Cast members wait to perform ethnic Yakan dances in Manila.

**GEORGE STEINMETZ    1993**
Clan leader of the tree-house people, wearing nose bone and bone necklace, Irian Jaya, Indonesia

**MICHAEL NICHOLS 1993**
A Ba-Benzele family rests in front of their forest home,
Republic of the Congo.

**Anyone** examining National Geographic's portrayal of the American Indian through the years would likely decide it has been incomplete and unbalanced, yet high-minded. Critics fault the Geographic for not reporting on the destruction of American Indian life and culture. But early in the 20th century, in an era when powerful white people considered non-white peoples inferior, the magazine acquired self-conscious Edward Curtis studio portraits, as well as pictures by lesser known photographers, all depicting American Indians with dignity.

The brightly staged, somewhat ridiculous picture (pages 56-57) taken by Robert F. Sisson from the backseat of a car at mid-century is an aberration, typical only during a brief period during the fifties and sixties. By the 1970s a stricter documentary approach was back in place. In 1994 the magazine published a story titled "Powwow" showing how "Native Americans honor their heritage," but not how their economic and social troubles almost obliterated that heritage. But the story's complex and intimate photographs by David Alan Harvey rise above the stated topic.

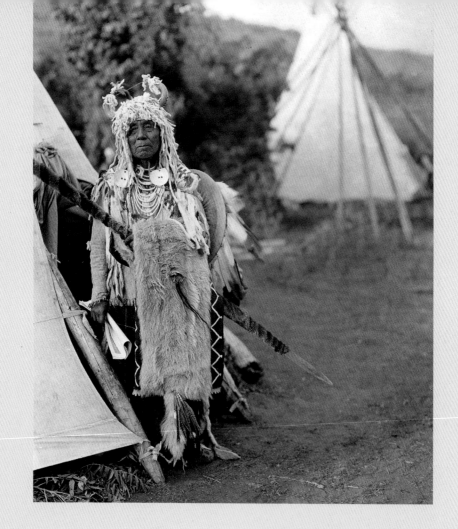

**DR. JOSEPH K. DIXON** **1921**
Medicine man, Northern Plains

**DR. JOSEPH K. DIXON   1921**

White Beaver, Northern Plains

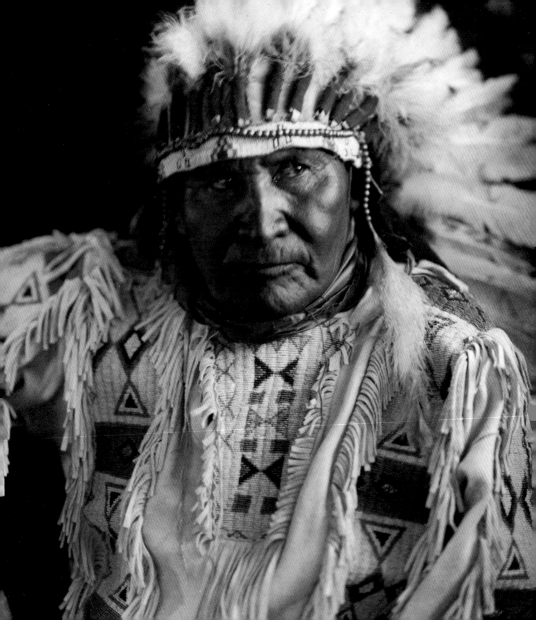

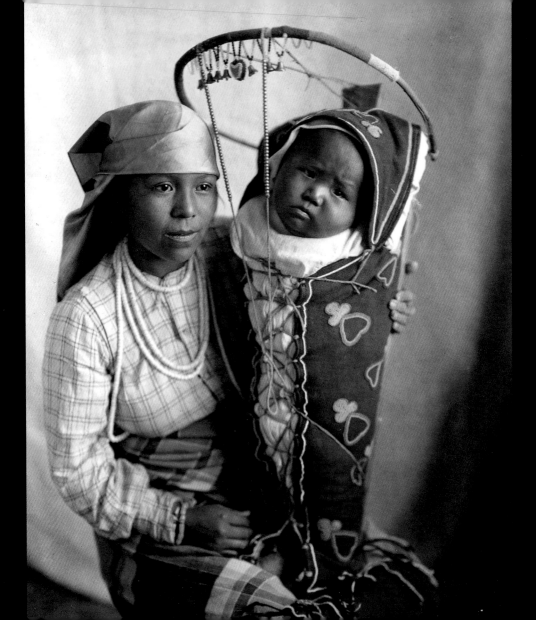

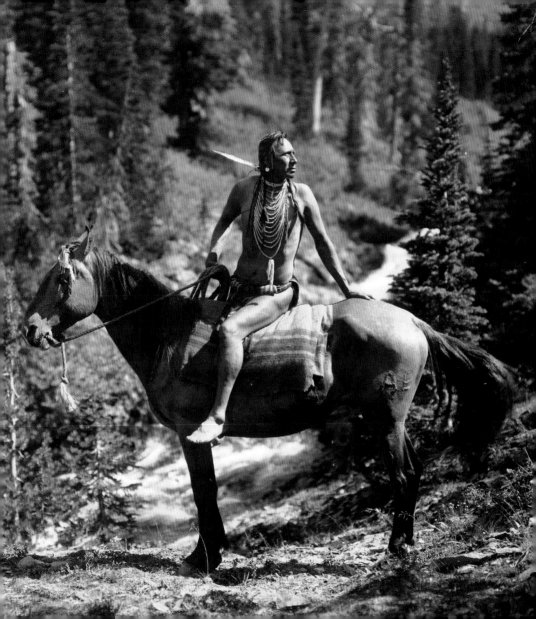

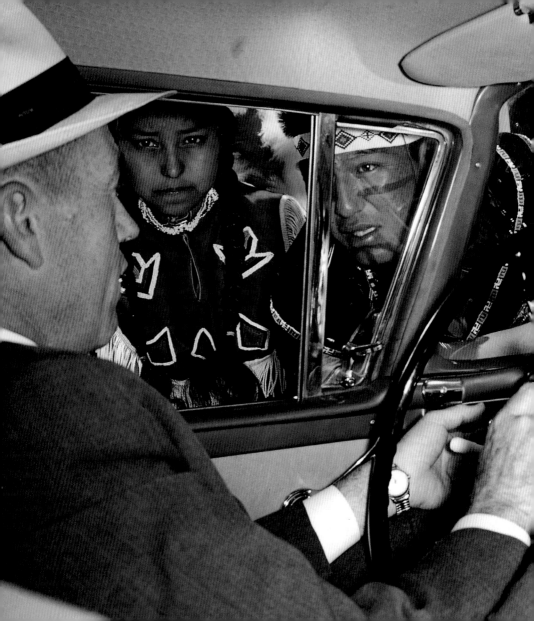

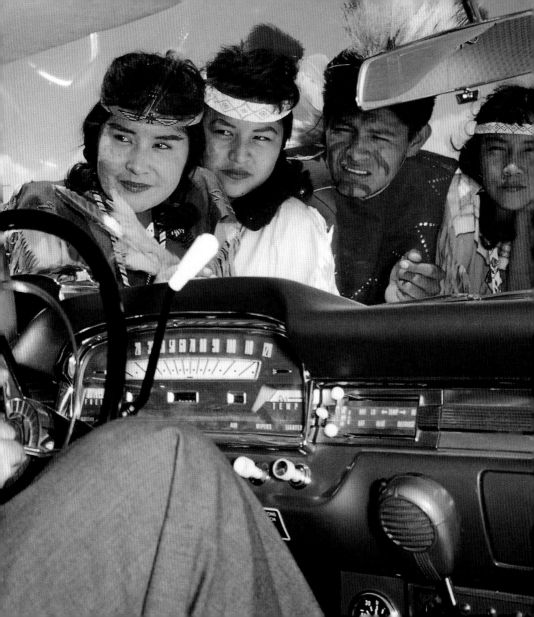

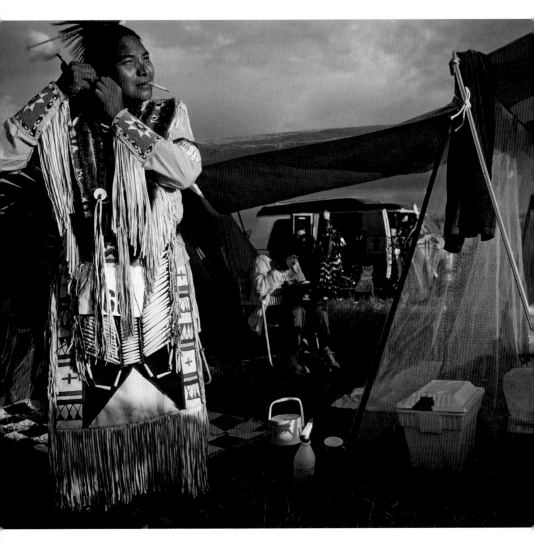

**DAVID ALAN HARVEY    1994**
Ed Blackthunder, a Sioux from Agency Village,
South Dakota, readies his costume before his dance
at the Rocky Boy Reservation powwow in Montana.

**In the** beginning, National Geographic photographed people to advance science. Expeditions to all the unknown spots on Earth were dreamed of and dared, all to fulfill the Society's 1888 mission to expand scientific and geographical knowledge. Traveling to unexplored places and documenting them called for huge physical and financial resources, a great deal of time, and experts in dozens of fields. One of those fields was photography.

The 1925 MacMillan Arctic Expedition pictured here involved two boats and and three amphibian planes generously supplied by the U.S. Navy. The point was to explore an area of "a million square miles lying between Alaska and the North Pole."

Two photographers, Maynard Owen Williams and Jacob Gayer, accompanied some 45 other members of the exploring party. They brought back the first color photographs ever made in the Arctic. Their goal in photographing people was to describe every aspect and variation of local attire. Early Geographic photographers were not charged with sensitively revealing human character, but they sometimes couldn't help themselves.

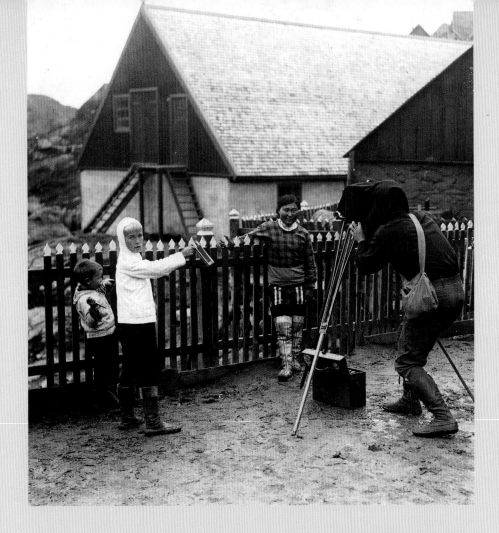

**JACOB GAYER   1925**
Sukkertoppen, Greenland

61

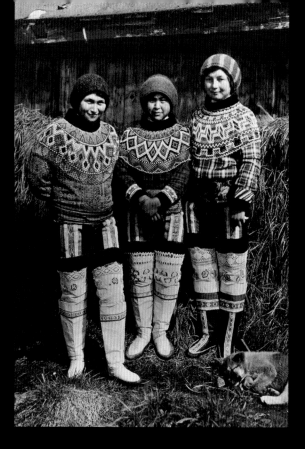

▲ **JACOB GAYER   1925**
Young women of Greenland in their warm,
colorful native costumes

▶ **MAYNARD OWEN WILLIAMS   1925**
Sukkertoppen, Greenland

# The last full-blooded Yahgan Indian in Tierra del Fuego was photographed by Sam Abell for a 1981

assignment. He placed her where a shaft of light and tobacco smoke gave her dignity, even a slight aura of mystery, and he took a position slightly below her. His picture was published. Abell also photographed Rosa at eye level (pages 66-67), in scale with her TV set, surrounded by her tattered belongings. This unpublished picture offers a different, expanded insight.

A decade earlier photographer Gerd Ludwig, also working from two viewpoints, took pictures of German artist Joseph Beuys. Beuys was a complicated, charismatic man, daring in politics and unconventional in his art. Ludwig saw Beuys's bold visionary qualities from behind (page 70), and an inquisitive, suffering intelligence directly face-to-face (page 71.)

The two photographs of a Blackfoot Indian (pages 68-69) show a man demonstrating a prayer to his sun god, apparently for a passing photographer collecting data on Indian rituals. The two pictures, meant only as ethnic studies, reinforce each other. In them, the human qualities of the man come through.

**SAM ABELL   1981**
Rosa, last of the Yahgan Indians, Tierra del Fuego, Chile

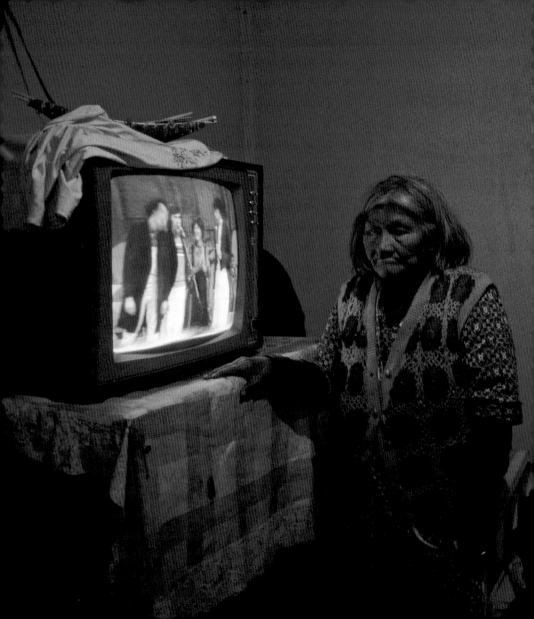

**SAM ABELL 1981**
Rosa, last of the Yahgan Indians,
Tierra del Fuego, Chile

**FOLLOWING PAGES:**
**◄ FROM GREAT NORTHERN
RAILWAY COMPANY 1916**
A Blackfoot Indian demonstrates a prayer to
his sun god, Glacier National Park, Montana.

**► FROM GREAT NORTHERN
RAILWAY COMPANY 1916**
Back view of Blackfoot Indian praying to
sun god, Glacier National Park, Montana

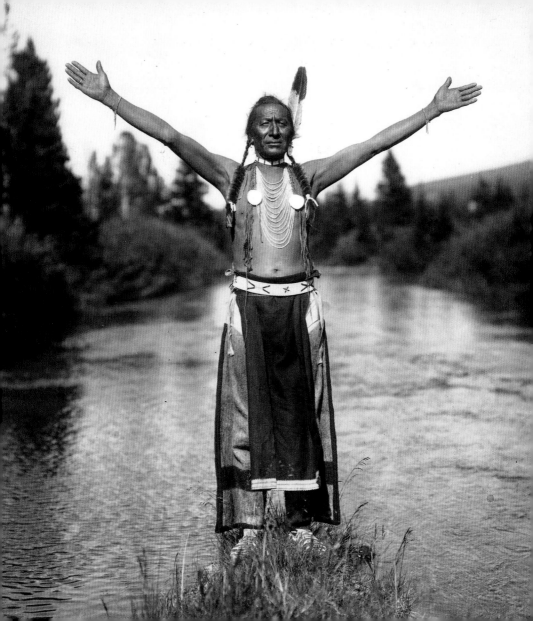

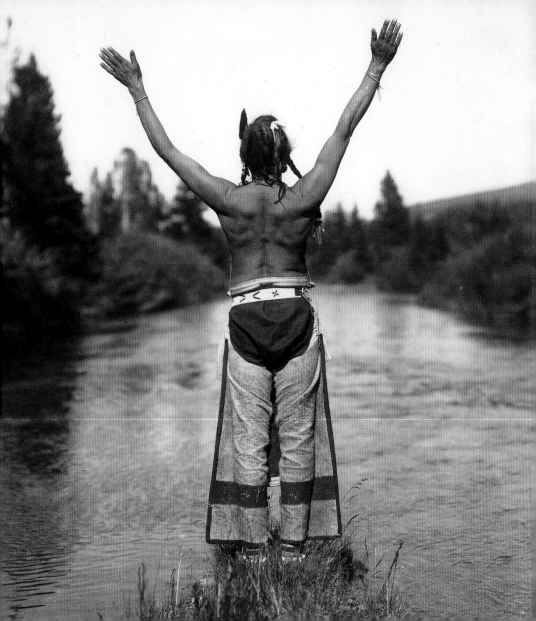

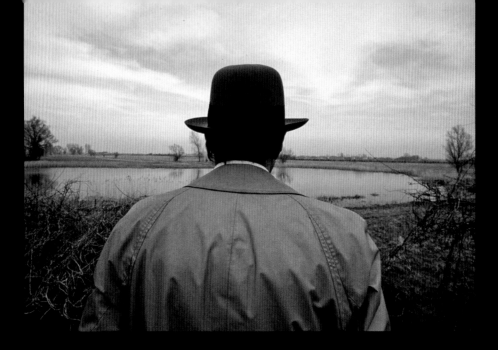

▲ **GERD LUDWIG 1978**
German conceptual artist Joseph Beuys looks at
the landscape of his childhood in Kleve, Germany.

▶ **GERD LUDWIG 1978**
Joseph Beuys visits his tiny elementary school
classroom in Kleve, Germany.

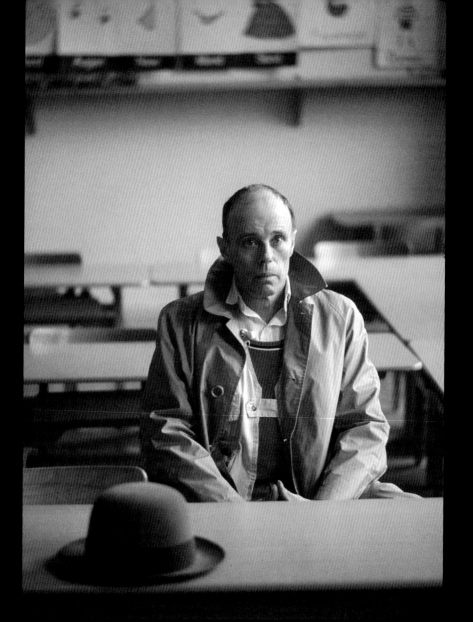

# The story of National Geographic portraits starts with two families that became one: While 23-year-old

Gilbert Hovey Grosvenor was in the process of falling in love with Alexander Graham Bell's daughter Elsie in 1899, Bell, the Society's second President, hired him to be editor of the Society's modest magazine. Elsie and Gilbert were married shortly afterward.

Grosvenor and his boss, now also his father-in-law, just so happened to share a love of photography. And young Gilbert was an amateur photographer himself, which was to have major implications for the Society's publishing ventures. It also resulted in a memorable family album.

Family photographs are among the dearest possessions in almost every household. The first pictures we care about are of the people we're closest to, and they are framed, displayed, and passed lovingly to the next generation.

The five National Geographic photographers who have written essays for this book have photographed their own families, of course, and each has selected a favorite family picture for these pages.

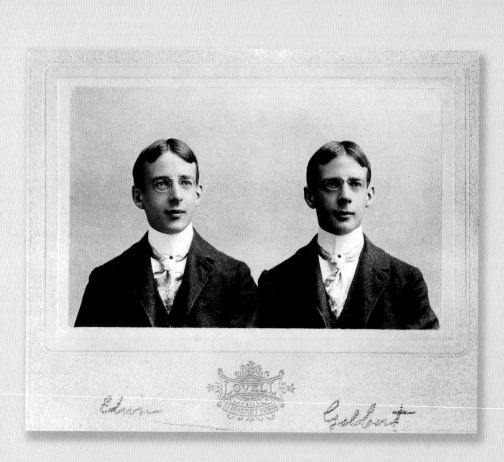

**GROSVENOR COLLECTION   1894**
The Grosvenor twins, Edwin and Gilbert, at age 18

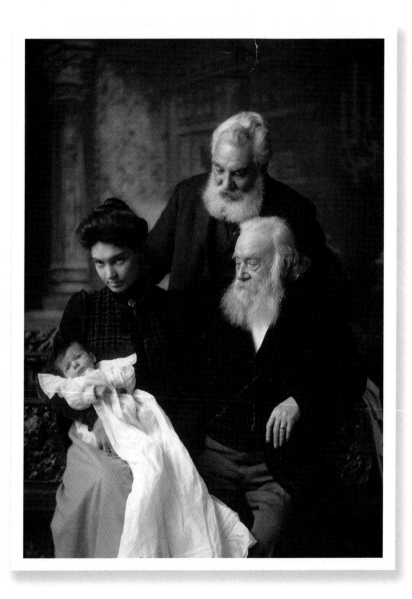

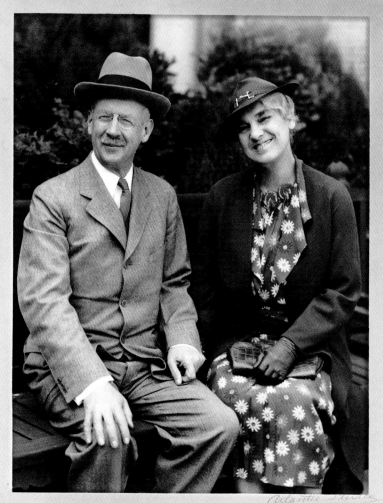

Atlantic City, April 29, 36

**PRECEDING PAGES:**

◀ **GROSVENOR COLLECTION    1904**
Elsie Bell Grosvenor

▶ **DAVID BACHRACH    1901**
Four generations: Elsie Bell Grosvenor and her baby,
Melville Bell Grosvenor; her father, Alexander Graham
Bell (standing); and her grandfather, Alexander
Melville Bell

**ATLANTIC STUDIOS    1936**
Gilbert H. Grosvenor, President and Editor of
the National Geographic Society, and his wife,
Elsie Bell Grosvenor, Atlantic City, New Jersey.

"This picture of my youngest child, Billy, was shot in Wales in 1996. It is taken in the house of my sister-in-law, where we sometimes go to stay. Their family lives there in a house facing right out onto the Menai Straits, overlooking Snowdonia. I took a lot of pictures there when the children were growing up—especially at low tide, when everyone used to go down to build sandcastles. The light was always so beautiful.

The other day I asked Billy, now ten, what he remembered of the circumstances around the picture taken here, with his aunt Brigid's dog Phoebe, and he said: "I don't remember any of my childhood. All I remember is blurred looking round... and then I was nine."

—STUART FRANKLIN

"My father, Thad Abell, was the most important person in my photographic life and over the years the person I photographed the most.

This portrait of us was made by me outside our home in Sylvania, Ohio, in 1977. In the basement darkroom of that house, I learned the techniques of photography from my father. But I learned more than that from him. On outings together, he taught me to see, and to think, photographically. In 2002 a book of my work, *Sam Abell: The Photographic Life,* was published. The editor and I chose this image for the cover."

—*SAM ABELL*

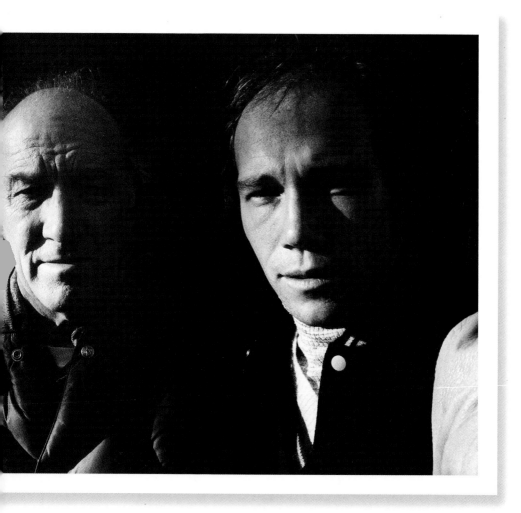

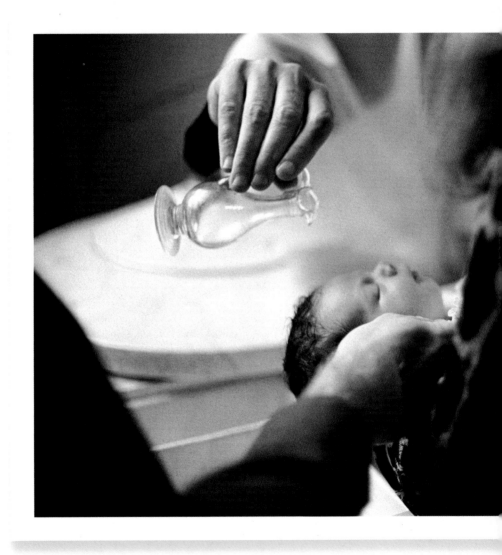

"My niece Sonya was less than a week old when she was christened, and my camera was not much older. I had yet to begin graduate school in photojournalism, but knew instinctively what everyone who has ever picked up a camera knows: Babies are adorable. In fact, evolutionary scientists say, we are hardwired to believe so, because human babies are not viable in the world until long after birth, and need all the adult protection they can get. So we feed and coddle them, christen and pray for them, and photograph them incessantly."

—*JODI COBB*

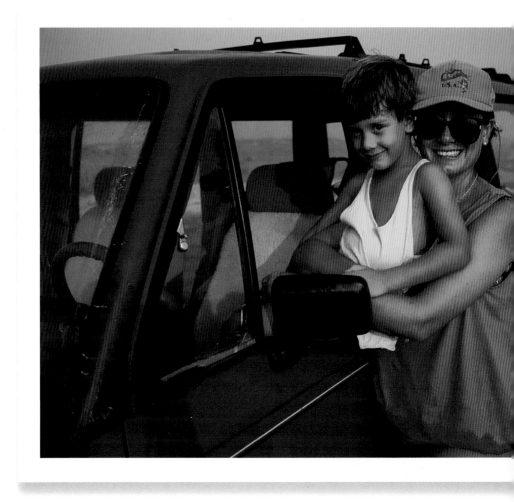

"This portrait is of my wife, Ani, and our son, Anthony, taken when he was five. We had rented a house at Hatteras, North Carolina. Ani loves the beach. So does Anthony. He was like a fish then, always in the water. I like the ocean, but I'm from Minnesota and I'm more at home on a lake. Here they are at the end of a day of swimming and fishing. Anthony, browned by the sun, has his mother's eyes. Ani's smile is brilliant. We were all happy that day, it seems. A place can do that to you."

**—WILLIAM ALBERT ALLARD**

"My family were my first subjects. By age 12, I was driving the whole family crazy with my passion. Having your picture taken was supposed to happen at Christmastime or birthdays or after catching a big fish—not just any old time. Why would anyone take a picture of someone mowing the lawn or getting the mail?

I had been reading everything I could get my hands on about photography. Not about careers or cameras, but about photographers—their lives, their work. I decided to document my family life in 1958, just to do it. The Harveys in 1958: new puppies, backyard softball, birthdays, and off for a family drive. The pictures were pretty simplistic and the captions even more so, but oh so authentic. I can't even come close to equaling the purity in this work today."

**—DAVID ALAN HARVEY**

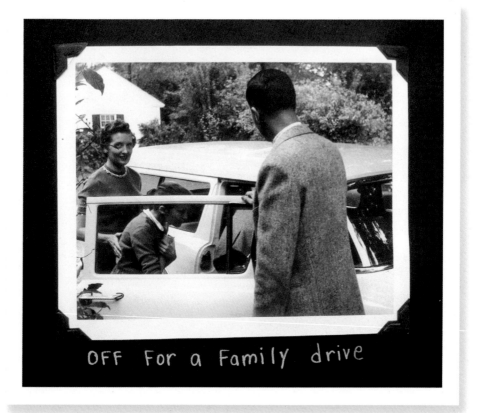

OFF For a Family drive

# The Strange and the Exotic

## BEFORE 1930

*Stuart Franklin*

UNPACK THE TRAVELER'S TRUNK. PUT ASIDE THE PAR-rots' feathers and leopard skins, the ancient codex of tattoos and tribal scarring, the spiraling rings and bracelets, the rivers of silver and gold. Clear away the cowry shells, the ceremonial daggers, and semiprecious stones. Unadorned, then, in a conspiracy of silence, the nameless remain: faces that do not burn with purpose, but smolder with the lack of it. Smiling, sullen, or angry, all are obedient to the demands of the camera: the Portuguese woman who "Wears Her Wealth Upon Her Head," the "Peasant Character as Sturdy and Unchanging as the Alps," or the hundreds of racial or ethnic specimens or "types" collected for the lingering gaze of the literati. This, for me, is the sad part of the National Geographic archive. Yet pride, joy, and self-esteem are also to be found in the early National Geographic collection. Ponder "The Belle of Mombasa with her Pet Deer" (page 123). Delight in the powerful gaze of a young Polish woman by Jan Bulhak, published in 1926 (page 154). Admire the striking portraits of Sicilian youth by von Gloeden. Enjoy the rueful smile of a Sardinian girl out shopping for eggplants (page 118). This 1923 hand-tinted photograph by Clifton Adams, taken on a lightweight film camera, marked a paradigm shift in National Geographic's approach to portraiture, and in editorial portraiture in general.

Starting in the 1920s, small, lightweight cameras allowed photographers to take meaningful, unposed "environmental portraits." These were known, in the magazine's vernacular, as "character studies," created in the field far from the stultifying lights of the studio. Increasingly, these studies were made in color, especially after the "Kodachrome revolution" of 1935-38. Over the past 80 years some of the finest examples of this style of portraiture have appeared in the pages of *National Geographic* magazine, as this book clearly testifies. Yet the early days of photography were different. Picture a white man hunched under a black cloth, gazing through a semi-transparent glass screen at a figure that will appear to him to be standing on its head. What is he doing? What is being exchanged, or taken? What strange thing is a photographic portrait? One thing is certain: The portraits that were published in *National Geographic* magazine before the 1930s, with a very few exceptions, are substantially different—as pictures—from those that are commonly exhibited or published as representative portraits of the period. I'm thinking of Imogen Cunningham's (1918) photographs of her parents, or of the painter Frida Kahlo; or Man Ray's (1922) Marchesa Casati; or Edward Weston's (1923) portrait of his Mexican lover Tina Modotti.

What makes the National Geographic collection different is that the vast majority of its early portraits form a collection that is ethnographic rather than photographic in emphasis, and so the portraiture lacks the disarming intimacy of, say, Julia Margaret Cameron's family recruited to pose as wood-nymphs, or Edward Weston's portraits of friends and family, or Richard Avedon's famous (1979) photograph of his dying father. Photographic portraiture is probably most at home, even perhaps most accomplished, in immortalizing those we love. By contrast, the National Geographic collection is a traveler's tote bag of the unusual, the exotic, the strangely costumed: the other.

I am a photographer. I'm not sure how to judge whether a portrait is successful, apart from the request that it should render immortal something of the mortal character of the subject. Probably I judge all portraits by reference to a picture taken by Henri Cartier-Bresson of the French-Algerian Nobel Prize–winning writer Albert Camus. It's not clear where the writer is standing, certainly somewhere in the street. He smokes, and wears a heavy overcoat. But it is not these details that draw me to the picture. A great portrait enlists something of the soul of the subject. A great portrait transcends its flimsy two dimensionality and evokes the living man or woman. It breathes. The Camus portrait has captured the intelligence of the writer so perfectly that it has rendered it a monument to inspired thinking. And so it is, for me, a work of art.

A HIGHLIGHT OF THE NATIONAL GEOGRAPHIC PORTRAIT collection is one of the rare sets of Edward S. Curtis's epic *The North American Indian*. This monumental archive consists of 20 volumes of illustrated text and 20 photogravure portfolios produced between 1907 and 1930. Yet contemporary historians puzzle over whether *The North American Indian* is a monument to Curtis's enterprise, zeal, and stamina or to the "vanishing race" he sought to portray—or both. Two recurring problems with the genre of photographic portraiture are: One, that the picture fixes the subject passively in time and space; and two, the picture abstracts narrowly from dynamic, changing, everyday life. Curtis, and many who followed him into portraiture, have thus been doubly vulnerable to criticism, accused both of false objectivity and of essentialism: treasuring a mythologized, ideal past. The Crow homeland, for instance, was perceived as a "veritable Eden of the Northwest." And as Christopher Lyman has commented, "Curtis's generation believed that Indians were only real Indians when they behaved as they were imagined to have behaved prior to contact with Whites." Airbrushed out were the

automobiles, railroads, and virtually any signs of modernity.

Yet, stereotypical as many of the images indeed are, nothing can detract from their documentary value, or from the actual experience of kneeling on the floor of the small storage room where these portfolios are kept at the National Geographic Society and leafing through the large prints. In the encroaching age of digital photography, the quality of the sepia-tone gravures is utterly breathtaking.

The photograph published here (page 130), "Tearing Lodge—Piegan" (1911), appears to have been taken somewhere in Montana, probably in Curtis's tent, with Pinokiminiksh, or Tearing Lodge, (in his seventies at the time) wearing his buffalo-skin war costume—hardly everyday gear. In the context it's rather like an elderly dowager being photographed in the bridal dress she once wore to the altar. By 1911 most of the Piegan (sometimes known as the Blackfoot) had been wiped out by smallpox, measles, the ill effects of whiskey trading, and starvation over the winter of 1883-84, long before the Curtis photograph was taken. At the same time the buffalo (or more correctly the American bison) of the warrior's war costume were hunted to virtual extinction.

It was perhaps the magnificent stateliness of Curtis's photographs that led Theodore Roosevelt to employ him to take his daughter's wedding pictures. Roosevelt had become a cattle rancher and keen buffalo hunter in the Dakota badlands before the cruel winter of 1886-87 decimated most of his cattle and drove him out of the saddle. But the call of the wild was not long suppressed. After stepping down as President in 1909, Roosevelt made a significant hunting expedition to East Africa and also explored the River of Doubt, a previously uncharted tributary of the Amazon River now called the Rio Roosevelt. He traveled with his son Kermit. One of the pictures from the Brazil expedition (pages 112-113) is representative of an entire genre of portraiture, practiced mostly by men and displaying their achievements: big fish, game trophies, and prize cattle.

Many of the photographers who supplied portraits to the Geographic before the 1930s took extravagant and sometimes heroic risks to bring back their stories. Of note are Joseph Rock, Eliza Scidmore, and W. Robert Moore. Self-taught, Rock was a man who liked to be treated like royalty, and he found China to be the place where he could best pull this off. According to a *National Geographic* magazine article written about him, he carried a portable rubber bathtub, a battery-powered phonograph, and two Colt .45 pistols on his extensive travels to the interior, sometimes with an escort of as many as 200 men, "bringing to readers' living rooms exotic kingdoms, faraway peoples, and snow-mantled peaks that were little known even to geographers."

Scidmore spent 50 years traveling, photographing, and writing about Alaska, Japan, India, and Southeast Asia, reporting on such diverse topics as elephant hunting in Thailand and a tsunami in Japan. She was instrumental in promoting the

use of color photography in the magazine and successful in getting some of the first such pictures published in her article "Young Japan" (July 1914).

Moore is best known for his coverage of the Ethiopian Emperor Haile Selassie's coronation in 1930, where he battled with "the fuss and feathers of ceremonial protocol" and the technical problems associated with desperately slow autochrome plates. Lack of light ruled out the chance to cover the main events, such as the coronation itself, and he was forced to delay his journey to enable him to photograph the potentate outdoors. Luckily, the emperor arranged a special train just for Moore, so he could meet the steamer for France. Technical problems dogged the traveling photographer: Plates had to be brought from Europe, often requiring a two- or three-month wait from the time of placing the order. Photographic materials deteriorated rapidly in the heat and humidity, and plates had to be washed in water cooled in a three-foot unglazed pottery jar. Even when they could be processed, despair was never far behind. Imagine the disappointment of long evenings spent developing plates in a hotel room only to find most of the images blurred. "We had motion but no editor would buy it," grumbled Moore.

APART FROM THE NAGGING TECHNICAL CONSTRAINTS, there was also pressure from the head office. One appeal was for pictures of pretty girls. In the article "The Black Journey: Across Central Africa with the Citroën Expedition" (1926), the photographer,

Georges-Marie Haardt, achieved his aim admirably with "The Favourite Wife of a Mangebetou Chief" (page 122), taken somewhere not far south of Lake Chad. An African woman poses in unrivaled profile, wearing an elaborate headdress. The only difference between the picture Haardt took and the published version is that in the latter her breasts were cropped off. Prurience? Hardly. Hundreds of bare-breasted women, all from poorer countries, were published at a time of booming subscription rates. The South Sea Islands were a favorite source for this kind of study, such as a Gauginesque moment captured in the Austral Islands and published in color in 1925 (pages 150-151). The Dayak tribes of Sarawak also fit the bill. Harrison Smith, a learned professor of zoology, merrily complied. Just over one half of the 57 pictures in his article "Sarawak—The Land of the White Rajahs" (February 1919) depict young tribal women whose bare breasts are prominently displayed to the reader.

The search for female beauty was not always easy. Tasked with such a mission, the photographer Clifton Adams wrote despairingly to his superiors from Sardinia: "About pretty girls as subjects, I've had 17 years photographing them and it's always a great pleasure. On this island there are very few really pretty ones as I judge them but I'm getting some negatives slowly." Where photography was difficult or out of reach for the wandering reporter, the gaps in the coverage were filled by images bought in commercially through the well-known commercial agencies or practitioners such

as Bourne and Shepherd, Underwood & Underwood, or von Gloeden, in Sicily.

Oriental "portraits" were sometimes supplied from the pseudo-ethnographic "colonial harem" exotica produced for French postcards and inspired, directly or indirectly, by Flaubert's erotic invocations of the temptations of St. Anthony, a third-century Egyptian abbot. The photograph entitled "Algerian Type. Young Moorish Girl. Algeria" was of this class. It was purchased from Levasseur by Maynard Owen Williams for National Geographic in 1924. The woman's expression, like that of many of the bought-in belles, is reminiscent of Edward Said's description of Flaubert's Egyptian courtesan: "She never spoke of herself, she never represented her emotions, her presence or history."

By contrast, the portraits of Baron Wilhelm von Gloeden are enervated by the subject's engagement with the photographer. Born into a German aristocratic family, von Gloeden removed himself to Taormina, an out-of-the-way town in Sicily. The intimacy of his work—particularly of Sicilian youth—derived from the relationships he enjoyed with his principal subjects. Shortly after arriving in Taormina, he eloped with his 14-year-old houseboy, nicknamed "Il Moro," and began to photograph his new lover and his friends.

NATIVE COSTUMES WERE AN OBSESSION FOR GEOGRAPHIC reporters in the early days. There was an undisguised obligation and a useful duty to collect evidence of what were considered to be disappearing customs and traditions. For example, during the 1925 Citroën Expedition across Africa, "particular attention was given to customs and costumes of native tribes which were slowly disappearing." A story by Eliza Scidmore: "Adam's Second Eden: Ceylon," consists largely of portraits of Tamil men and women in costume—"The Basket Trick Juggler" (page 163), for instance. But the exotic costumes often obliterated the qualities of those who wore them.

Many countries, such as Slovakia, were perceived as "vast museums of folk art"; their people, through both photography and text, were mere expressionless mannequins. In Maynard Owen Williams's story "Czechoslovakia, Key-land to central Europe" (February 1921), young Slovaks were photographed in "fast-disappearing" national dress. And the fascination with costumes was not simply restricted to young women. A photograph entitled "Public Shepherds in Their Field Costumes" is a posed picture of a matching pair of middle-aged men in traditional hat, sash, walking stick, and briar pipe, standing unceremoniously in front of a hedge.

Countless versions of these pictures exist in the collection. In many cases subjects were categorized according to "types." "Types of Benguet Igorote girls" from the Philippine Islands, "Cowboy types" from the Camargue, and yet more "types" from the High Tatra mountain region of Czechoslovakia are examples of this popular approach to portraiture.

Few of the subjects have names, for two reasons. First, they were seen as specimens or

"archetypes," and therefore their singularity, as people, served no editorial purpose. Second, many of the pictures were bought in as stock and were poorly captioned. Sloppy captioning was not, however, magazine policy. Photographers on contract were duly upbraided for supplying insufficient "legends": Somewhere between 30-50 words was normally required for each caption. The same applies today.

Oddities within tribal custom were particularly prized as subjects for portrait photography. In Upper Burma Alfred Joseph Smith discovered that the Palaung women were made to wear brass rings around their necks, arms, and legs, amounting to a weight of 50-60 pounds. "The neck rings, as thick as the little finger, are put on the girl in infancy, four or five rings at first and others added as fast as she grows, till 18 or 20 keep the neck always stretched." The resulting portrait (page 110) is of two such women standing at attention on either side of what seems to be a Burmese colonial official in a pith helmet.

The formative years of *National Geographic* magazine were particularly interesting, not least because the photographic medium was changing so rapidly. When the magazine first started to publish photographs in the early 20th century, large, unwieldy plate cameras were all that were available. They were highly unsuitable for peripatetic photographers, and the film they used was impossibly slow. Early large-format photographic portraiture, while highly influenced by painting, tended to deliver rigidly posed pictures with out-of-focus backgrounds: that is, without the geographical sweep of mannered period paintings.

The lack of background was clearly unsuitable for a magazine whose mandate was to show people in situ, in their native setting. Franklin L. Fisher, an Associate Editor in the early years, had demanded as much in a memorandum instructing one of the photographers: "I don't mean that he should avoid taking pictures of public buildings and things of that sort but those that he does take should have prominently in the foreground a picturesque native figure or something to put a little pep into the picture." This could only be achieved with effect when cameras became light enough and film fast enough to catch people "on the fly."

An early signal of the way portraiture would develop can be seen in Clifton Adams's 1923 picture of a Sardinian girl. Smiling, confident, alive, here is a young girl in the marketplace with her mother and grandmother, shopping for eggplants. This is a true environmental portrait. In many of the finest portraits, there is a haunting beauty that has little to do with the physical countenance of the subject. "Beauty," as Santayana reminded us, "is an emotional element, a pleasure of ours, which nevertheless we regard as a quality of things." Perhaps it is this emotional link between the photographed and the photographer that determines the merit of a portrait.

— STUART FRANKLIN

# Editor Gilbert Hovey Grosvenor had no interest in the art world, and the idea that photography

could be art never really occurred to him. For his fledgling *Geographic* magazine he wanted uncomplicated pictures of real life at its most exotic and surprising. In December 1904 pictures of the Tibetan capital, Lhasa, arrived in the mail unexpectedly, and Grosvenor had the chance to publish them a month later. To print them in the conservative, semi-academic magazine was a bold and expensive decision at the time, but the pictures were an enormous hit with Society members.

This fact confirmed Grosvenor's conviction that photography could give credibility to any eyewitness account and encouraged him to build a photographic collection. At first he obtained pictures from acquaintances, and when he traveled he picked them up from curio shops, professional studios, other collectors, and photographers. The word got out, and pictures began to come in to the Geographic unsolicited. Staffers, trained or not, took pictures too. Most portraits were stiffly posed and showed people as ethnographic types. The images accumulated and were on hand for magazine stories if the need arose.

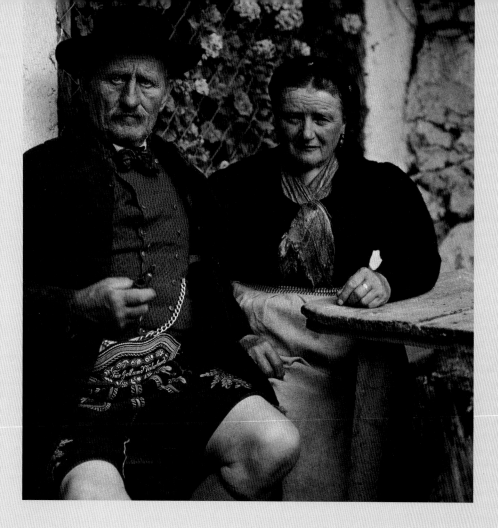

**HANS HILDENBRAND    1929**
A couple in traditional dress in Alpine Austria

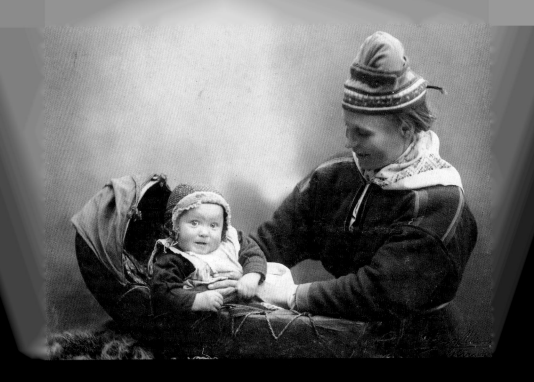

▶ **BORG MESCH   1923**
A Lapp woman displays her baby in a tree-trunk cradle.

▶ **E. M. NEWMAN   1922**
A Swedish girl delivers the milk and takes care

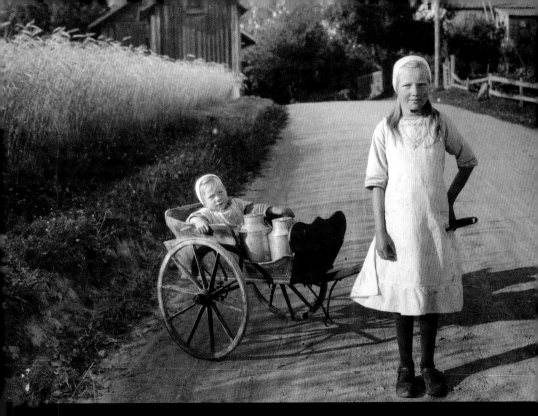

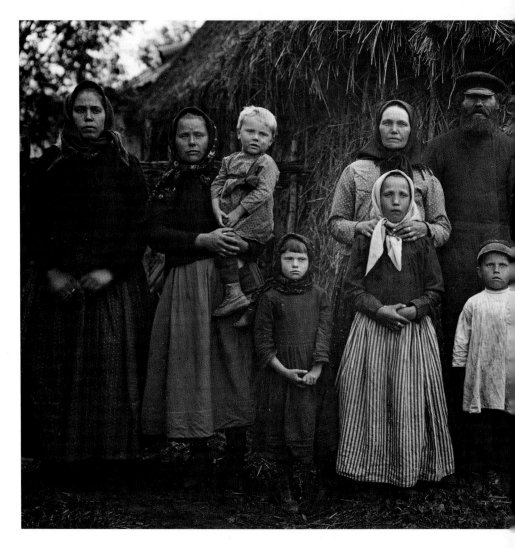

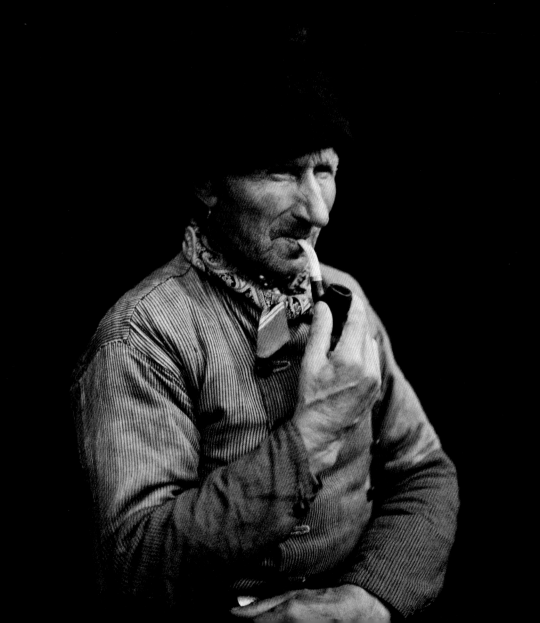

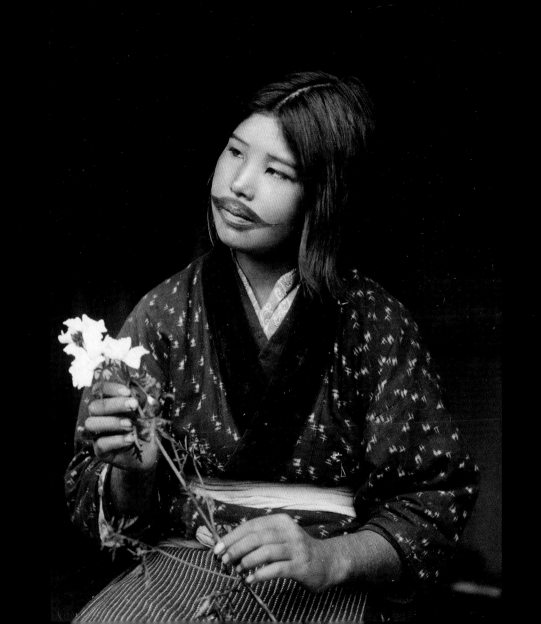

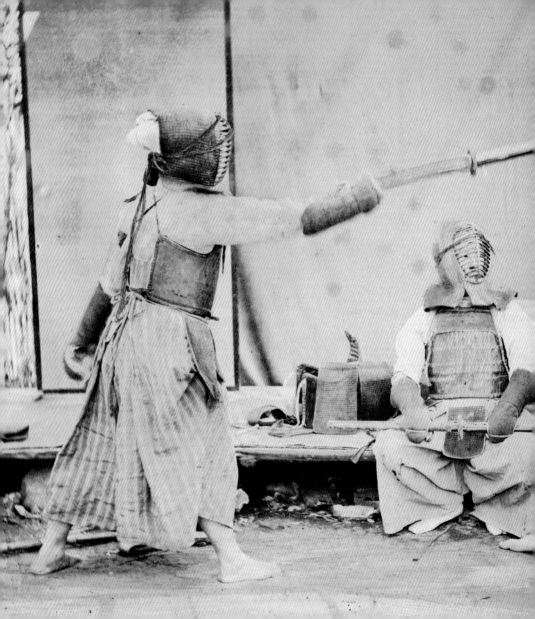

FOLLOWING PAGES:
CLIFTON R. ADAMS   1928
A French trapper displays a two-week catch
of red fox skins, Turtle Lake Reservoir,
Lake Michigan.

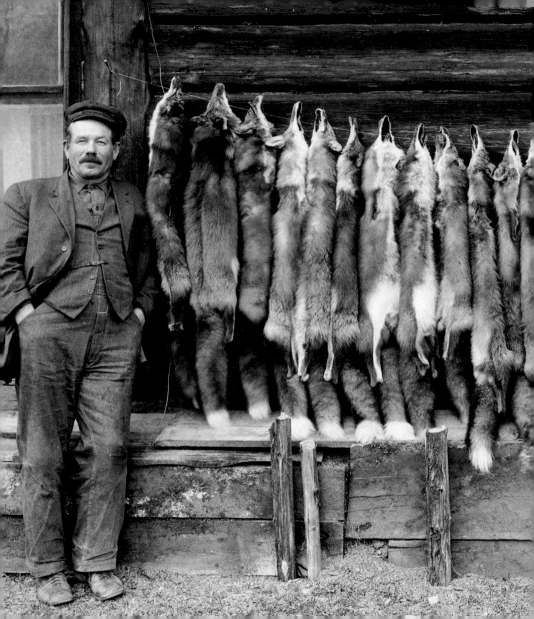

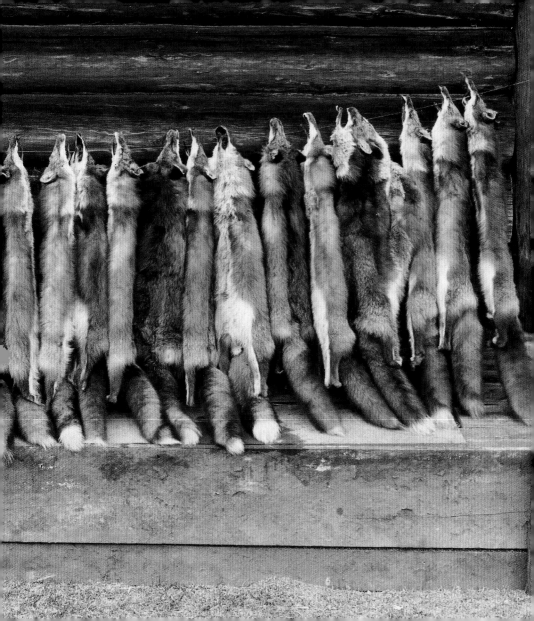

**JOSEPH F. ROCK    1924**
Exotic flora in the mountainous rain forest
of East Maui, Hawaiian Islands

"Self taught, Rock was a man who liked to be treated like royalty and he found China to be the place where he could best pull this off. According to a *National Geographic* article written about him, he carried a portable bathtub, a battery-powered phonograph, and two Colt .45 pistols on his extensive travels to the interior, sometimes with an escort of as many as 200 men 'bringing to readers' living rooms exotic kingdoms, faraway peoples, and snow-mantled peaks that were little known even to geographers.'"

—*STUART FRANKLIN*

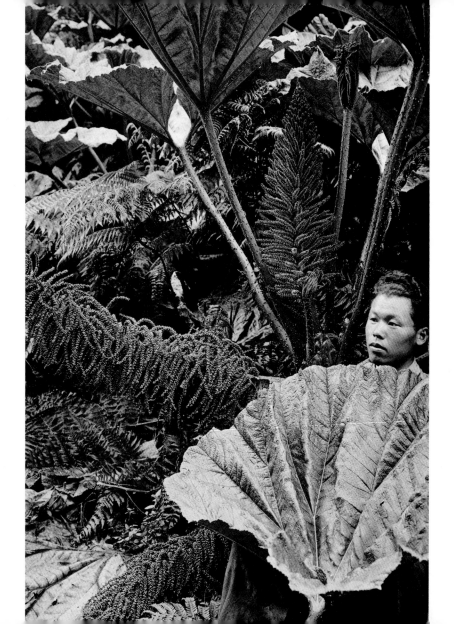

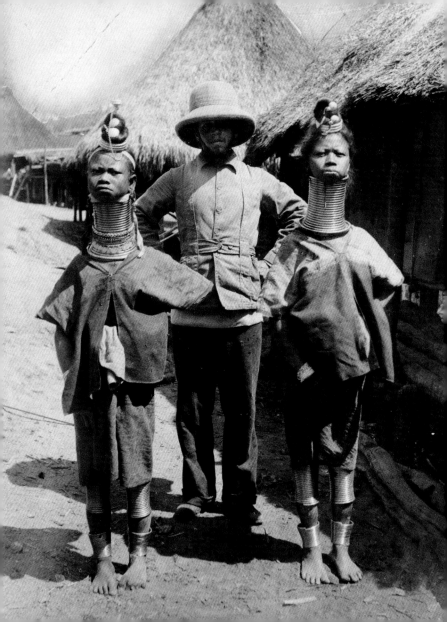

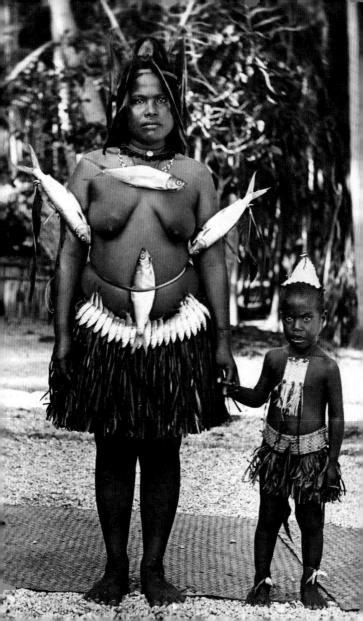

**PRECEDING PAGES:**
◄ **ALFRED JOSEPH SMITH   1913**
Palaung women of Upper Burma

► **FROM ROSAMOND DODSON
RHONE   1921**
Costumed for the fish dance on the island
of Nauru

**KERMIT ROOSEVELT   1914**
Theodore Roosevelt displays a jaguar
trophy from his expedition to Brazil.

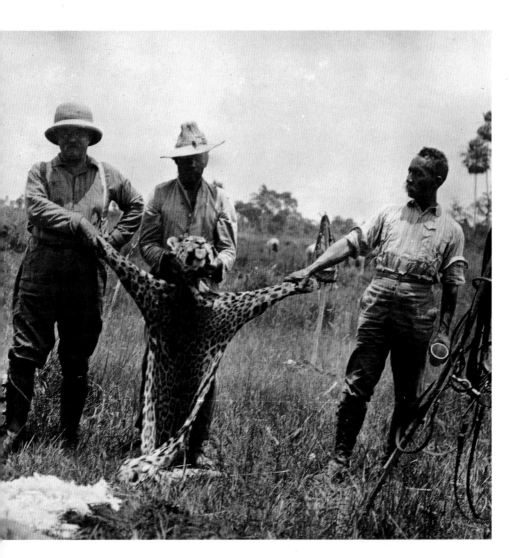

◄ **HANS HILDENBRAND** 192
Salzburg, Austria

▲ **A. W. CUTLER** 1922
A Portuguese woman carries her chic

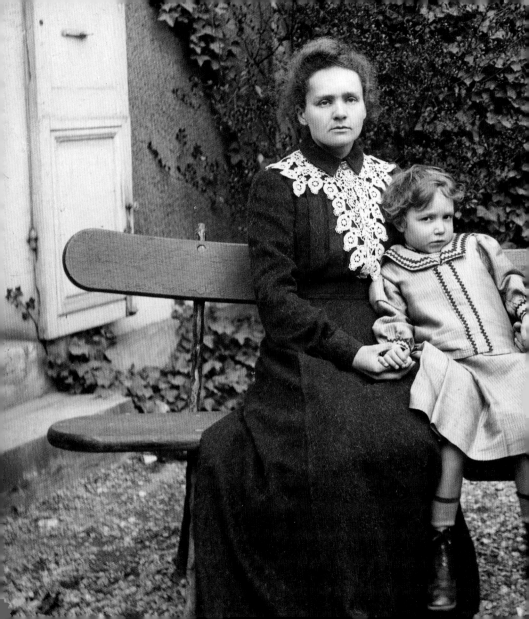

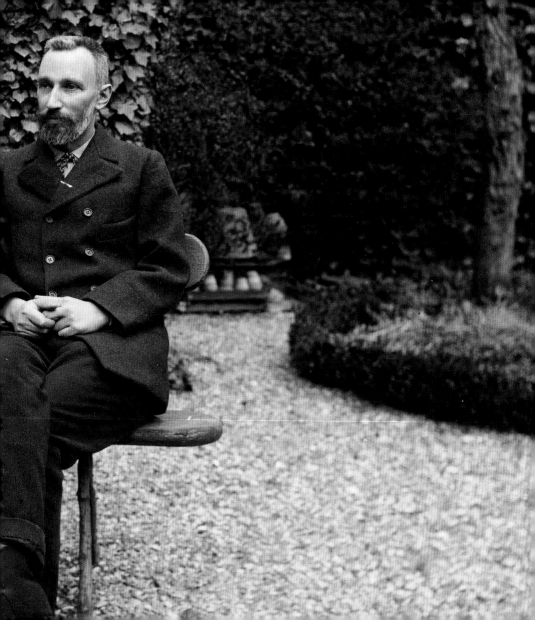

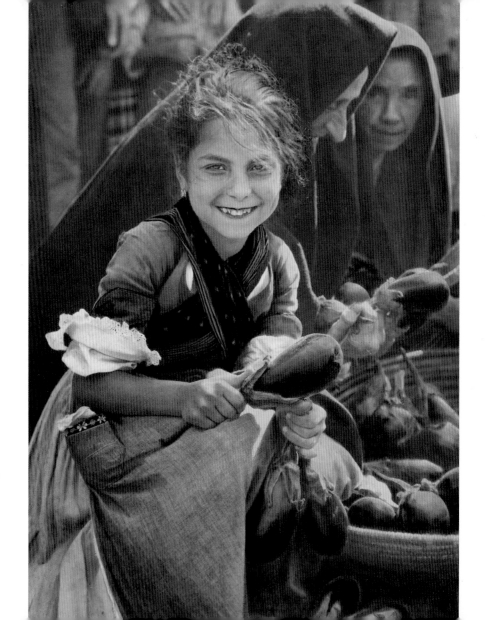

"This 1923 hand-tinted photograph by Clifton Adams, taken on a lightweight film camera, marked a paradigm shift in National Geographic's approach to portraiture, and in editorial portraiture in general. Starting in the 1920s, small lightweight cameras allowed photographers to take meaningful, unposed 'environmental portraits.' These were known . . . as 'character studies,' created in the field far from the stultifying lights of the studio."

—*STUART FRANKLIN*

**PRECEDING PAGES:**
**H. C. ELLIS   RECEIVED 1918**
Physicists Pierre and Marie Curie, with their daughter

**CLIFTON R. ADAMS   1923**
A Sardinian girl from Iglesias shows off her selection of eggplants at market.

**FROM MAYNARD OWEN WILLIAMS   1921**
Bohemian children of Chod, Czechoslovakia,
in the mountains on the border with Germany

**FOLLOWING PAGES:**
◄ **CITROËN CENTRAL AFRICAN
EXPEDITION   1926**
The favorite wife of a Mangebetou chief in Africa

► **UNDERWOOD & UNDERWOOD   1909**
A stylish young woman of Mombasa holds
her pet deer.

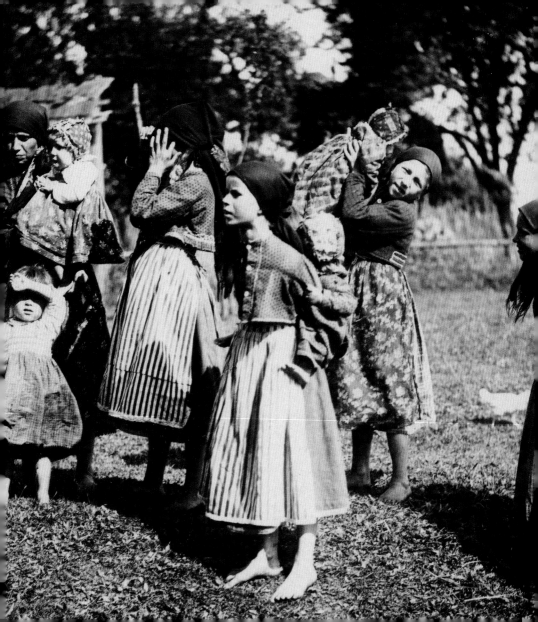

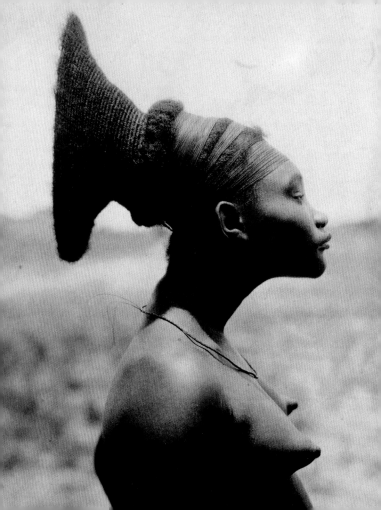

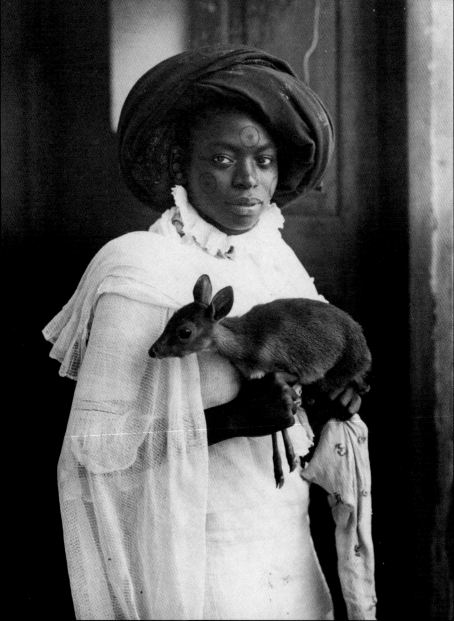

# There didn't seem to be a way for the Geographic to cover sensitive issues at home in the United

States without getting unpleasantly emotionally embroiled, but politics in remote places were innocuous: Russian peasants demonstrating in Siberia in 1920; Persian revolutionaries taking refuge in the British Legation in Tehran in 1906 (page 126); even heads of convicted thieves shockingly decapitated and displayed on a billboard in China (pages 132-133) acquired an aura of unreality with distance from American shores. The emotional distance was easy to maintain in an age when communication was cumbersome and long-distance travel was uncommon.

Some thought Grosvenor's avoidance of controversy close to home was a sign of weakness. Others respected the objectivity this suggested. The Geographic did cover selected current events nearby—the good works of the American Red Cross during World War I (page 127), for example, and the arrival of hopeful immigrants ready to begin new lives in the U.S.

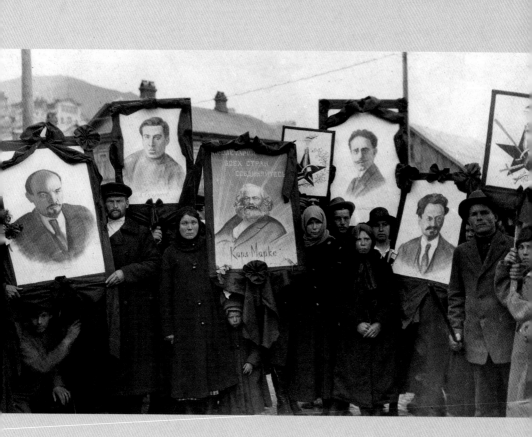

**KADEL & HERBERT 1920**
Russian peasants carry placards during
a Bolshevik celebration.

125

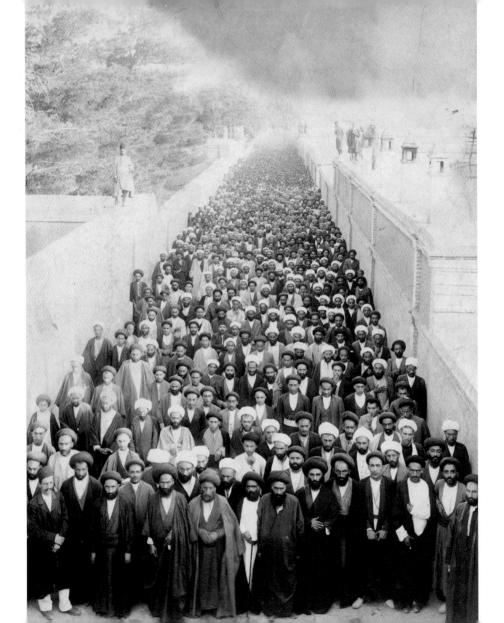

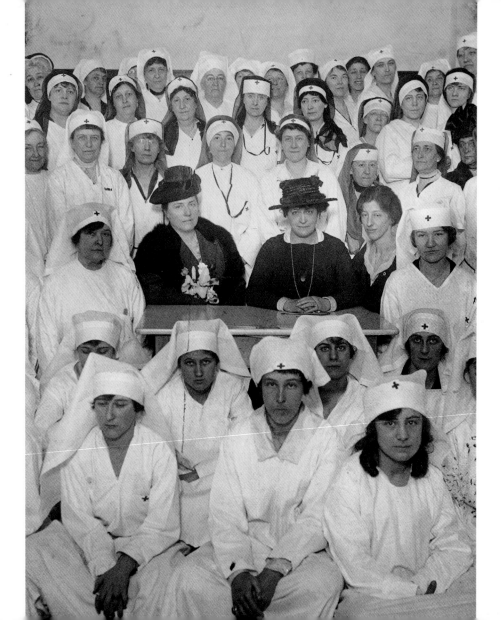

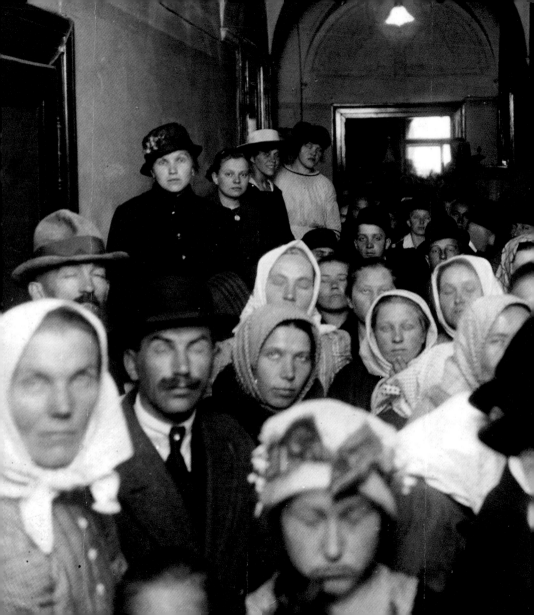

**PRECEDING PAGES:**
◄ **UNDERWOOD & UNDERWOOD**
**1906**
Revolutionaries in Tehran who took refuge
in the British Embassy

▶ **UNDERWOOD & UNDERWOOD**
**1917**
American Red Cross workers at head-
quarters in New York

**HARRY A. MCBRIDE**
**DATE UNKNOWN**
Immigrants to U.S. in Prague, Czechoslovakia

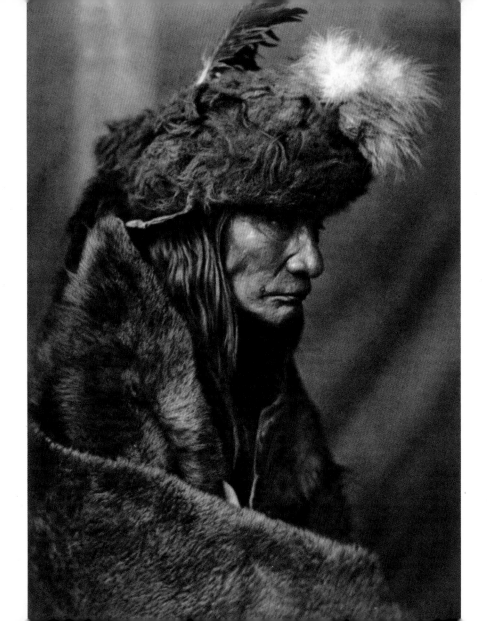

" 'Tearing Lodge—

Piegan' (1911), appears to
have been taken somewhere in
Montana, probably in Curtis's
tent, with Pinokiminiksh, or
Tearing Lodge, (in his seventies
at the time) wearing his buffalo-
skin war costume—hardly
everyday gear. In the context it's
rather like an elderly dowager
being photographed in the
bridal dress she once wore to
the altar . . . It was perhaps
the magnificent stateliness
of Curtis's portraits that led
Theodore Roosevelt to employ
him to take his daughter's
wedding pictures."

—*STUART FRANKLIN*

**EDWARD S. CURTIS  1911**
Piegan Indian Tearing Lodge, Montana

**FOLLOWING PAGES:**
**CLAUDE MEACHAM  1927**
Heads of outlaws are posted on a billboard
in Nanking.

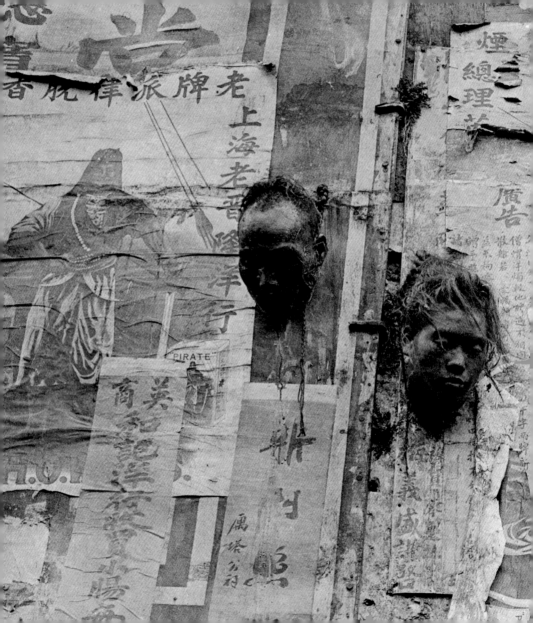

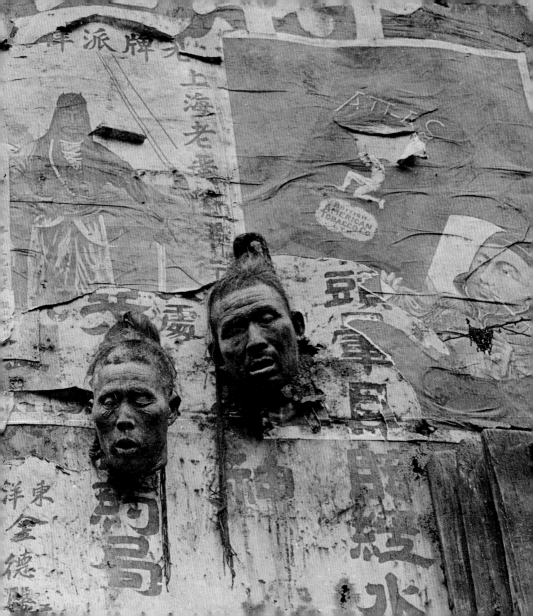

**PHOTOGRAPHER UNKNOWN    1911**
Northern France

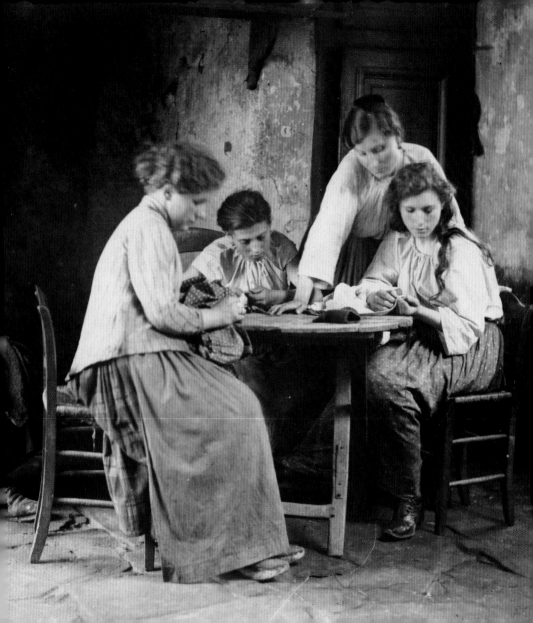

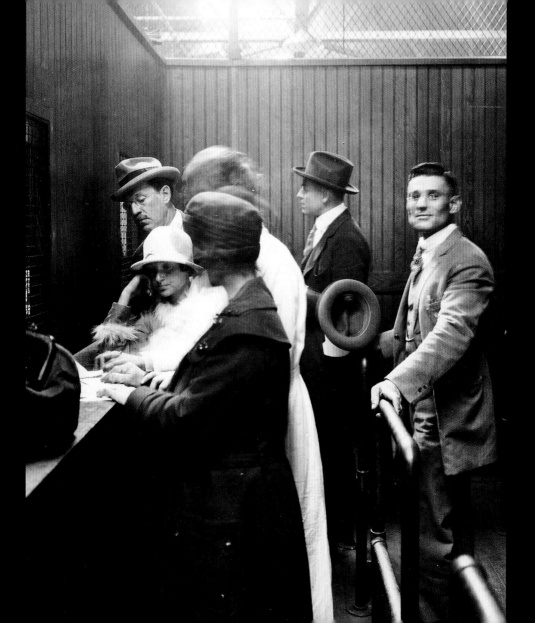

RHODE ISLAND HOSPITAL TRUST CO.    1923
A Red Cross worker helps an immigrant purchase a railroad
ticket at State Pier, Providence, Rhode Island.

# Gilbert H. Grosvenor, *National Geographic*'s first Editor, was a highly talented entrepreneur.

He realized that to make cultural geography compelling, and to sell magazines, it would be useful to publish pictures readers would be enchanted by. Photographers diligently doing their jobs in the field documented local peoples formally and informally, but not evenhandedly: They photographed far more women than men, whether by their own inclinations or a little nudging from headquarters, or both.

Pictures of dancing girls (pages 140-141) seem to be the sole excuse for a January 1914 story titled, "Here and There in Northern Africa." The girls are posed in desert settings, in Algeria and Tunisia, wearing coins and silks. An Old Testament quote from Jeremiah tells readers these girls are not "respectable." In hundreds of stories, for more than a century, photographs of women from Puerto Rico to Poland, Japan, central Africa, Europe, and the Americas, ranging from sensitive to lighthearted to melodramatic, have graced the *Geographic*'s pages, and they still do.

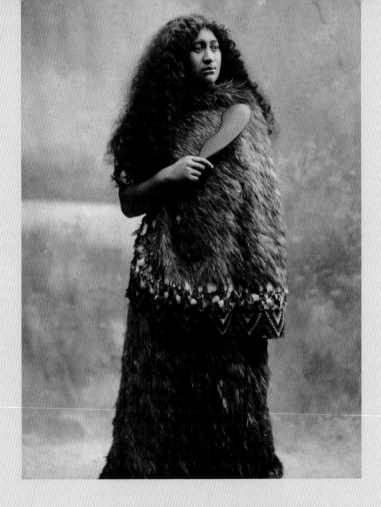

**THE TESLA STUDIOS    1921**

A Maori woman models the prized feather cloak worn
by persons of rank. The weapon she holds of nephrite,
or greenstone, was used in war.

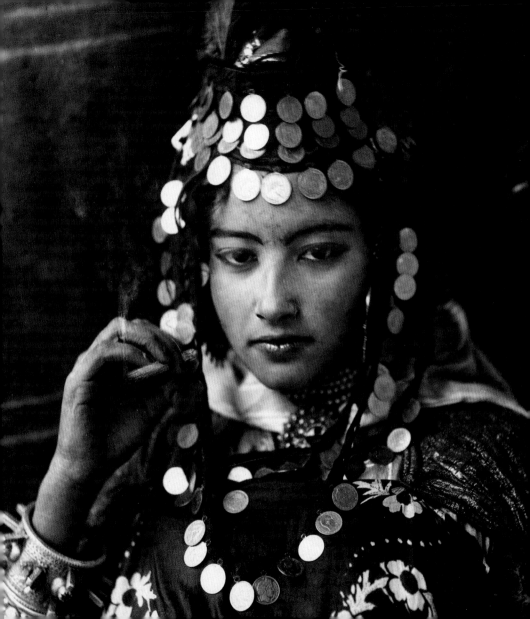

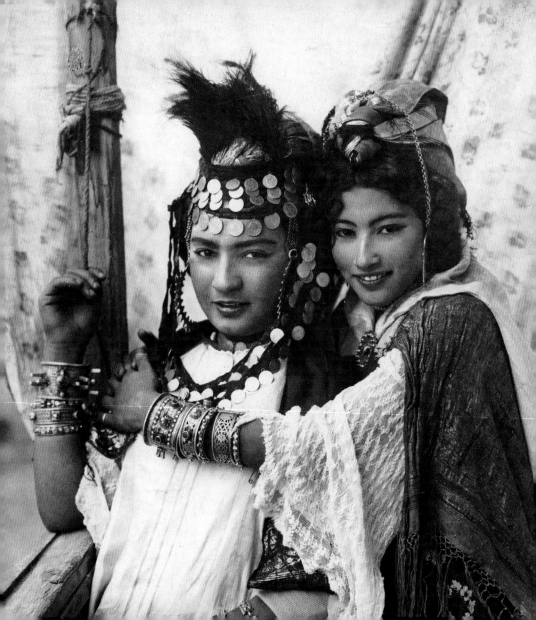

**PRECEDING PAGES:**

◄ **LEHNERT & LANDROCK    1914**

Dancing girl from the Ouled Nails tribe,
Tougort, Algeria

▶ **LEHNERT & LANDROCK    1914**

Girls from the Ouled Nails tribe will use
the gold pieces from their headdresses
as a wedding dowry.

**CHARLES MARTIN    1926**

Picking apples in Winchester, Virginia

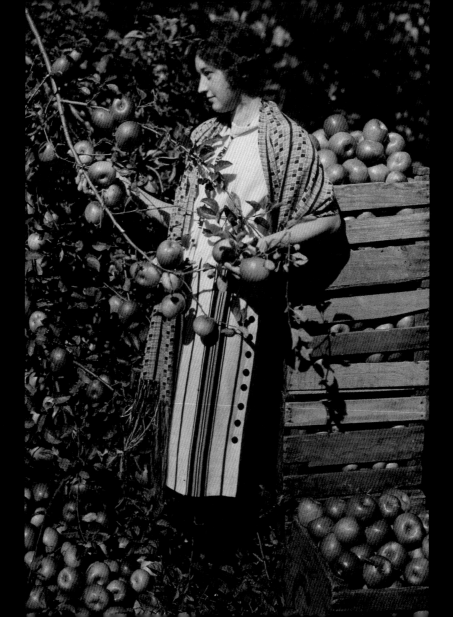

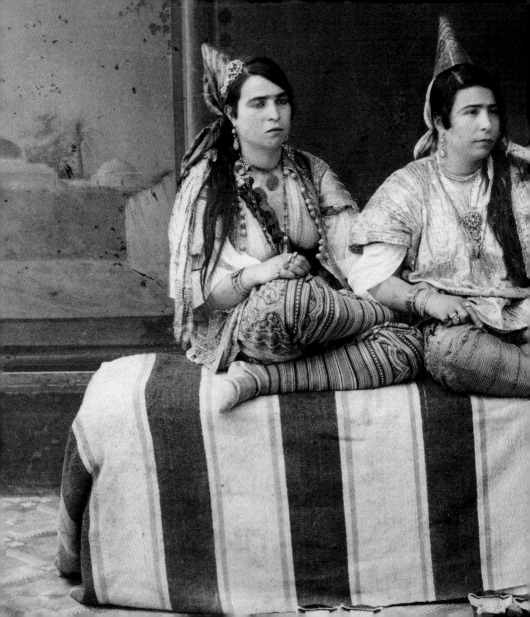

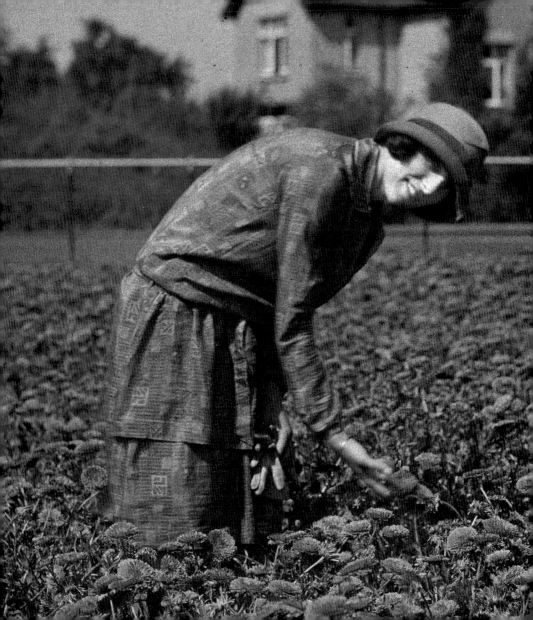

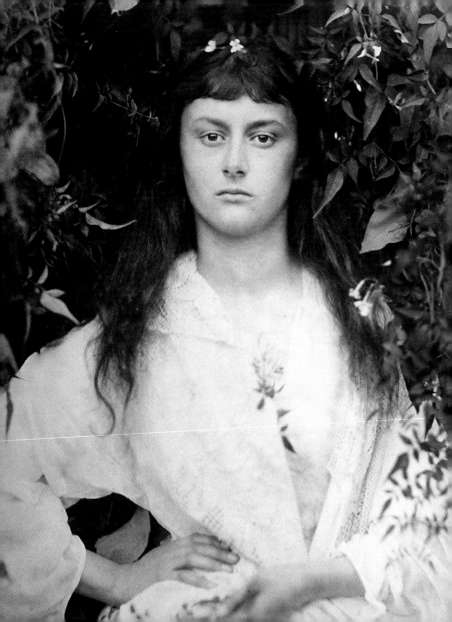

**PRECEDING PAGES:**
◄ **CHARLES MARTIN   1924**
A Puerto Rican debutante in the 1920s

▶ **JULIA MARGARET CAMERON
1872**
Alice Liddell, inspiration for Alice in
Wonderland

**ROLLO H. BECK   1925**
In the South Seas, Austral women grate
coconut meat.

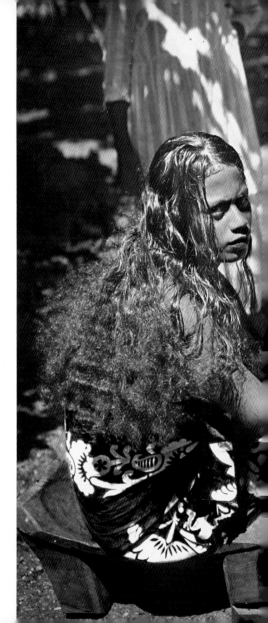

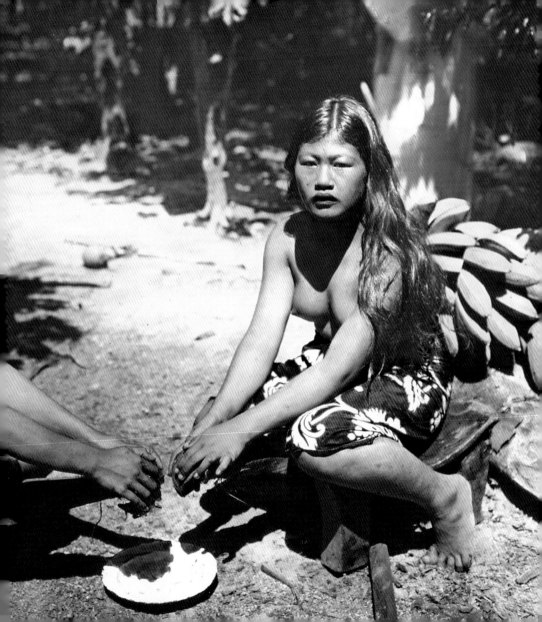

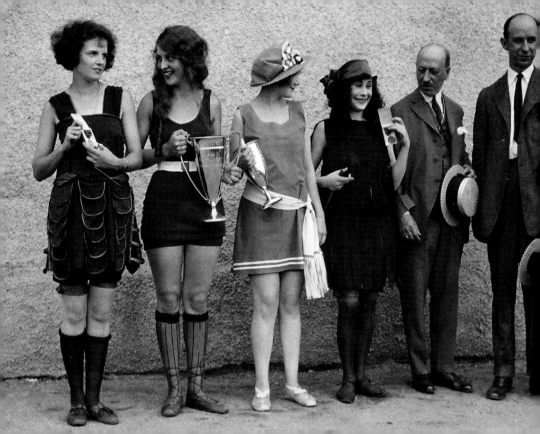

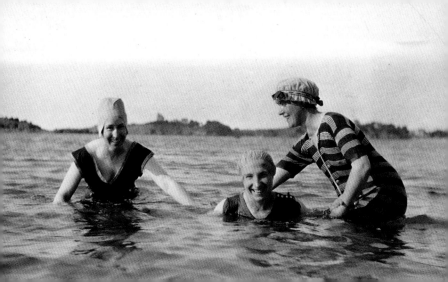

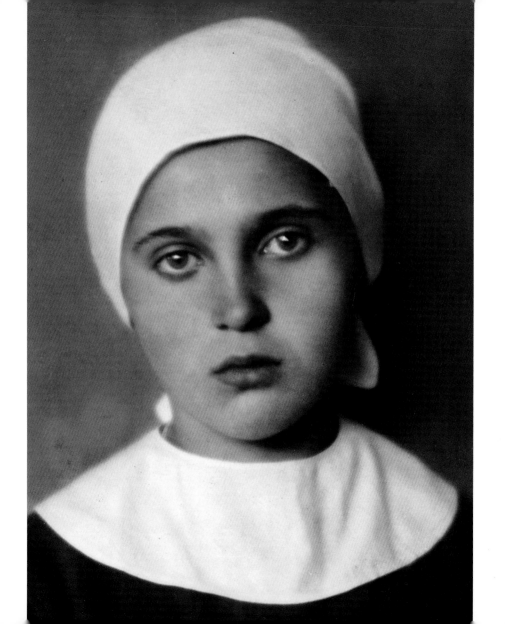

**JAN BULHAK 1926**
A young woman from Wilno, Poland

**FOLLOWING PAGES:**
◄ **FRANKLIN PRICE KNOTT 1936**
Autochrome collection

► **ALEXANDER GRAHAM BELL
COLLECTION 1912**
A Tamil girl from Ceylon

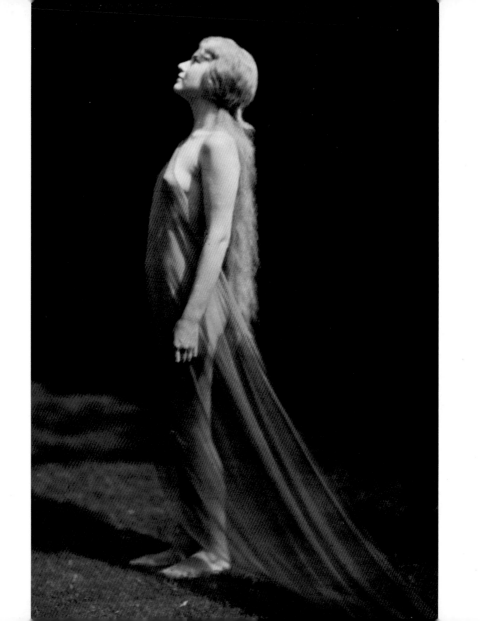

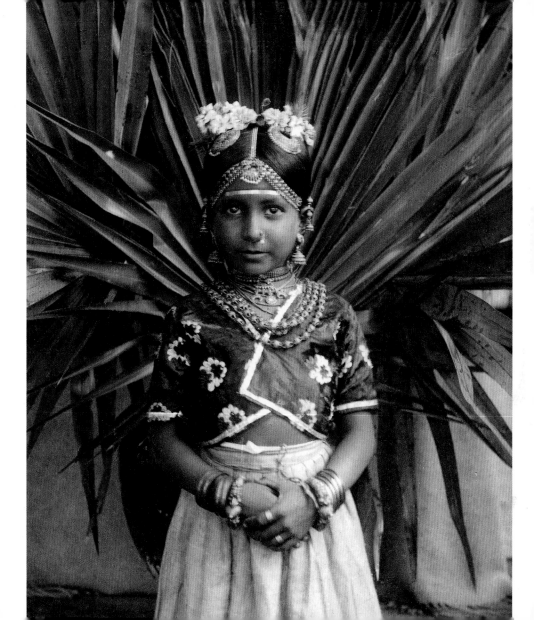

**Photography's** stunning power to collect facts on the one hand and create fantasies on the other

can be delightful or maddening, depending upon the viewpoint of the particular audience. The manipulation of images is as old as photography itself, and controversies about it began long before the digital revolution. A photograph, manipulated or not, may be used to reveal reality or obscure it. Clearly, the simple acts of taking a picture and displaying it can get very complicated indeed.

Most photographs by Baron Wilhelm von Gloeden, an East Prussian aristocrat who settled and worked in Sicily beginning in 1898, are fantasies in which young boys are posed to suggest a bucolic Greek paradise and blossoming masculinity. Geographic travelers passing through Sicily purchased 200 of his photographs for the archive, and editors used several in magazine stories about Italy and the emigration of Sicilians to America.

The *Geographic* occasionally illustrates editorial ideas with photographs, and in the early days airbrushed pictures to clean them up. But through the years it has become an ever more deeply held creed of *Geographic* editors and photographers that great photographs cannot be manipulated.

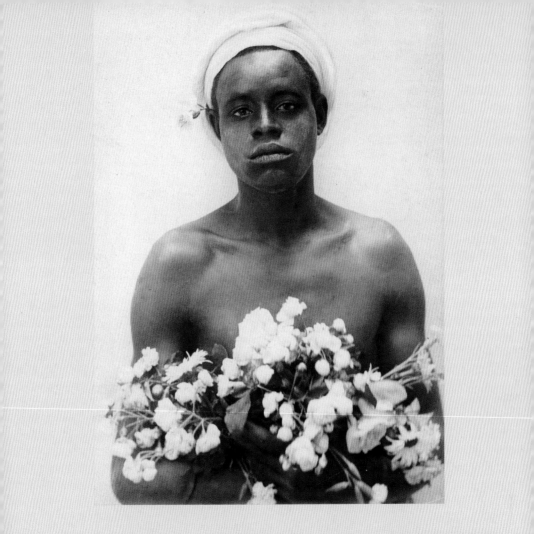

**WILHELM VON GLOEDEN**   **DATE UNKNOWN**
Sicilian youth

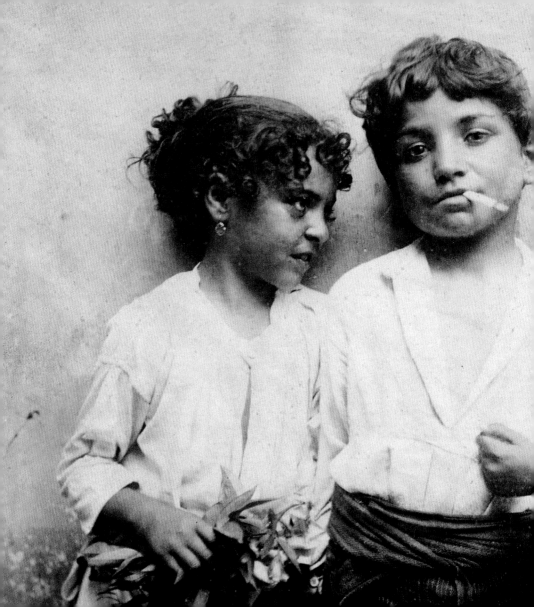

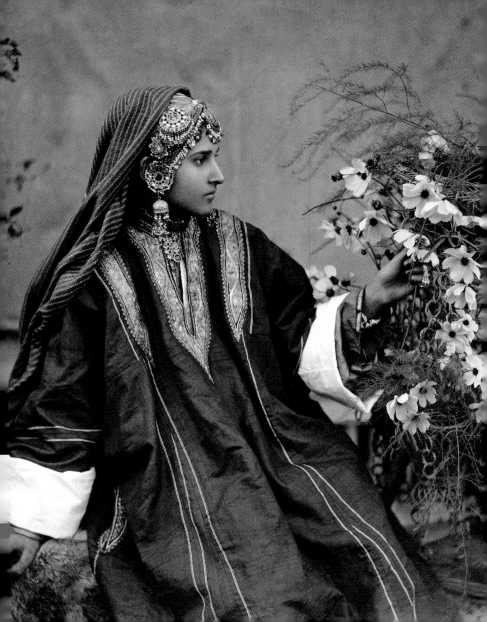

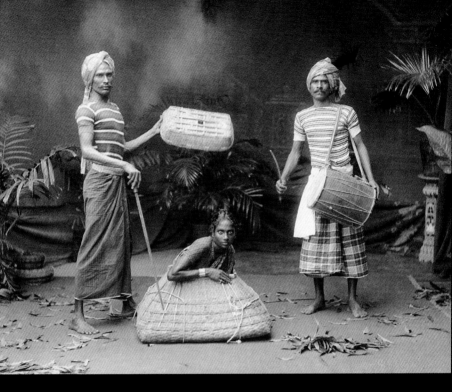

◄ **FRED BREMNER  1924**
Dancing girls of Kashmir often would sing and dance
in worship of Hindu deities in temples.

▲ **ALEXANDER GRAHAM BELL
COLLECTION  1912**
In Ceylon, Tamils perform a magic trick with a sword
and a boy in a basket.

# Away from
# Depression and War

## THE 1930s AND 1940s

*Sam Abell* (signature)

A GREAT STILLNESS LIES OVER THE PAGES OF *NATIONAL Geographic* magazine in the 1930s and '40s. The portraits, especially, stare steadily back at the reader, in sharp contrast to the vivid images that come to mind when the words "Great Depression," "Dust Bowl," and "World War II" are spoken. The face of those decades was a dark but dynamic one, rendered in well-known black-and-white photographs of the dispossessed and imperiled.

The most powerful of these photographs is Dorothea Lange's portrait titled "Migrant Mother." It is an emotionally intense portrait of a strong but worn woman, looking beyond the camera into an uncertain distance. On either side of her face, children burrow into her neck. The portrait is an iconic, still involving image because it is intimate and realistic.

But this intimate, realistic, emotional black-and-white portrait of life was not one seen by readers of *National Geographic* magazine in the 1930s. The portrait of life they saw month after month was a reassuring one, seen from a distance and rendered, increasingly, in sunny color.

In a fat, 90-page article titled "Louisiana, Land of Perpetual Romance," 1930, for example, readers saw photographs of the Mississippi River gracefully curving through a land of plenty—vast plantations of crops, enormous catches of fish, trophy alligators, and stately homes with deeply developed gardens.

Culturally, the theme of the article was the unbroken continuity of social traditions, coexisting beside the triumph of economic engineering. Portraits of Mardi Gras royalty, costumed Indians weaving baskets, and black youths enjoying watermelon mingle with landscapes thick with oil wells and large lakes bisected by immaculate, almost empty, highways. It is a portrait of prosperity and of progress.

Editorially, this represents a point of view, and it was a popular one with readers. During the decade of the 1930s, when historic numbers of businesses slowed or ceased to exist, the *Geographic* survived and magazine circulation grew slightly—no mean feat. Then, as now, the magazine's editorial point of view was delivered mainly by the photographs. Looking back now it is, at first, not easy to identify with the photographs, the photographers, or the point of view.

But a closer view of the thirties and forties changes that impression. Those decades were revolutionary years for photography at the Geographic. New techniques for making and printing photographs made these exciting years the beginning of the Geographic's modern era. It was an era that has lasted, with little fundamental change, until now. Understanding why will not be hard for anyone who switches, this decade, from film to digital imaging.

THE WORD "REVOLUTION" IS COMMONLY USED TO describe the digital divide photography is now crossing. But in the thirties and forties a similar switch slowly took place, and the implications for photography were if anything more significant than the changes occurring now. The revolution in photography of those decades came from camera and film designs. Cameras were made smaller and lighter. Film speeds, especially for black and white, were made "faster." These changes freed photographers. For the first time photographers were easily able to pursue human "moments." More than anything else it is the absence of such moments that separates modern photographs from photographs of the pre-1940 years.

The so-called candid photographs in the magazines of this era are as stiff as Civil War studio portraits. There is little difference between the portraits and the landscapes, city scenes, and objects that are pictured. All of them are still lifes.

That stiffness slowly altered over the decades of the thirties and forties. "It was changeover time," recalls longtime staff photographer Volkmar Wentzel. "The generation change, from large format to 35 millimeter came with Luis Marden's vision."

It was staff photographer Marden who championed the use of small, lightweight Leica cameras in place of the bulky box cameras and heavy tripods most photographers were using. These smaller cameras enabled photographers to move subtly with their subjects in pursuit of telling moments. Editorially and artistically it was the most influential technological change in the hundred-year history of photography at the Geographic. It produced a new kind of image, an intimate one.

By comparison the technological change from film to digital seems at this point to be about how the image is "captured," stored, transmitted, and viewed. In documentary photography it has yet to produce an authentically new kind of image.

Seventy years ago, in the heart of the Depression, I wonder what gave "authenticity" to a National Geographic photographer's work. Certainly not intimacy. In fact, it was the opposite. One of the ways the magazine established its point of view was by distancing the viewer from close contact with daily reality.

This was done several ways. First there is a stepped-back look. The numerous traditional landscape photographs have this look, but so do city scenes and industrial locations. In an article on New York City there are 22 images of inert buildings, and this at a time when the milling flux of the city's streets was alive with portrait possibilities.

Another way to achieve distance from the Depression was to take readers on adventurous expeditions, into the study of science or nature, and

on journeys to far off "traditional" cultures. Within these stories the most used distancing device was the aerial photograph. Article after article in the thirties and forties is dominated by scenes photographed from the air. An example is the almost endless, 111-page article "Conquest of Antarctica by Air," by Richard E. Byrd. Aerial photography was the new fascination of the era, and such stories had the most elemental ingredients of *National Geographic* magazine within them: adventure, exploration, nature, and science. But obviously an emphasis on aerial photography didn't lead to deep development of intimate portrait photography.

That trend, which was to influence later generations of Geographic photographers, was being pioneered by young, independent photographers such as the Frenchman Henri Cartier-Bresson, who was working, often in the same countries as Geographic staffers, with a Leica and fast black-and-white film.

Geographic photographers, by contrast, were pioneering color photography. The film speeds for color were significantly slower than for black-and-white films. This fact, combined with the Geographic's still ongoing tradition of using large cameras, slowed the inevitable evolution toward more candid, intimate, more "moment"-dependent photography. It can be said that in important ways, the pioneering of color photography for publication had the effect of setting back the progress of portraiture at the Geographic.

Thus a viewer today looking for intimate portraits in the *Geographics* of the thirties and forties finds few of them. What one finds are formal photographs, in which people are frozen into the compositions. If the photograph is a landscape, then people appear "for scale." If an object is the subject of the picture, someone holds it. If the scene is shown in mid-range, like a garden or streetside café, people pose as the local population. If the scenes photographed are in color, then people wearing vivid clothes are shown, for "color."

USING PEOPLE AS PROPS WAS SO PERVASIVE AT THE Geographic that one imagines it constituted the in-house culture of photography. Those photographers who did it well succeeded; those that posed people poorly, or perhaps refused, did not.

This brings up an interesting question. Who took pictures for National Geographic in the thirties and forties? A broad array of individuals it turns out. The photographs were produced by staff photographers, writers, and editors; by scientists, explorers, agency photographers, and the wire services; by amateurs and the anonymous. And also, especially during the war years, by the government, including the military.

Often an article was "illustrated" by more than one photographer, and it wasn't uncommon for there to be many photographic points of view in lengthy articles. This was in keeping with the Geographic's editorial philosophy of emphasizing information in the imagery, not individual authorship. That said, the Geographic has always been generous with bylines for photographers, and the

staff photographers of the era were well known to readers because they were so prolific.

In the early thirties Maynard Owen Williams was chief of the elite Foreign Editorial Staff, a group of men (and they were all men) who photographed, and sometimes wrote, the most important stories. Williams himself was often in the field, most memorably as the photographer on the 1931-32 Trans-Asiatic Expedition. His work on that epic overland trip was lavishly published over three magazine issues.

Working at the same time were staff photographers who were to have phenomenally long careers. W. Robert Moore became known as "the million-mile man" for his prodigious travel at a time when miles were hard earned. And the distinguished careers of Volkmar Wentzel and Luis Marden—both still active photographically in the 1990s—were just beginning in the 1930s. The self-educated Marden spent most of his career overseas. An inventor (of the Aqua-Lung, with his friend Jacques Cousteau); a linguist (he spoke five languages); an explorer (he found the submerged shipwreck, the *Bounty*); a botanist (a Brazilian orchid is named for him), he was also a distinguished, pioneering color photographer whose work spanned the technological changes of the century— from Autochrome to Kodachrome to computers.

Exemplary though their careers were, it can now seem that Geographic staff photographers were most directly under the influence of the magazine's conservative practice of photography and editing during the thirties and forties. To them fell the formulaic "state," "city," and "country" stories that were the mainstay of the magazine for more than half a century. Looking back on these stories today, there is an interchangeable, anonymous quality to most of them.

BUT OCCASIONALLY A PHOTOGRAPHER WORKED TO CREate a self-directed, original, and distinctive body of work. One of the most memorable was made by the young photographer Volkmar Wentzel. In the late 1930s Wentzel produced a black-and-white photographic essay titled, "The Nation's Capital by Night."

In his words he wanted "to catch something of the witchery of Washington after dark." In the half-darkness of the lamp-lit city, Wentzel found "unsuspected definition of form and contour revealed." He made most of the photographs on "damp and foggy nights" for "the heavy atmosphere that was present."

In April 1940 the resulting photographs were published in an elegant 16-page portfolio with a minimum of text. The classic status of Wentzel's work was confirmed 50 years later, when the photographs were exhibited in their entirety at the Corcoran Gallery of Art in Washington, D.C. Such are the strength and staying power of the images that the sculpted portraits of the statues still seem to speak to us.

There is an art to making inanimate objects come alive in a photograph, and Wentzel used light and shadow, form and void, near and far to animate the static scenes he photographed. Overall there is a dramatic, moody calm to these photographs of Washington at night. It is the calm before a storm

that would forever alter the city, the nation, and the world. The heavy atmosphere of the Depression was giving way to the winds of war.

If the *Geographic* had turned a blind eye to the Depression, it turned a distant one to the unfolding events in Europe, Asia, and the Pacific. While other magazines, notably *Life,* put their photographers on the front lines, the *Geographic* stood back from, and above, the combat. The distancing that characterized coverages in the thirties continued into the forties and right through the war years. There are few photographs like Robert Capa's historic black-and-white images of soldiers in the surf at Normandy. The grainy, rough immediacy of those images made them not only a defining emblem of war, but also of war photography.

Instead of such immediacy the *Geographic* produced stories such as "Normandy and Brittany in Brighter Days" (1943), "At Ease in the South Seas" (1944), and "Northern Italy: Scenic Battleground" (1945). These stories portray the landscape of war through rose-colored lenses. Colorful scenes of peaceful prosperity alternate with remote, black-and-white aerial photographs of geometric bomb patterns on the land below.

In terms of portraiture, few faces emerge from the fog of war. A notable exception is a U.S. Army photograph of soldiers crossing the Rhine River in Germany. The anonymous photographer's presence is unmistakable. He is one of the hunched men in the boat, but he's risking his life by raising his camera to make an intimate and telling photograph. In it

the fragments of faces express the anxious essence of war at the front.

There are also isolated, arresting images of the war from picture agencies and the military: Jews at a detention camp in Palestine; German refugees returning to Berlin and staring into shop windows; an exultant Eisenhower after the war.

But the main contribution the *Geographic* made during the war was not with photography, but with maps. There was even a story about the making of maps in 1944. There are also abundant feature stories from behind the lines and in the home front such as "Winning the War of Supply" (1945).

It is the haunting absence, not the presence, of photojournalism that marks the war years at National Geographic. As for portraiture, it rarely revealed the tumultuous times. In an article titled "Face of Japan" (1945), by W. Robert Moore, there are no portraits.

Between the war's conclusion in 1945 and the end of the decade, the times were more congenial for the *Geographic's* upbeat editorial philosophy. For the first time in 15 years there actually was a degree of prosperity, and the contrast between life on the streets and life on the printed page became less jarring.

This five-year span of time allows one to look at what the *Geographic* and its photography had been about, not what it hadn't been about. The best that can be said about the magazine was that it was reassuring at a time when optimism was in short supply. In truth economic depression wasn't

worldwide, and neither was the World War, despite its name. Once a month the magazine arrived in its readers' homes with a brighter outlook than that provided by other magazines, newspapers, and the radio. It was also, as always, informative. The optimism of the magazine was embedded in the imagery, which grew brighter and more colorful as the dark decades of the thirties and forties unfolded. Some of my favorite photographs of the era are the ones of people exuberantly holding things—flying fish, starfish, lobsters, dogs, bouquets, and babies. There was also a charming and carefully developed art to posing groups of people.

Photographs like these—and there were many of them—are simply fun to see. And my certain thought is that the photographs were fun to be a part of, both for the subjects and for the photographers. Perhaps there was great value in this point of view that we now underestimate. During decades of deprivation and doubt, the *Geographic* brought a sunny, funny sense of life, along with steady doses of inspiring adventure.

But it wasn't adventure that the photographer George Rodger was seeking at the end of the 1940s. It was inspiration. Rodger and his pregnant wife left their home in Europe and traveled deep into interior Africa. The couple's close contact with the war in Europe had sadly disillusioned them about life. Their journey was a search to find a new basis for believing in humanity. They settled in with the remote Nuba people of southern Sudan, and Rodger photographed their traditional way of life. Through their strength and humanity he found his faith returning.

That strength is the subject of my favorite photograph. It is a double portrait of dust-covered wrestlers, one carrying the other in triumph (page 228). I picture George Rodger in front of them with his Leica, moving as they move, seeking the picture. The one he delivers is immediate, intimate, and involving. It is only a moment, but within it is the essential power of portraiture. It is timeless.

In any decade it is this elusive quality of timelessness that photographers seek in their work. It is this seeking that unites the photographers in this book.

Volkmar Wentzel's "The Nation's Capital by Night" was an inspiration for my photographs of Civil War battlefields, and George Rodger's Nuba portraits were on my mind 50 years after he made them. Like him I was at work in a remote and traditional culture—the Aborigines of far north Australia.

One torrid day I accompanied a group of young Aborigines to a pond, where they jumped and splashed, stirring the clay on the bottom of the pond. One of the young men, Trumain (page 419), spontaneously gathered a handful of the clay and began to smear it on his arms and face, as Aborigines have done for millennia. I felt the revelation of looking into a face and suddenly seeing deep into racial memory. I stepped toward Trumain and made several swift portraits before he swam off. It was only a moment, but it was authentic—intense and intimate. But timeless? Only the decades will tell.

— SAM ABELL

# In keeping with *National Geographic*'s aversion throughout the 1930s to everything unpleasant,

the magazine's editors ignored the Great Depression and published defiantly optimistic stories. In April of that year, less than six months after the October 1929 stock market crash in the United States, a story titled "Louisiana, Land of Perpetual Romance" featured a photograph of a woman holding a box of strawberries, with the caption " . . . strawberries are Louisiana's contribution to the nation's fruit bowl."

All decade long a range of products, from vegetables and flowers in South Carolina (page 174) to red snappers caught in the Gulf of Mexico (page 175) to fashionable feathers and robes in Alabama (pages 180, 181) seemed to show that America was fine, or would be.

National Geographic wasn't the only organization that catered to America's desire for escape. Flashy Hollywood movies and magazines like *Fortune* offered other kinds of fantasy and the belief, just when all seemed lost, that prosperity was within reach. *Geographic* magazine subscriptions grew, and not a single employee was laid off.

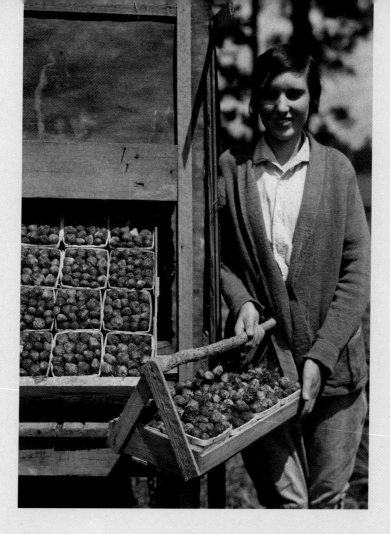

**EDWIN L. WISHERD    1930**
Strawberry harvest, Hammond district of Louisiana

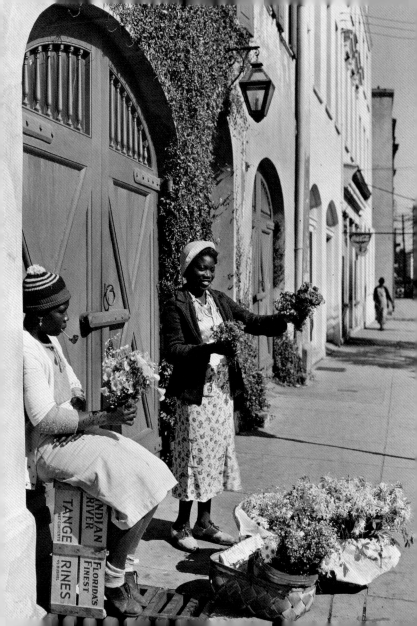

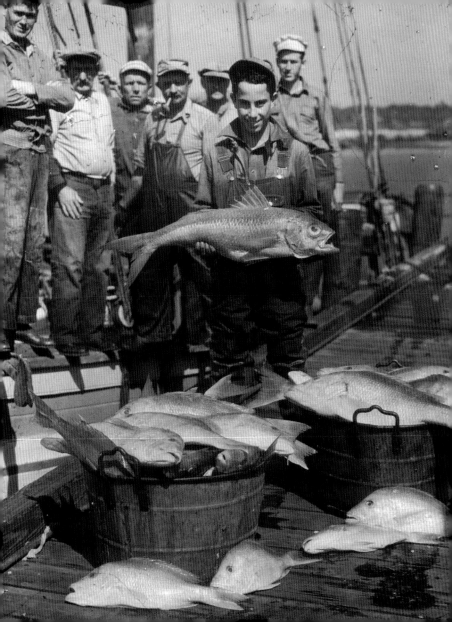

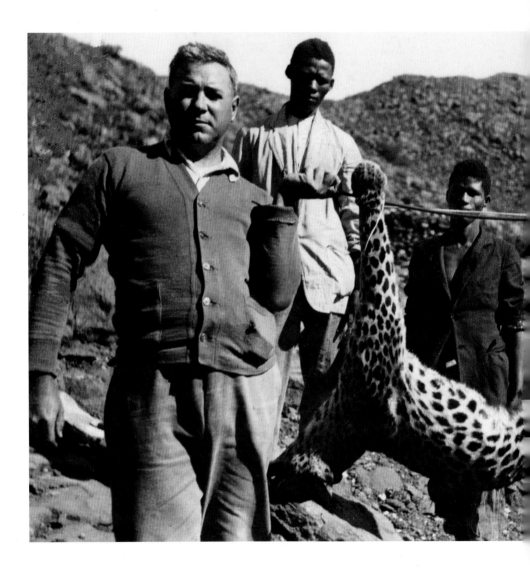

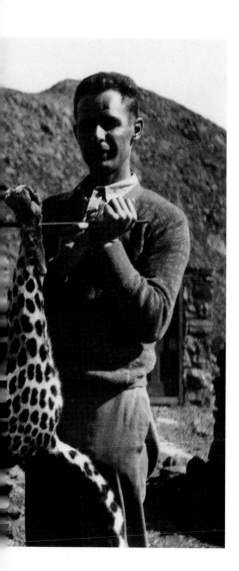

◄ **B. ANTHONY STEWART**  **1939**
Flower vendors along Rainbow Row,
Charleston, South Carolina

▶ **EDWIN L. WISHERD**  **1931**
Red snappers from the Gulf of Mexico near
Mobile, Alabama

**MRS. WILLIAM H. HOOVER**  **1930**
William Hoover and Fred Greeley show
off their leopard catch, Mount Brukkaros,
Southwestern Africa.

**FOLLOWING PAGES:**
**◄ EDWIN L. WISHERD   1931**
Decorating with feathers was a home industry
in early 1930s Alabama.

**► EDWIN L. WISHERD   1931**
Colorful beach robes were made in Anniston,
Alabama, from the state's wealth of raw cotton.

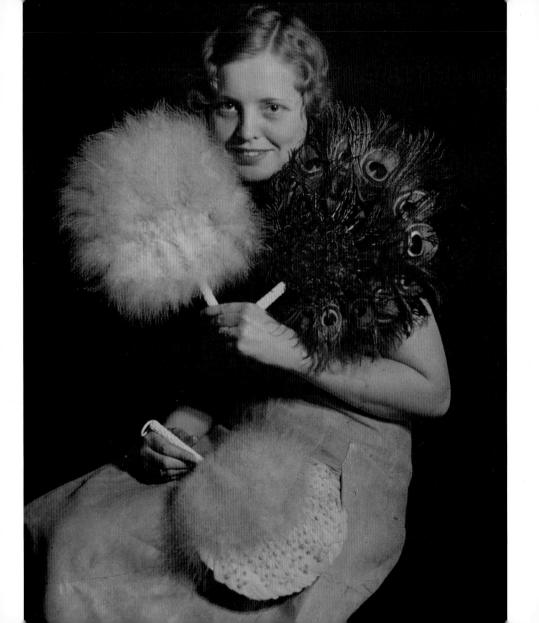

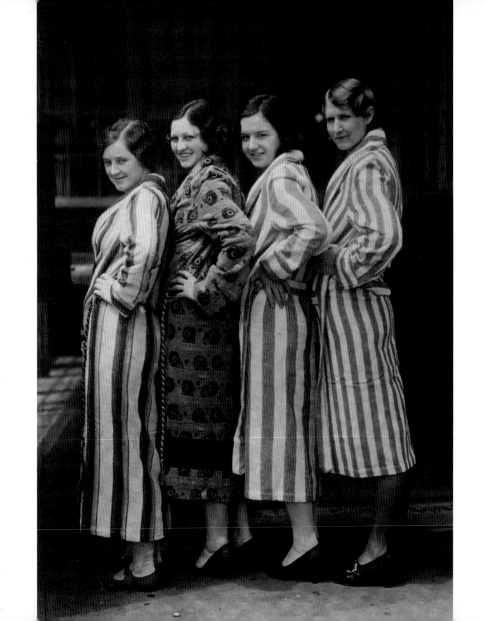

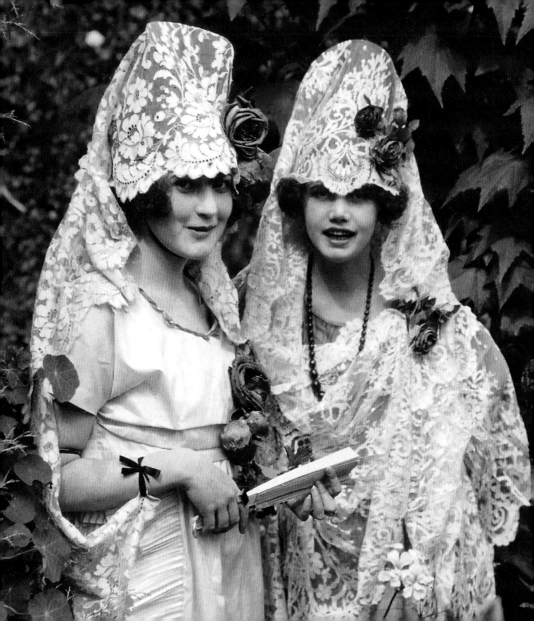

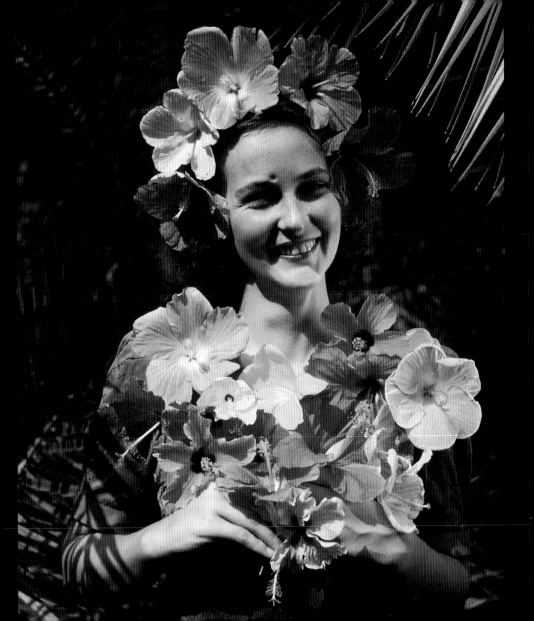

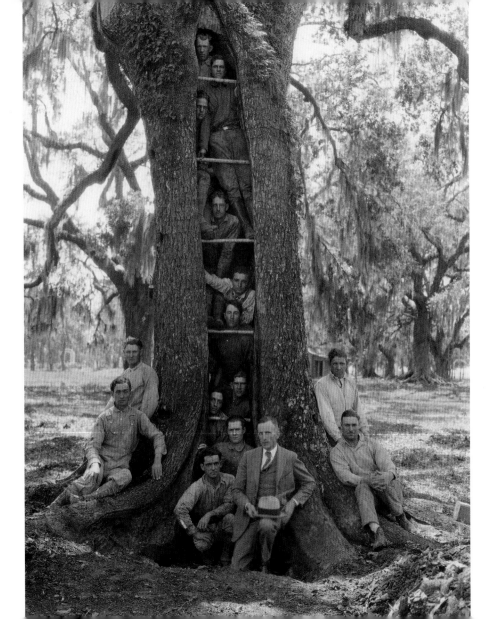

**W. ROBERT MOORE    1931**
An actress is dressed for a masculine
role, Indochina.

"Another way to achieve distance from

the Depression was to take readers

on adventurous expeditions, into

the study of science and nature, and

on journeys to far off 'traditional'

cultures . . . But . . . new techniques

for making and printing photographs

made these exciting years the

beginning of the Geographic's

modern era. It was an era that has

lasted, with little fundamental

change, until now. Understanding

why will not be hard for anyone who

switches, this decade, from film to

digital imaging."

*—SAM ABELL*

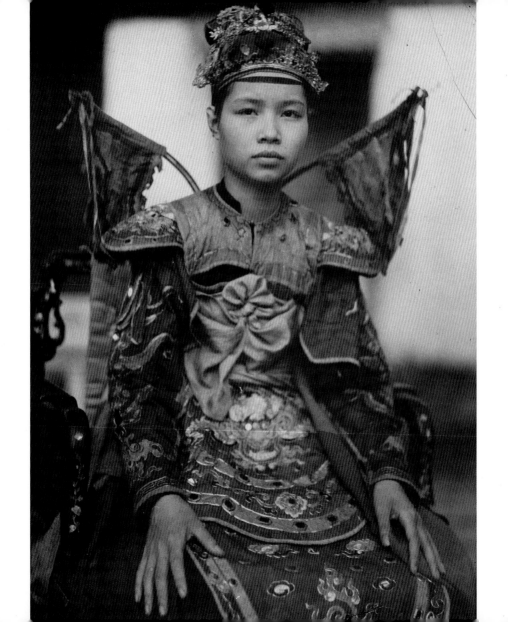

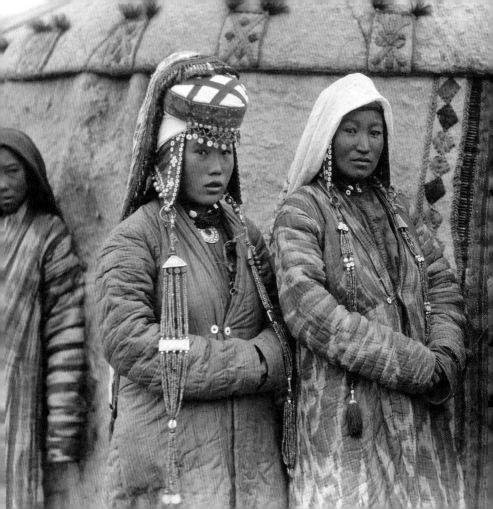

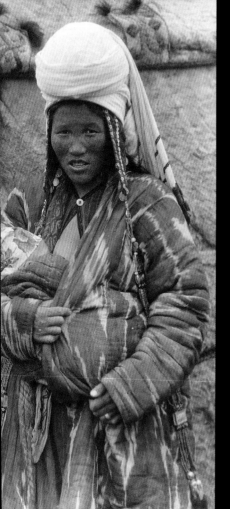

**MAYNARD OWEN WILLIAMS   1932**
Young women of the Steppes, Central Asia

**FOLLOWING PAGES:**
◄ **B. ANTHONY STEWART   1941**
Young woman in a costume of Crete

▶ **PER BRAATEN   1935**
A Norwegian bride wears a silver
wedding crown.

# Exploration and the adventure that happily, though often painfully, accompanied it, were

always central Geographic activities that both educated and entertained the public, but they were particularly popular in the 1930s. Sometimes the Society collaborated with other organizations or the U.S. government to allow explorers to reach their dreamed-of destinations: Adm. Richard Byrd, here dressed in a caribou-skin suit and accompanied by his pet terrier, Igloo, made his historic flight to Antarctica with support from the Society and other organizations.

The Society also continued to undertake daunting expeditions on its own. For example, the Citroën Central African Expedition—begun in 1931—sent a caravan of half-tracks 7,370 miles across Asia, from the Mediterranean to the Yellow Sea. Portraits of the explorers and peoples along the way accompanied celebratory stories. Botanist-photographer-adventurer Joseph Rock went on perilous, hair-raising journeys to unknown territories in western China and Tibet for months on end and sent back color photographs (pages 198-199), in which he and local tribesmen were opulently dressed.

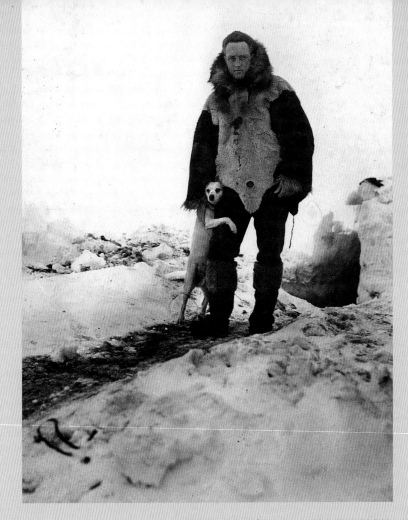

**BYRD ANTARCTIC EXPEDITION   1930**
Adm. Richard E. Byrd in 1929 at the South Pole
with his pet terrier, Igloo

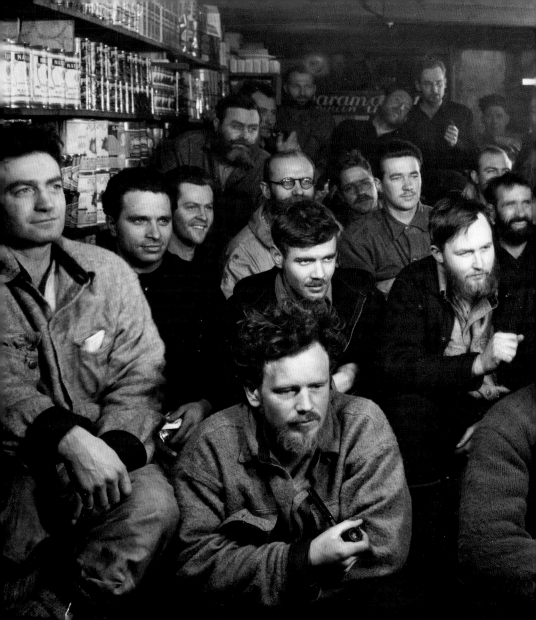

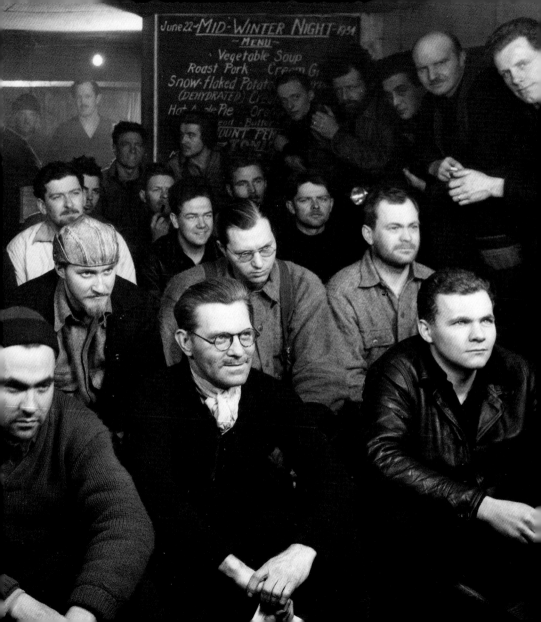

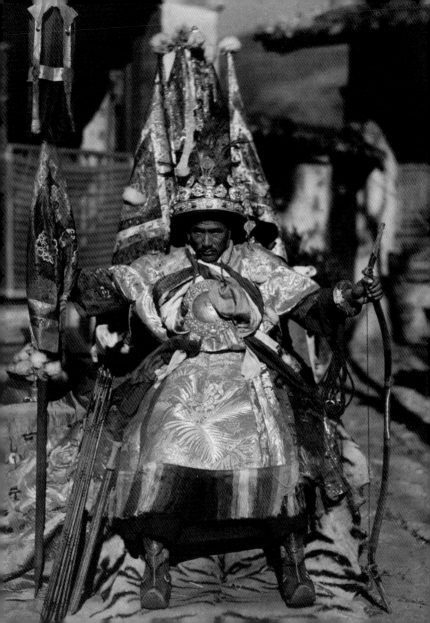

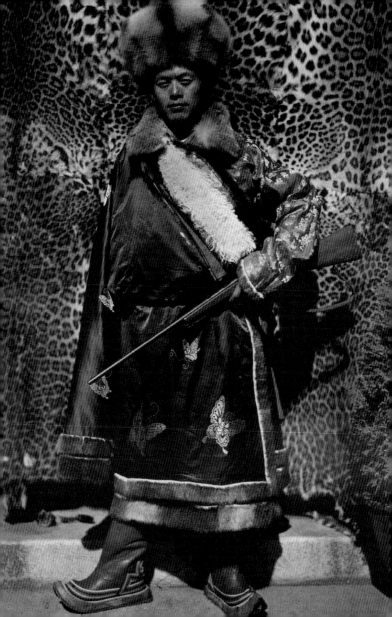

**PRECEDING PAGES:**
**BYRD ANTARCTIC**
**EXPEDITION    1935**
Explorers on the Byrd expedition enjoy a
show in the mess hall on a midwinter night.

◄ **JOSEPH F. ROCK    1935**
This Tibetan costume supposedly causes
the god Chechin to make the wearer violent.

► **JOSEPH F. ROCK    1931**
A Nashi mountain guide, who assisted the
National Geographic Society's expedition
in China and Tibet

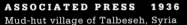

**ASSOCIATED PRESS    1936**
Mud-hut village of Talbeseh, Syria

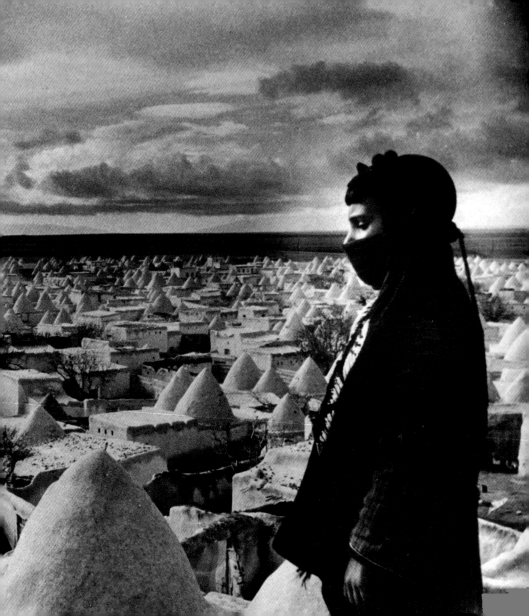

▲ **DONALD F. THOMSON   1948**
With a dog his sole companion, Dr. Thomson meets
"King" Wongo and his ghostly hunters.

▶ **DONALD F. THOMSON   1948**
Bride in Arnhem Land, northern Australia,
wears a tiara from which dangle six crocodile teeth.

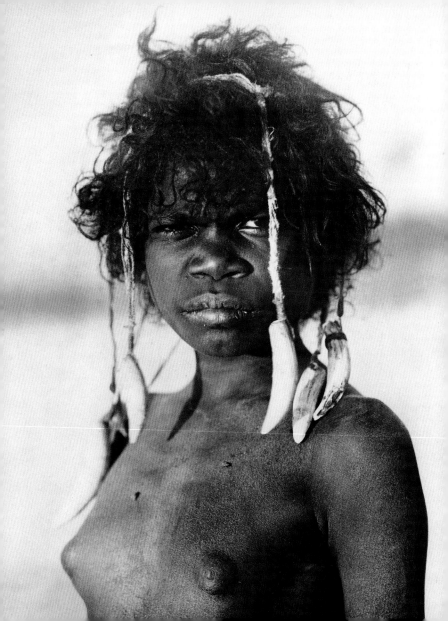

"The film speeds for color were significantly slower than for black-and-white films. This fact, combined with the Geographic's still ongoing tradition of using large cameras, slowed the inevitable evolution toward more candid, intimate, more 'moment'-dependent photography. It can be said that in important ways, the pioneering of color photography for publication set back the progressive photography of people at the Geographic."

*—SAM ABELL*

**B. ANTHONY STEWART 1940**
Bobbing for apples at the Martinsburg, West Virginia, Apple Harvest Festival

**FOLLOWING PAGES:**
◄ **WILHELM TOBIEN 1930**
Young women in the Canary Islands show their Spanish heritage.

► **WILLARD R. CULVER 1938**
A champion Abyssinian male cat is pampered at the Djer-Mer Cattery in Washington, D.C.

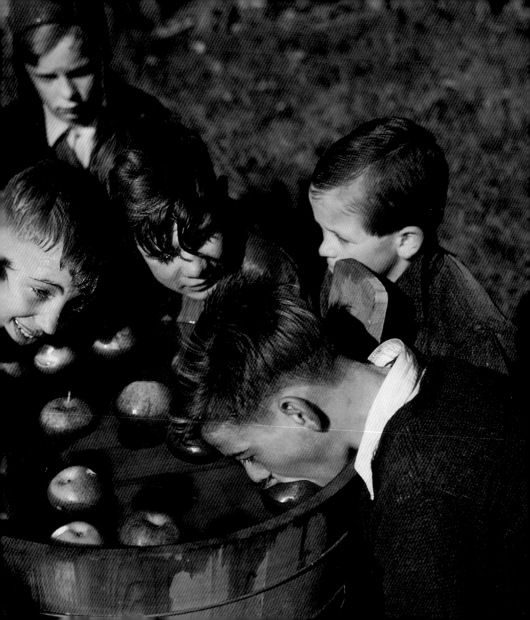

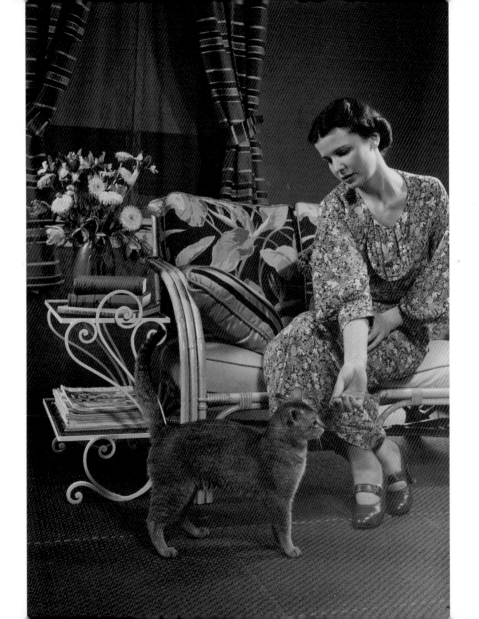

# America and National Geographic never doubted the virtues and possibilities of technology.

Gadgetry and romance blurred when Dr. Auguste Piccard soared gloriously into the "stratosphere" in 1933. To advance scientific understanding back on Earth, unique and strange creatures were photographed, usually with a person present to provide interest and scale (pages 210, 211). The photography staff grew and so did the magazine's investment in color printing. A number of photographers who began taking pictures in the thirties had long careers at the Geographic: B. Anthony Stewart, still working into the 1970s, was considered "the world's most-published color photographer" by insiders.

New products—especially textiles and plastics—and groundbreaking technologies in communications, transportation, and industry were explained, pictured, and celebrated in all their variations. People, almost always women, were happily posed using the items and devices under scrutiny. A story about rubber featured oxygen masks (pages 212-213) and hot water bottles (pages 214-215) among other miraculous products that seemed to anticipate the space age.

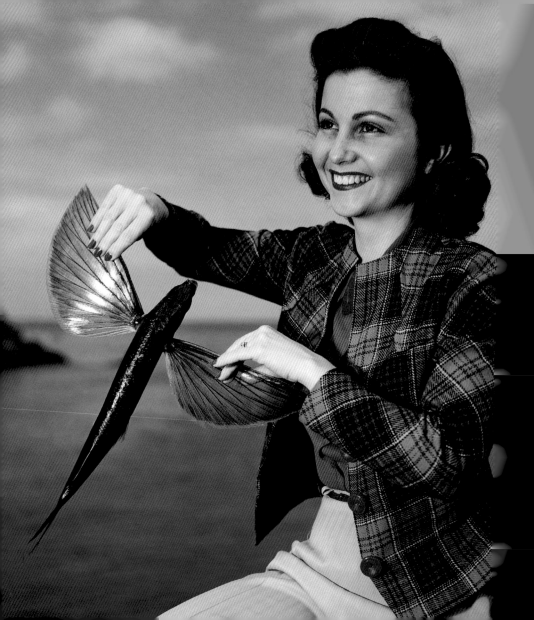

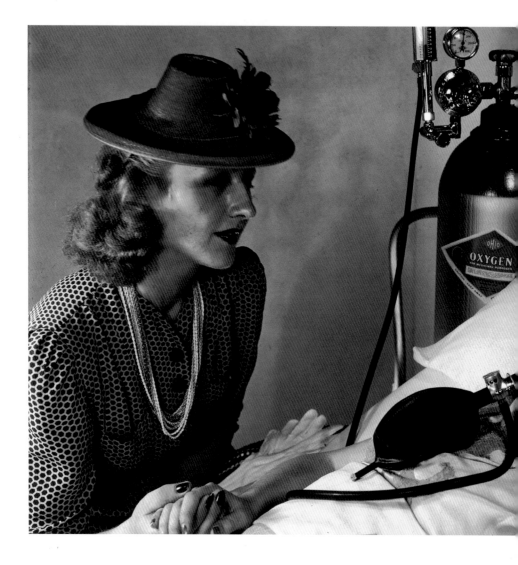

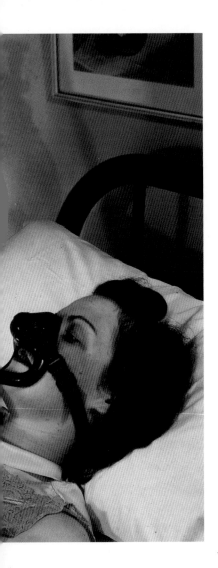

PRECEDING PAGES:
◄ C. E. WALTER 1930
A seven-pound deep-sea crawfish caught off
the Louisiana coast

▶ B. ANTHONY STEWART 1942
Wingspan of a flying fish is proudly displayed
near the island of Santa Catalina, California.

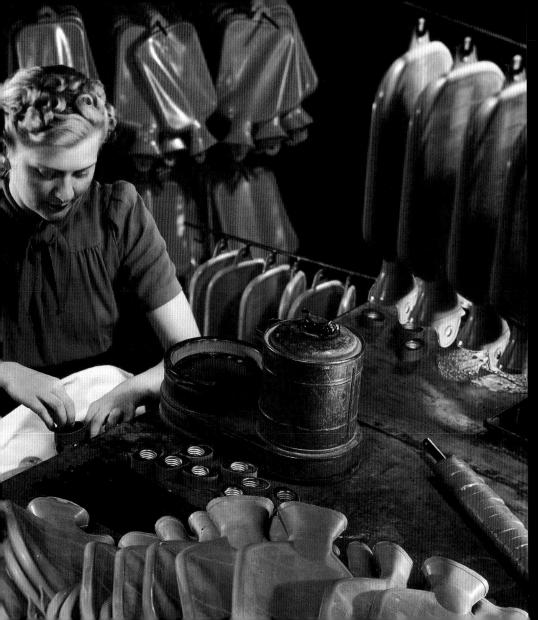

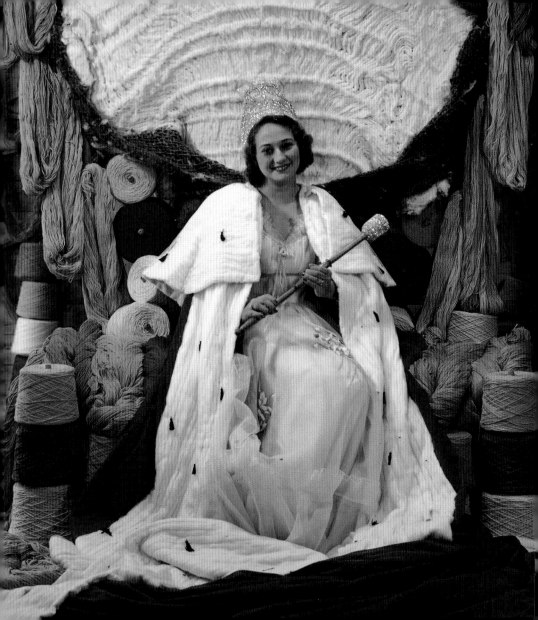

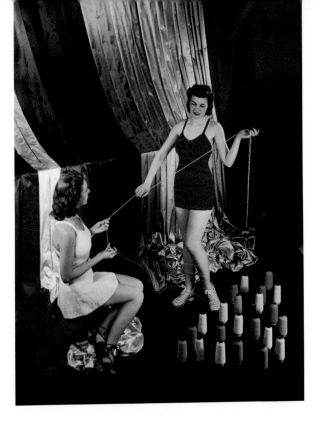

**PRECEDING PAGES:**
**WILLARD R. CULVER    1940**
Vulcanized hot water bottles, Goodrich rubber factory

◄ **J. BAYLOR ROBERTS    1941**
Queen of the cotton festival, Gastonia, North Carolina

▲ **WILLARD R. CULVER    1940**
Bathing suits made from latex encased in cotton thread

# "You don't say anything bad about somebody and you don't publish embarrassing photographs

and information on people. If you can't say anything nice, you say nothing." This is how longtime Editor and President Gilbert M. Grosvenor describes the philosophy of his grandfather, the magazine's first editor, who started the Geographic's photography collection and then shaped it for 50 years.

Nowadays we wouldn't consider the portrayal of people in the thirties and forties always "nice," but those were very different times. The difference can be explained in part by reverence for science, which allowed and encouraged such respected fields as anthropology, and highly regarded organizations as National Geographic, to consider people as ethnic types. Types easily become stereotypes, and *National Geographic* portrayed every ethnic and social classification at home and abroad. So did every other magazine and newspaper. Minorities and women are still working to overcome the results.

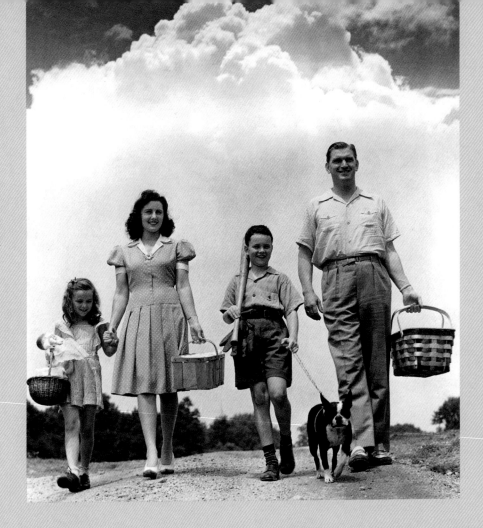

**HAROLD M. LAMBERT 1943**
A family looks for a picnic spot.

**B. ANTHONY STEWART** **1935**
Fishing near New Haven, Connecticut

Students in a Persian girls' school

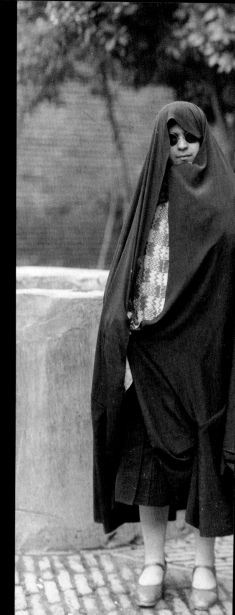

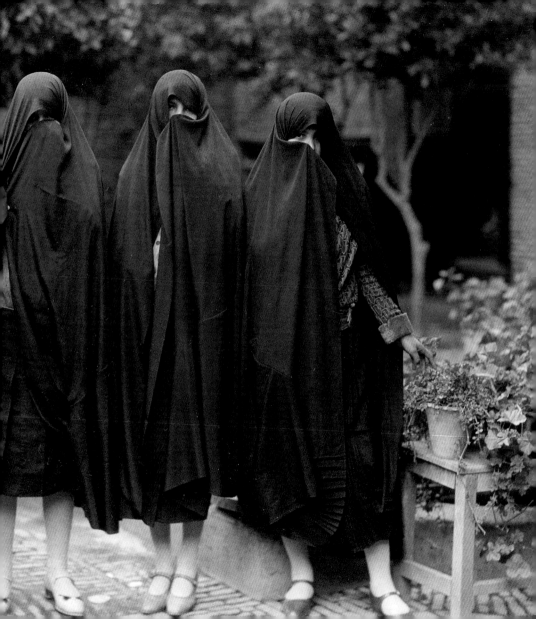

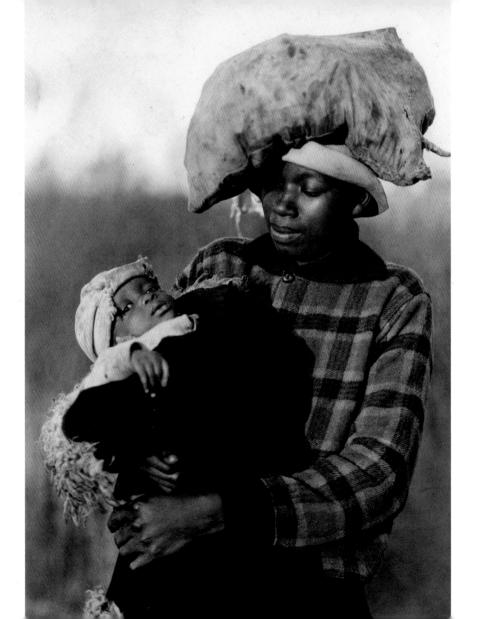

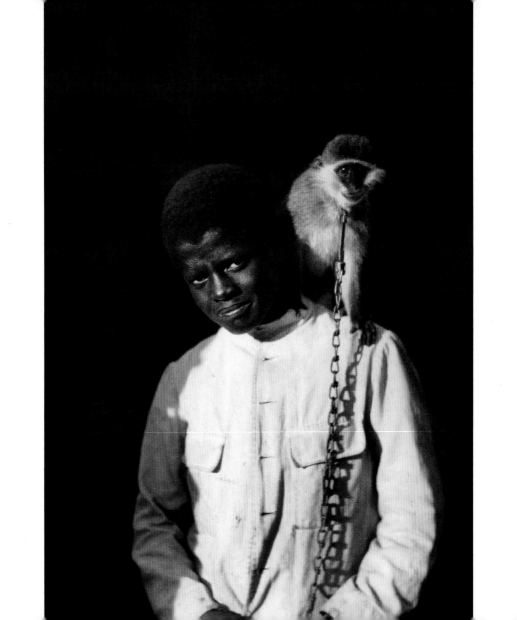

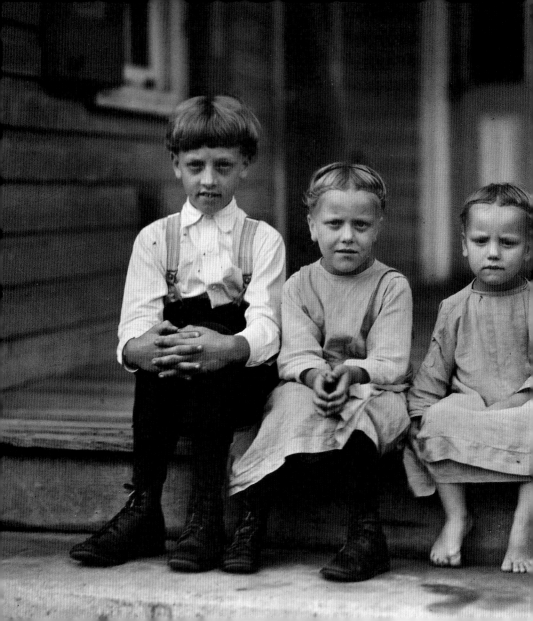

**PRECEDING PAGES:**
◄ **W. ROBERT MOORE**   **1934**
A woman balances yams on her head and
her baby in her arms on one of Georgia's
Sea Islands.

► **W. ROBERT MOORE**   **1935**
An Ethiopian and his pet monkey

**J. BAYLOR ROBERTS**   **1938**
Amish children on their porch in Pennsylvania
Dutch country

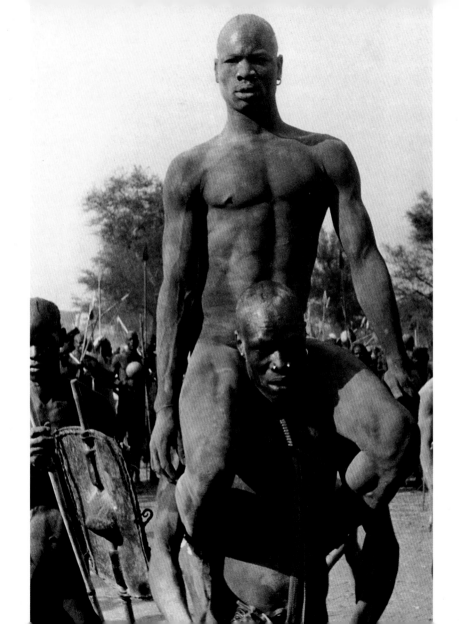

"George Rodger and his pregnant wife traveled deep into interior Africa. . . . They settled in with the remote Nuba people of southern Sudan, and Rodger photographed their traditional way of life. Through their strength and humanity he found his faith {in life} returning. That strength is the subject of my favorite photograph. It is a double portrait of dust-covered wrestlers, one carrying the other in triumph. . . . The [picture] he delivers is immediate, intimate, and involving. It is only a moment, but within it is the essential power of portraiture. It is timeless."

*—SAM ABELL*

A victorious Nuba wrestler is carried on a teammate's shoulders, Sudan.

# World War II was not a controversial war, and patriotism was at an all-time high. Censorship,

along with the patriotism, made it easy for National Geographic to adhere to its policy of publishing positive pictures. Newspapers, and especially *Life* magazine, fought hard to put photographers in the thick of combat instead of accepting pictures offered by the U.S. military and government-approved photo agencies. To some extent they succeeded, but ultimately they all published what they could get and for the most part were comfortable with that.

The Geographic actively sought and published many of the sanctioned photographs. Occasionally mistakes were made—pictures that showed Berlin just before the war looking prosperous under Nazi rule, for example. All the while National Geographic photographers continued to generate and the magazine continued to publish sympathetic pictures of people everywhere—German refugees, Jews in Palestine, and Americans back home—always prevailing against adversity.

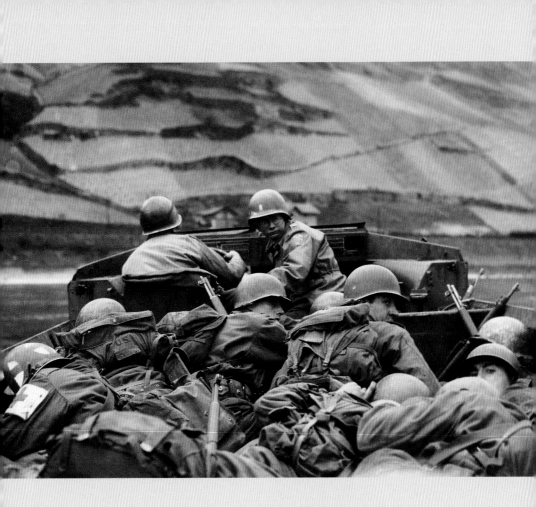

231

German refugees returning to Berlin after the
Allied bombing

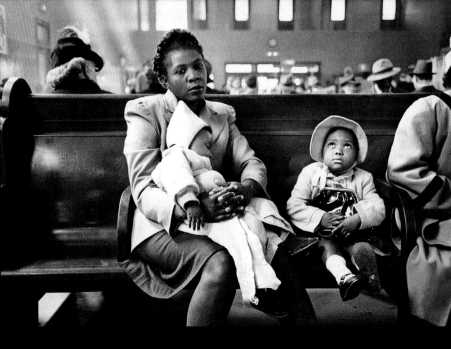

▲ **ESTHER BUBLEY** **1943**
Waiting Room, Greyhound Bus Terminal, New York City

▶ **GABRIEL MOULIN** **RECEIVED 1943**
Commuters, San Francisco, California

234

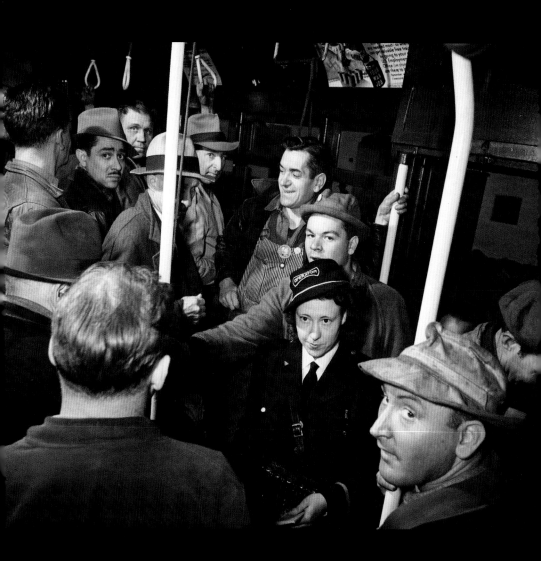

## J. BAYLOR ROBERTS  1949

The new mark—with a fixed buying power—brings
long-hidden goods into view, Stuttgart, Germany.

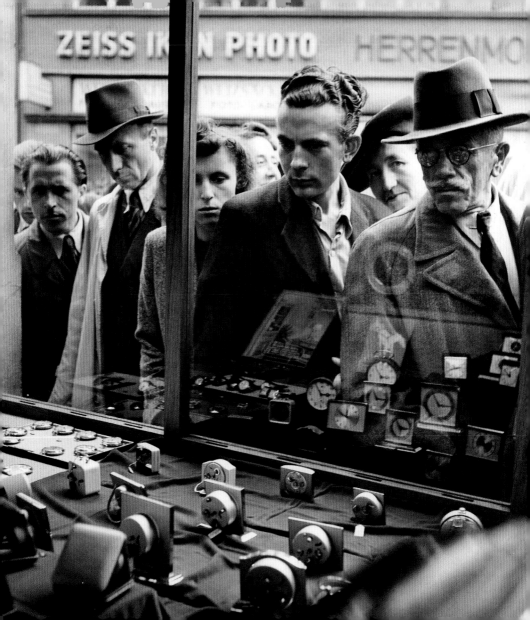

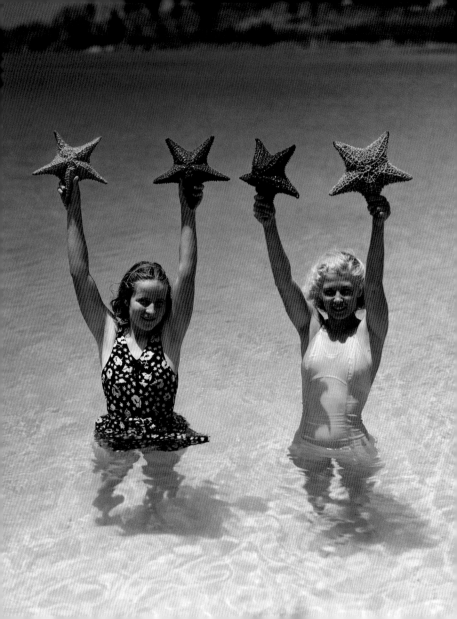

EDWIN L. WISHERD    1940
"Stars" plucked from balmy seas, St. John,
U.S. Virgin Islands

**PAUL M. SCHMICK    1945**

Gen. Dwight D. Eisenhower acknowledges an
ovation from citizens of the District of Columbia,
Statler Hilton Hotel, Washington, D.C.

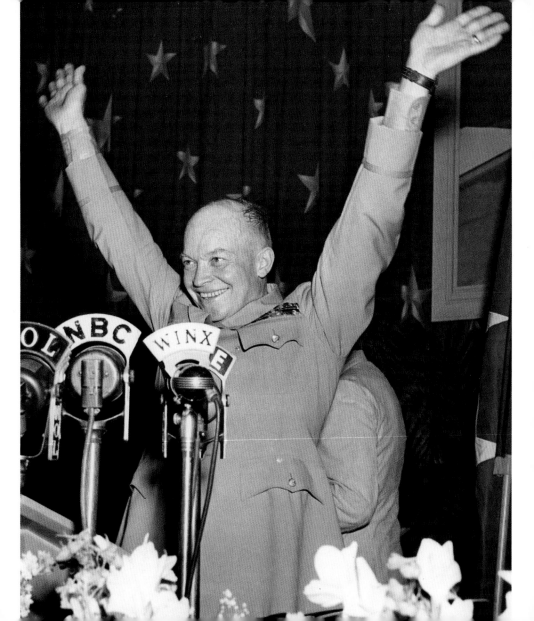

# Cheerful Kodachrome Days

## THE 1950s AND 1960s

BEFORE WE CONSIDER PORTRAITS, PERHAPS WE SHOULD consider the face.

There are more than six and a half billion in the world today, yet we can instantly recognize an individual one. The human face is the first thing we see when we're born, when our eyes lock on our mothers' and form that most profound bond of love. (Studies show that a newborn minutes old can distinguish a face from a random pattern.) From that moment on, faces surround us, define us, attract and repel us. And, for photographers, insatiably intrigue us.

Why is the face arranged as it is, with the eyes, nose, and mouth in the same lineup on everyone? What makes our face different from other animals' and makes it human?

The body needs food to survive, and the face exists to feed it. The mouth is the first feature to appear on the embryo and is the dictator of the face. It calls the shots, and every other organ on the face lines up in support. Unlike the rest of the animal kingdom, humans eat with hands or knife and fork instead of claws, fangs, muzzles, or beaks. That's why our face has evolved into its current arrangement and why our mouths

are so small, our teeth so uniform, and our chins so useless.

The eyes seek the food, locking onto prey during ancient hunts or scanning a menu in today's cities. The nose is the intake/exhaust vent to the lungs, but also sniffs food for safety. The lips protect the mouth, shut out intruders, and are so alert they can spot any imposter in our food, from a fly to a single hair.

But far more than a simple fuel line, the face is a masterpiece of communication technology. Humans have more facial muscles than any other animal on Earth, and scientists have identified thousands of universal expressions.

While the mouth is the functional center of the face, the eyes are the emotional, the windows to the soul. The eyebrows, lifting or furrowing, signal surprise, excitement, disappointment, or anger. The mouth grins, grimaces, and pouts. The tongue sticks out in derision. The lips join the interior of the body with the exterior, and with their exquisite sensitivity become the most intimately physical part of the face. They signal sexual availability and desire and seal it with a kiss. The nose, however, just sits there. It plays a silent part in

communication, but a starring role in appearance: It is the most variable feature of the face.

So: Eyes, nose, and mouth, all arranged in roughly the same way; yet how fine our eyes are to tell male from female, young from old, family resemblance, and whether the infant favors her mother or her father. The human eye meticulously recognizes—and judges—the slightest variations. And judge we do.

We learned through centuries to overlook the function of the face and to assess its appearance instead. We give value to looks to ensure the survival of the species, evolutionary scientists say. In northern climates women admire a man with a long thin nose because they find it attractive, not because they realize its efficiency in warming up the air he breathes so his lungs won't freeze. And in the tropics, women prefer a man with a wide nose that admits more air to his lungs to make him faster and more powerful. Women today are not considering his lung capacity or its usefulness on the hunting grounds; they just subconsciously know these men will make good mates who will put food on the table. So looks become an advertisement for characteristics that once ensured survival, and sometimes still do.

For most of human history, we lived as hunter-gatherers and saw only the few faces of fellow tribesmen or villagers. Before mass media, before travel, before cities, there were only a certain number of faces to gaze upon, and to choose among as mates. But our ancestors became skilled at detecting the minutest differences in those few faces: a fraction of an inch, here or there. And that has changed the world.

SO IT'S NOT SURPRISING THAT WHEN PHOTOGRAPHY was invented, it loved the face.

A portrait gives us the permission to stare that is forbidden in real life. Artists and photographers record the likenesses, and stare we do, searching in private for clues to attraction, identity, personality, and ancestry. But we want our personal gallery of portraits—ourselves, our families, and friends—to be distinguished, charming, and loving, not disturbing, distasteful, or painful. We don't want memories of the family at the funeral; we want memories at the wedding. We want to be soothed.

But portraits are not benign. They can provoke and repel as well as soothe. In the end, the face is the sitter's, but the portrait is the photographer's.

And therein lie the conflicting ambitions of portrait photography and the moral dilemma of photojournalism. The sitter for a portrait wants to look good, but so does the photographer, and these can be mutually exclusive ends. A flattering likeness belongs to the commercial world, not the art world. As Susan Sontag observed, "much of modern art is devoted to lowering the threshold of what is terrible." When the photographer's reputation trumps the subject's dignity, photography can be very cruel indeed.

The purpose of photojournalism is to shout, attract attention, shine light on an injustice, or reveal a hidden truth. At the same time, it can invade privacy and even betray. In both studio and journalistic portraiture, while the results can be intriguing, horrifying, amusing, or memorable—or even change the world—even a viewer can sometimes feel complicit in an exploitation.

Photography deals with surfaces. What appears to be, is. But, sometimes, isn't. A photograph can lie, easily and boldly. It can't tell whether a woman is a real geisha or just dressed like one. Or whether a scowling middle-aged European man with a spreading waistline and rumpled khakis is a notorious trafficker of human beings or an annoyed businessman tired of a photographer's impositions.

Contrary to popular sentiment or a photographer's conceit, I don't believe a person's face alone can reveal his character. So the photographer becomes detective as well as explorer, searching for clues that tie up the loose ends and complete the picture—whether the subject is holding a gun or a baby, or whether he's wearing a fireman's hat or a cowboy hat. His hat tells me more than his face does. In the end, the pure portrait conveys only what he looks like, how long he's lived, his mood at the moment, and the skill—and intent—of the photographer. We need his environment for the whole story.

"THE TASTE OF A TIME IS NOT THE ART OF A TIME," said Marcel Duchamp. Artists and photographers have always challenged complacency, and in the 1950s and '60s, more than merely planting seeds of change, they buried land mines that would explode for decades.

Ozzie and Harriet defined the fifties, but so did photographers Richard Avedon, Irving Penn, and Diane Arbus. Magazine readership, which had soared during the war years, flourished with postwar affluence and the rise of the middle class. Optimism reigned: The Civil Rights bill was passed, the interstate highway system was built, Jonas Salk invented the polio vaccine, color TV was introduced, Hawaii and Alaska became states, Disneyland opened, and the Soviets launched Sputnik and all eyes turned toward the stars—both celestial and earthly—as models and photographers became celebrities.

Portraits of Twiggy and Jean Shrimpton were ubiquitous, sex was everywhere, and the movie *Blow Up* drove every man to want a Nikon slung

around his neck and every woman to covet a miniskirt that barely covered her derriere. Fashion photography led the way, pushed the boundaries of good taste and nudity, and energized documentary photography as well. And when Hugh Hefner started *Playboy*, portraiture never looked back.

The early sixties brought the Beatles to America and changed the face of pop culture in this country. But as the decade progressed, the exuberance of the "youthquake" dimmed, and the mood turned dark with the war in Vietnam, massive antiwar marches on Washington, race riots, Chappaquiddick, the assassinations of John and Robert Kennedy and Martin Luther King, China's Cultural Revolution, the building of the Berlin Wall, and the Six-Day War in the Middle East. The decade turned into an anguished and questioning one, creating powerful, shocking images that would become the icons of the postwar generation: Robert Kennedy's face on the floor, dying; Jackie Kennedy's behind her black veil, stoic (page 305); and the Vietcong prisoner's at the moment of his execution, which many credit for spurring the end to the war in Vietnam. The decade seemed defined by the still image. Now, years later, photographs are being made by the millions, but they don't seem to stick, somehow.

While waves of change crashed over the globe, the Geographic, for the most part, seemed safely nestled in its own harbor, lulling the local folk with tales of happy peoples in other lands. The photographers themselves were adventurous men—always

men—heroically challenging the world, escaping hearth and home for wilder locales. But the pictures they brought back rarely challenged much. While barriers were falling in other media, *National Geographic* magazine buttressed its own with cinder blocks of simple images without a trace of danger or irony.

All was calm, all was placid, the men manly, the women decorative and nonthreatening. The men, when not at rest or posing, were active and making things. The women, pretty and demure, were content at home, or colorfully working in the fields. The "natives" of the world were safely foreign. And the events that were rocking the world were mostly absent from the magazine's pages.

Instead, the novelty of color film and the desire for upbeat images produced strained and almost unbelievable images. The photograph of a woman making a snowman (page 260) doesn't ring true, somehow. Our intuition rejects the authenticity of the image before our intellect poses the question: Why decorate a snowman from behind? The stiffly posed Mada tribesmen (page 289), so ferociously dressed and mysteriously masked, are described as practicing pagan sacrifices. But this potentially terrifying sight has been stripped clean of its threat of danger by the harsh light of the noonday sun—and the cheerful green cornstalks in the background.

The perfect exception to the general lack of irony in the magazine's pages was Tom Abercrombie's picture of a veiled woman and caged birds caught

in one iconic image (page 278); the message is as crystal clear as it is unexpected and rings as true today as it must have then.

But almost surreptitiously, a few photographers began to challenge the status quo. Most notably, the deceptively straightforward work of Bill Allard began to appear. Gorgeously composed and illuminated, Allard's photography disregarded trends and fads and eschewed "lensing" (the gimmicky lens effects fashionable at the moment) to add drama or faux excitement. Allard seemed simply to approach people, like them, and photograph them. But he was, then as now, exquisitely attuned to subtle detail and steadily added the elements that took the photographs beyond mundane: The pipe smoke hovers over the Basque's head like an earthly halo; the Amish boy's hand and the guinea pig's foot mirror each other in their pink pointiness (page 309). He noticed the grace of a gesture, the enigma of expression on the Basque men's faces in a group shot (page 306), where, disturbingly, one face edges out of the corner of the frame and lifts the photograph out of the ordinary.

Almost romantic, not specifically of a time and place—those pictures remain important and compelling today, presaged the future of the magazine, and opened the door to a new generation of photographers.

I WAS ONE OF THOSE WHO WALKED THROUGH THAT door. Taking full advantage of advances in technology—the single-lens reflex camera and faster film speeds—as well as our journalism backgrounds, this new generation avoided the use of flash and set-up scenes and instead sought spontaneity and serendipity. Then, as now, we tried to show the world its daily life, not just its wars, famines, earthquakes, and scandals.

Many young photographers cut their teeth on the Vietnam War, but continued to travel extensively when it ended, bringing back dramatic images from all over the world. National Geographic welcomed the new work from those adventurous photographers. But this was a notable exception. After the Vietnam veterans came home, the U.S. began to turn inward. Budget cuts in many media corporations forced foreign bureaus to close and international news coverage to dwindle as Americans became more and more isolated in their own culture. The huge power and efficiency of Western media had an unanticipated and unintended consequence: The world learned far more about Western life than vice versa. Mass communication seemed to become a one-way street. I recently witnessed the somewhat bizarre result in the field, where tribal villagers debated the merits of the American presidential candidates, while a presidential candidate himself could not name the head of state of a large Asian nation.

Because much of my childhood was spent abroad, I learned from an early age that there were many ways of looking at things, that most of the world faced difficulties that my peers in the U.S. could not even imagine, and that many of those

problems arose from a lack of appreciation of other cultures. I found this lack of global understanding—and interest—more than just a handicap; it was, and is, a national crisis. So I became a photographer, like many others of my generation, to save the world, of course.

First, I wanted to portray women in a realistic light. Women were making huge advances in the late 1970s, when I began photographing, but were still decorative objects in the pages of the *Geographic*. I shot them branding cattle, racing horses, and mining coal. But in the male-dominated culture of the magazine at the time, even these pictures had to be singled out as "different": they were labeled "the first woman coal miner," etc. But I persevered, and soon, to my delight, women's "firsts" became a mere cliché.

Years later I still find myself drawn to the worlds of women, especially in societies that keep them secluded, oppressed, or in some way second-class citizens. I have entered worlds closed to outsiders for centuries: the women of Saudi Arabia and the geisha of Japan. And most recently, I photographed the most closed society of all: the world's 27 million 21st-century slaves, most of whom are women and children, already society's most vulnerable people. The trafficking of human beings has become the world's third largest criminal activity—and I needed to give it a human face. I sought out victims to find faces of stoicism, courage, pain, and hopelessness. And I confronted traffickers who were responsible for the beatings,

rape, and torture of countless young women and children—to find the faces of evil.

I want to tell stories. But I want the people themselves to provide the narrative, and for that you must take a step back from the close-up. For me, the staged portrait becomes the last resort when I fail to connect with a person in a natural way or when becoming a fly on the wall or a human shadow is impossible. It is a shortcut, an excuse, and an exercise in frustration: I want to be invisible. I don't like people staring back at me. I'm basically shy and a bit reclusive, and life on the road has taken its toll—a carapace toughened by years of repetitive affection and leave-taking, rinse and repeat. I tend to not want to engage every person I photograph. I don't always want to ripple the waters.

I don't like trying to converse through an interpreter while I'm watching intently for the gesture and expression that can define the moment and waiting for the light, color, and background to converge in some sort of harmony. I don't want anyone to say, "What do you want me to do?" I want to take them out of the studio and back into their lives. That's where the real story is.

— JODI COBB

**The general** magazine-buying public was ready for domestic cheer, even trivia, after the trauma of World War II, and the contentment on *National Geographic* magazine's pages, supported by advanced technology delivering super-bright colors, made a spectacular impression. Red was the color of choice, so photographer Luis Marden was lucky to encounter his Lobsterettes on the coast of Maine in 1952. Geographic photographers providing for less lucky situations often carried red scarves and shirts.

In spring 1976 the Museum of Modern Art, New York, mounted its first show of color photographs. More than a year later critic Janet Malcolm wrote in the *New Yorker,* "Color photography, which up to now had been associated with photography's most retrograde applications—advertising, fashion, National Geographic-type travel pictures . . . —suddenly became the medium's most advanced form of all." But in spite of the new respectability of color in the art world, *National Geographic* never quite lived down its exuberance of the 1950s and 1960s.

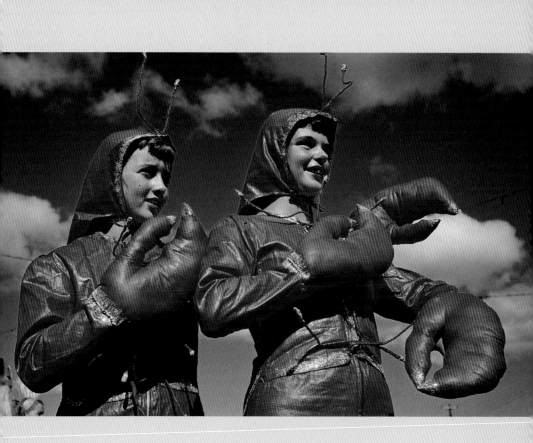

**LUIS MARDEN    1952**
Lobsterettes at the Rockland, Maine, lobster festival

**FOLLOWING PAGES:**
**DAVID S. BOYER    1954**
A young Lebanese girl harvests fruit from the Asian
loquat tree.

253

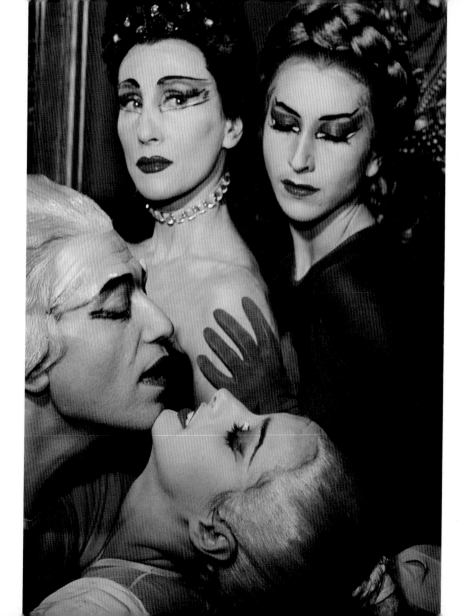

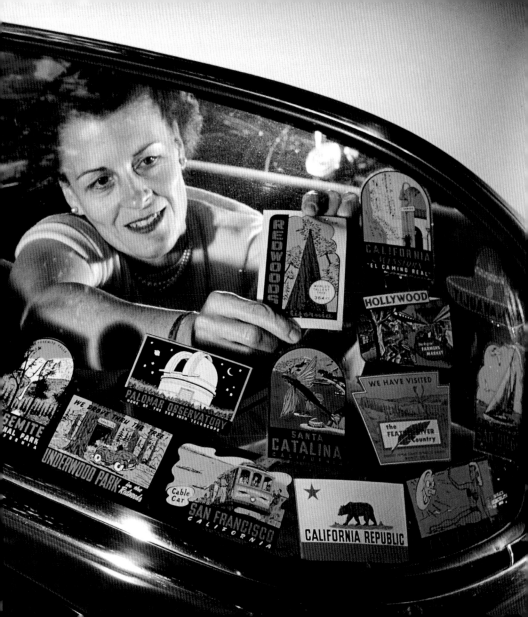

" ...The novelty of color film and the [magazine's] desire for upbeat images produced strained and almost unbelievable images. The photograph of a woman making a snowman doesn't ring true, somehow. Our intuition rejects the authenticity of the image before our intellect poses the question: Why decorate a snowman from behind?"

*—JODI COBB*

**It's no** accident that juicy red tomatoes are the subject of a photograph by Geographic photographers Franc and Jean Shor, who set out to show a quaint, industrious lifestyle on a Spanish island. Ever searching for eye-catching scenes, photographers tweaked the situations they found or else fully staged them. The encounter between photographer Robert F. Sisson and Mrs. George Marshall III, a woman in bed wearing a hot-pink bathrobe under a pink blanket reading to her six grandchildren (page 269), obviously wasn't a chance one—none of these photographs were stumbled upon unexpectedly. Entire tableaux were arranged to illustrate imagined lives in popular *Geographic* stories about American cities and states and exotic foreign metropolises and villages.

Ironically, the arranging of elaborate scenes for the sake of photography has become very fashionable these days. Modern photographic fictions that imitate documentary moments provoke questions about reality itself. Today at the Geographic, however, there are no questions on this subject: Documentary photography is held in very high regard and neither photographs nor scenes are manipulated.

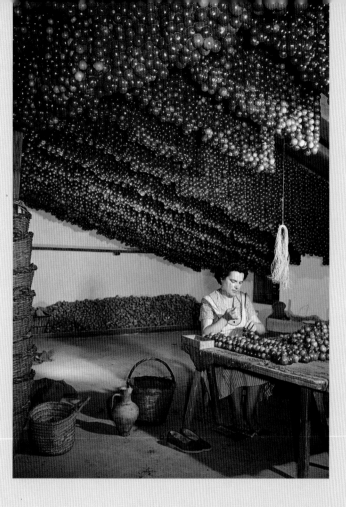

**FRANC AND JEAN SHOR   1957**
A Majorcan woman pierces tomato stems and strings
them from attic beams, keeping the fruit fresh until
it goes to market.

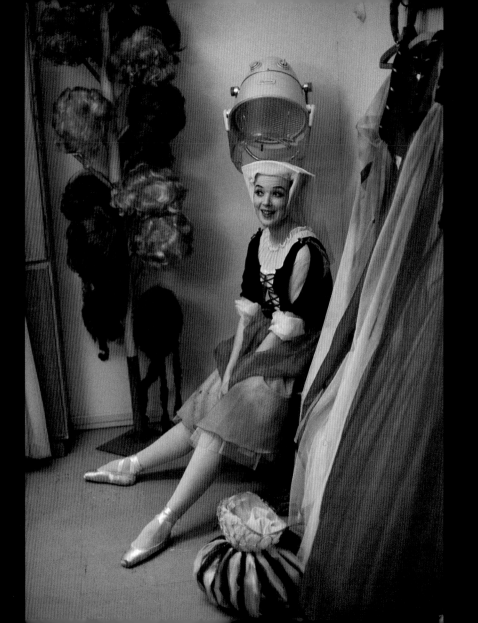

◄ **GEORGE F. MOBLEY** 1968
Ballerina in Helsinki, Finland

▶ **B. ANTHONY STEWART** 1953
Meat products of Swift & Company are
displayed in East St. Louis, Illinois.

**BATES LITTLEHALES** 1963
Prince Ranier and Princess Grace pose
on a yacht in the harbor of Monaco.

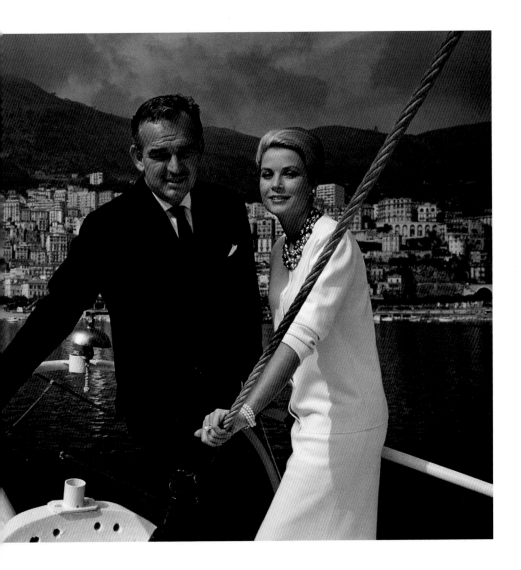

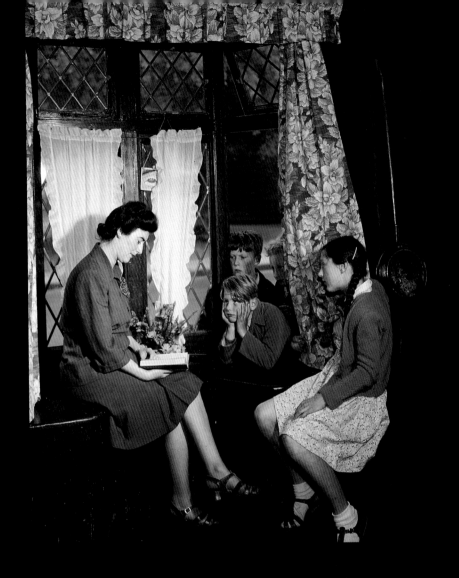

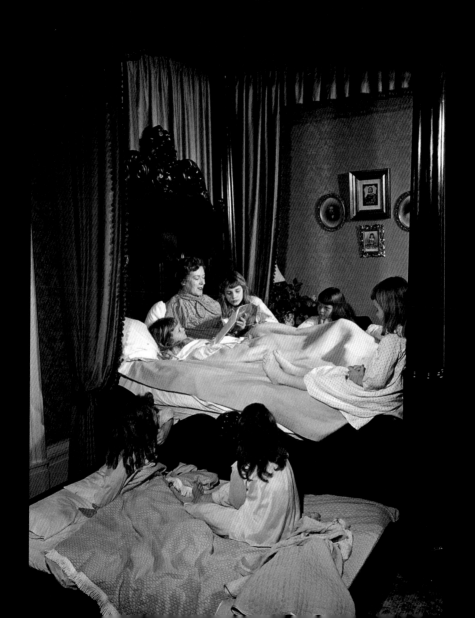

◄ **B. ANTHONY STEWART** **1953**
Children hear a story about Pilgrims in
Chantry House in Massachusetts, where
the treasurer of the *Mayflower* once lived.

► **ROBERT F. SISSON** **1960**
Mrs. George Marshall III reads to her
granddaughters, who are the fifth
generation of the same family to live
in their Natchez, Mississippi, mansion.

**JOHN E. FLETCHER AND B.**
**ANTHONY STEWART** **1953**
Students at Georgetown University in
Washington, D.C., study foreign languages
on tape recordings.

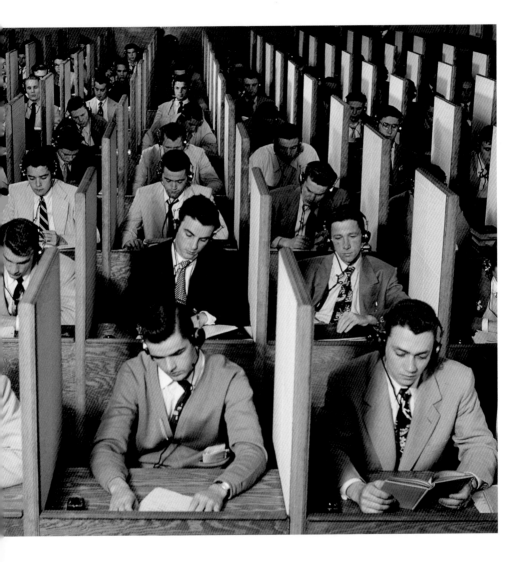

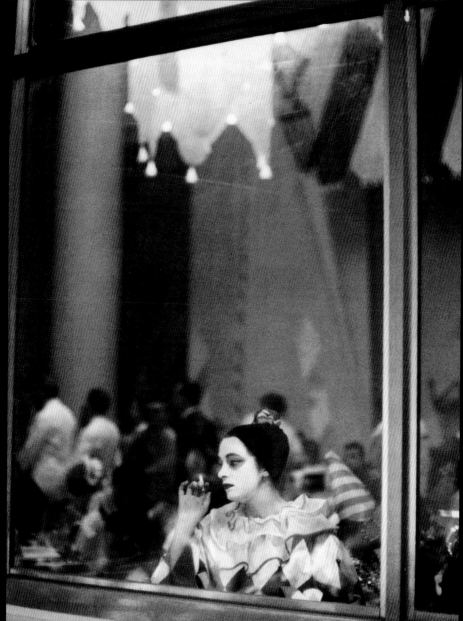

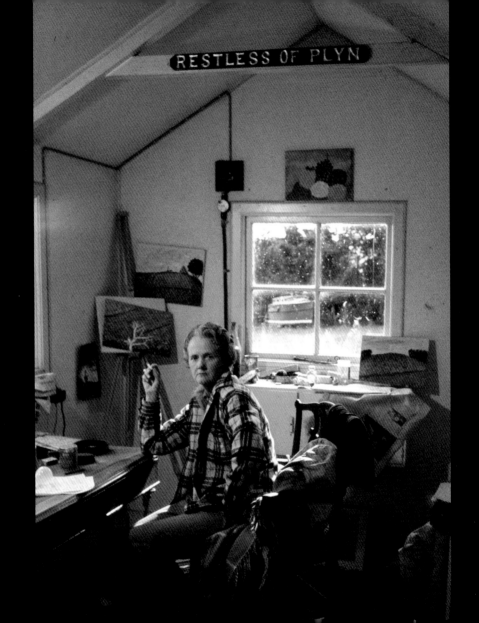

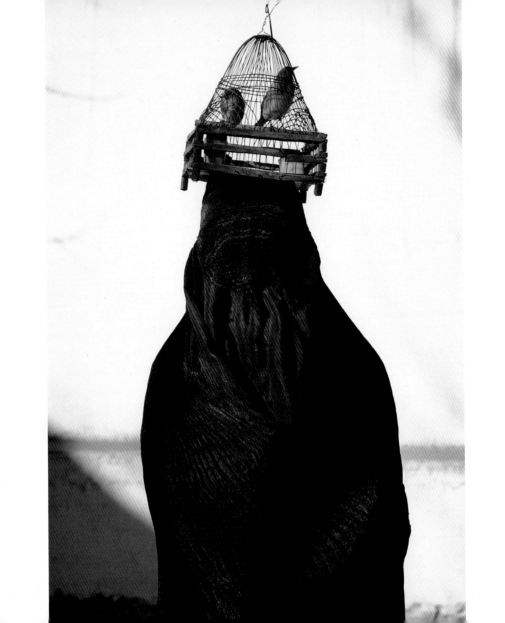

"The perfect exception to the lack of irony in the magazine's pages was Tom Abercrombie's picture of the veiled woman and caged birds caught in one iconic image; the message is as crystal clear as it is unexpected and rings as true today as it must have then."

—*JODI COBB*

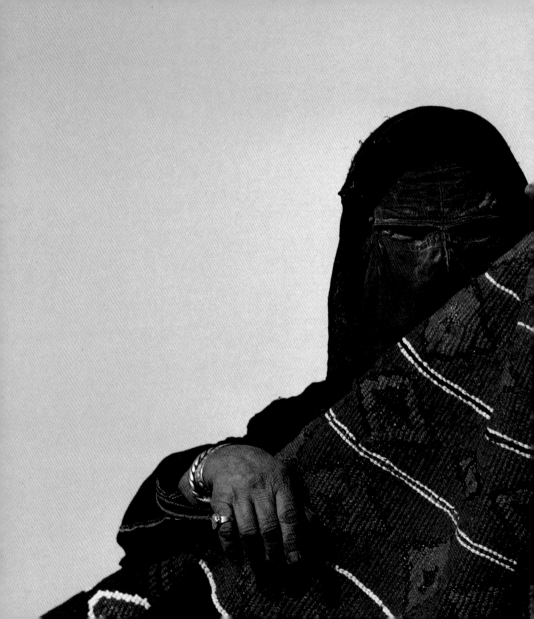

# Photographers working in the fifties and sixties for the Geographic were adventurous men—

Barry Bishop reached the top of Mount Everest in May 1963 and raised the American and National Geographic flags after spending the night precariously exposed, oxygen supplies exhausted, at 18 degrees below zero. And through it all he bravely took pictures. Tom Abercrombie froze up to his eyelashes in 1958 when he was on assignment in Antarctica and made sure he was photographed that way for posterity (page 284).

Geographic photographers worked at every altitude, in every climate, but the pictures they brought back during this era were usually mild and safe. In one (page 286) a Turkish woman holds a smiling little girl, and in another (page 287), made 11 years later, a Russian woman carries her less cheerful child. Both these pictures employ a noncontroversial recipe for popularity—mothers and sweet babies wearing local costumes.

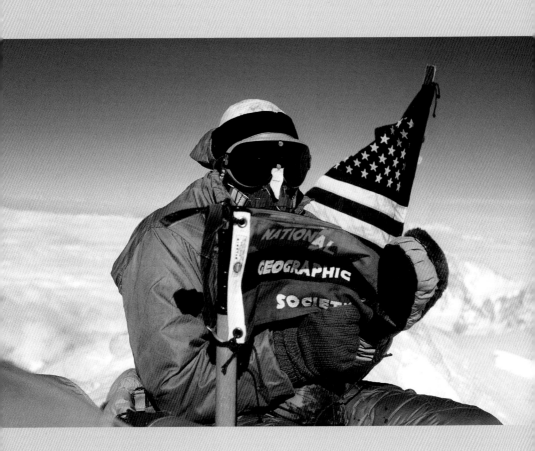

**LUTHER JERSTAD    1963**
Barry Bishop holds the Geographic flag and Old Glory atop Mount Everest.

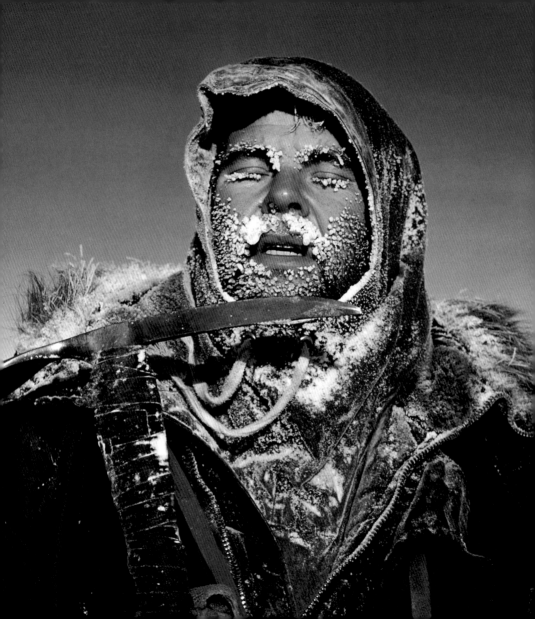

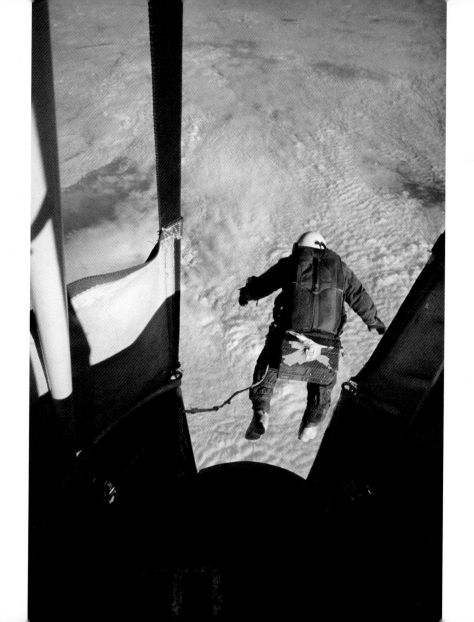

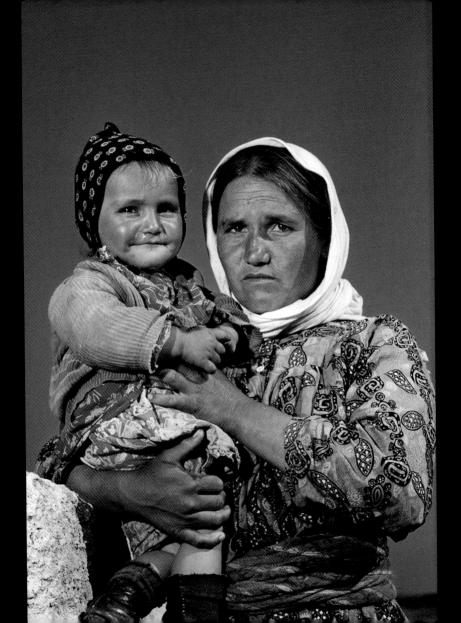

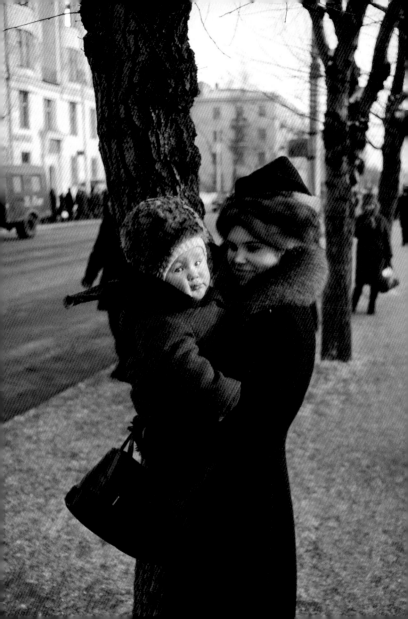

"The 'natives' of the
world were safely foreign. . . .
And the stiffly posed Mada
tribesmen, so ferociously dressed
and mysteriously masked, are
described as practicing pagan
sacrifices. But this potentially
terrifying sight has been stripped
clean of its threat of danger by the
harsh light of the noonday sun—
and the cheerful green cornstalks
in the background."

*—JODI COBB*

**JEANNETTE AND MAURICE
FIÉVET    1959**
Mada tribesmen wear sisal masks, monkey
fur, pompoms, and horsetail fly whisks.

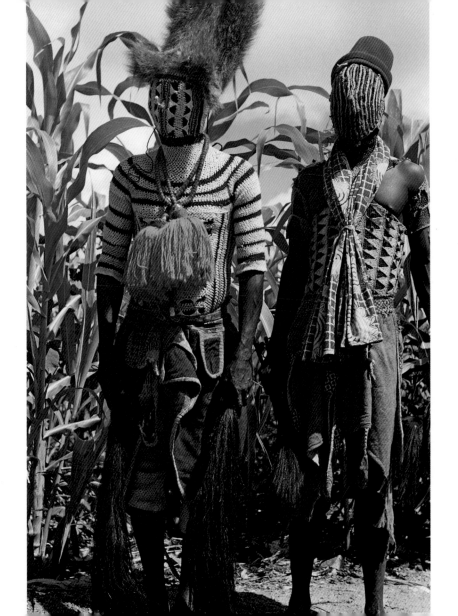

# In Papua New Guinea, a painted dancer smoking a homemade cigarette is about to "leap into the

future" with the help of practical Australian administrators. A group of women in mourning, their faces blackened with pig grease, stand to benefit from the same wise benevolence (page 292). Strangely foreign and unusually beautiful peoples appear on the Geographic's pages at mid-century, now more colorful than in earlier years. Legendary photographer and adventurer Luis Marden could boast of daring exploits and also appreciated the exotic women of Tahiti (page 298). He and his colleagues photographed women in the Belgian Congo, Borneo, and New Guinea, showcasing unfamiliar hairstyles, facial scars, and bare breasts.

Western countries considered remote cultures primitive; in need of modernization from the "civilized" world; alluring and exotic; and always worth knowing about. That these compelling worlds were targets for westernization now seems unfortunate in many ways, but the desire to bestow them with technology and their eagerness to embrace it were widespread.

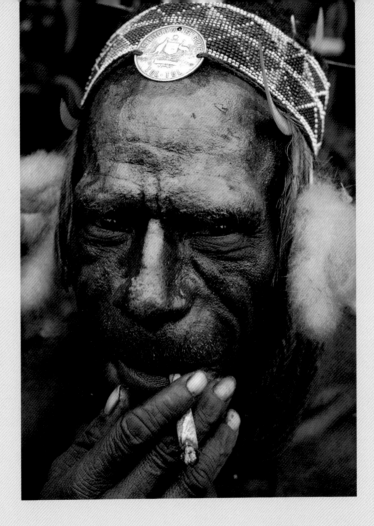

**JOHN SCOFIELD    1962**
Dancer in Papua New Guinea

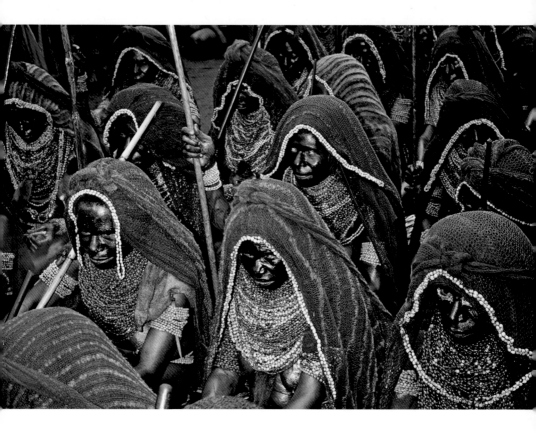

▲ **JOHN SCOFIELD 1962**
Sweet-potato sacks, greased faces, and seeded necklaces
mark women mourners in Papua New Guinea.

▶ **JOHN SCOFIELD 1961**
A charcoaled celebrator in cardboard ears and horn
portrays a Mardi Gras devil in Port-au-Prince, Haiti.

**VOLKMAR WENTZEL   1951**
Pagan demons in the January festival of witches'
Sabbath in Badgastein, Austria

**FOLLOWING PAGES:**
◄ **W. ROBERT MOORE   1952**
Facial scars, braids, and elongating a baby's skull
were fashionable in this tribe in the Belgian Congo.

▶ **HEDDA MORRISON   1956**
Sarawak mother and baby of the Sea Dyaks spend
hours in cool, shallow waters.

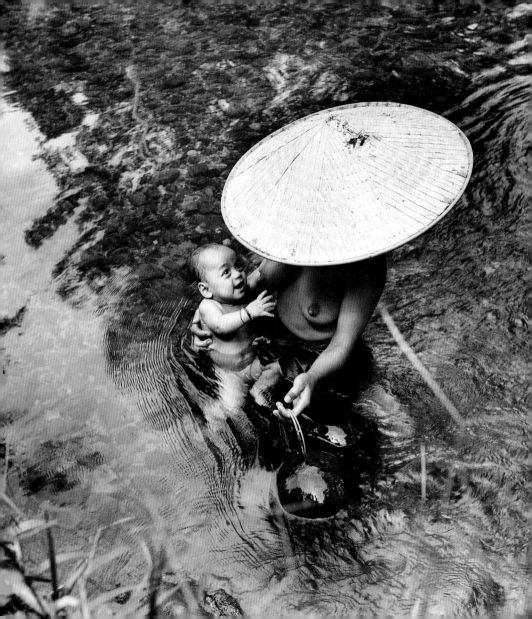

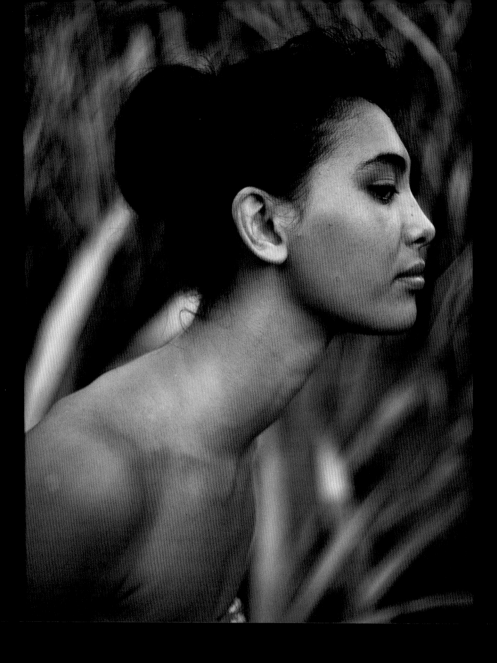

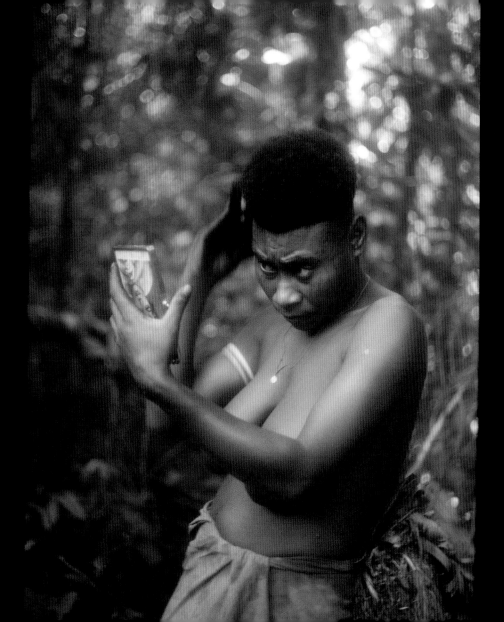

**► ANN CHOWNING   1966**
In the South Pacific, a Kaulong woman
combs cosmetic blackening into her hairdo.

**TOR EIGELAND   1962**
A South African girl carries pineapples.

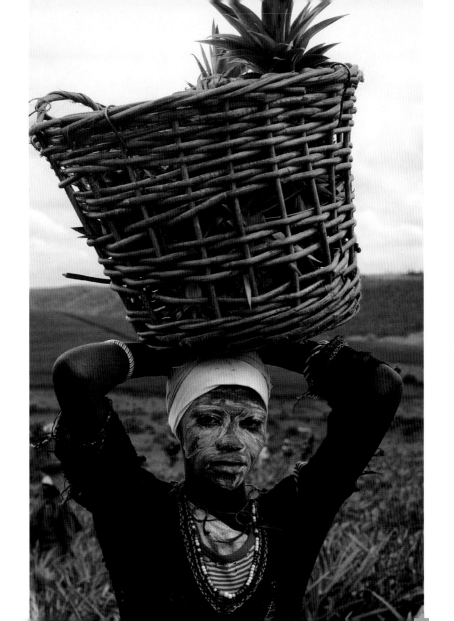

# The Grosvenor family knew and associated with highly placed political figures, and because

of the magazine's large readership, patriotic viewpoint, and readiness to go all out on every story, access to world celebrities in every field grew over time. But Geographic photographers never became starry-eyed pursuers of celebrities. Sometimes a head of state was photographed as part of a broader subject, or a picture was acquired for possible future use and, like this one of young Queen Elizabeth riding in the backseat of her official car, was never published.

But occasionally a story about a world figure was so important it cried out for coverage. In March 1964 the magazine devoted 52 pages to the memory of John F. Kennedy. The story, titled "The Last Full Measure," was written by National Geographic President and Editor Melville Bell Grosvenor and comprised some 40 photographs by staff and freelance photographers.

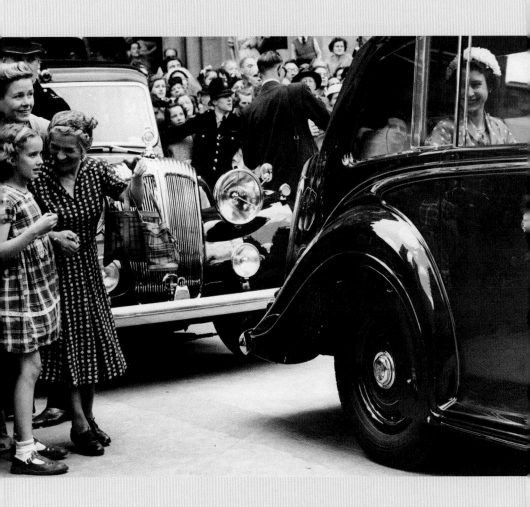

**KEYSTONE PRESS AGENCY 1954**

England's Queen Elizabeth, London

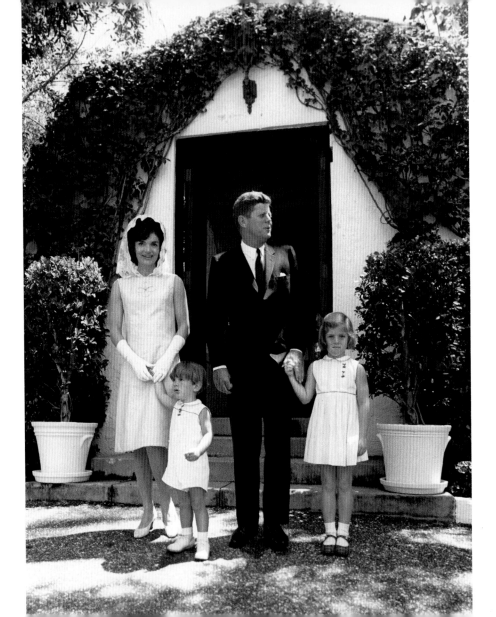

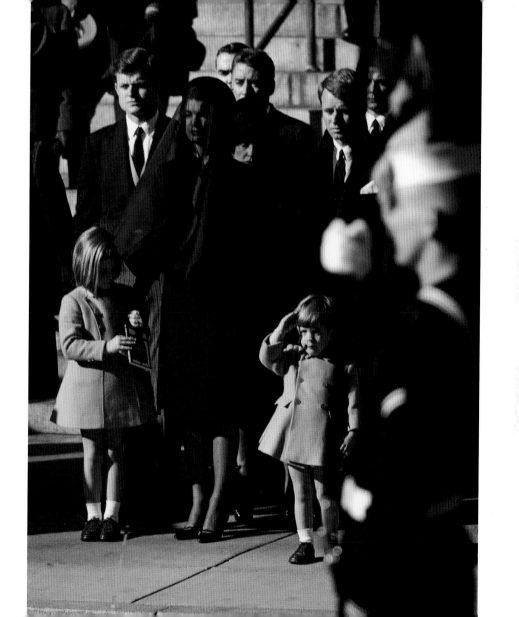

**WILLIAM ALBERT ALLARD   1968**
Basque farmers in France

# "Almost surreptitiously,

. . . the deceptively straightforward
work of Bill Allard began to
appear. Gorgeously composed and
illuminated, Allard's photography
disregarded trends and fads. . . . He
noticed the grace of a gesture, the
enigma of expression on the Basque
men's faces in a group shot, where,
disturbingly, one face edges out
of the corner of the frame and lifts
the photograph out of the ordinary.
Almost romantic, not specifically of
a time and place—those pictures
remain important and compelling
today, presaged the future of the
magazine, and opened the door to a
new generation of photographers."

*—JODI COBB*

**WILLIAM ALBERT ALLARD**   **1965**
Amish boy with his pet guinea pig, Lancaster County,
Pennsylvania

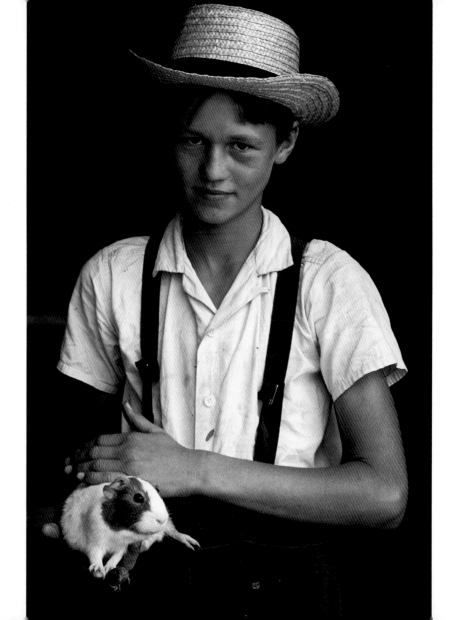

# Back to Realism

## THE 1970s AND 1980s

*[signature]*

IT'S ALMOST ALWAYS ABOUT THE EYES, ISN'T IT? Doesn't a fine portrait somehow always revolve around the eyes? Sometimes even when you can't look into them? I think so.

It was a portrait of a soft-eyed, tanned-skinned Amish boy, looking directly at me and holding his pet guinea pig, that started both my relationship with *National Geographic* magazine and my career as a professional photographer. In 1964 I was a newly hired summer photographic intern at the magazine, having just graduated from the University of Minnesota after first studying for a year at an art school in Minneapolis. That portrait was one of the first pictures I made as a professional, as well as one of the first I made in color. It became the opening picture to a story about the Amish of Lancaster County, Pennsylvania, published in July 1965, a story some credit as the beginning of a more intimate way for the Geographic to look at people. It certainly jump-started my career, now in its 40th year.

Prior to my arrival at the Geographic, the sum of my college photographic experience was in 35mm black and white. The photographers whose work I looked at during those formative years, to name just a few, were Paul Strand, André Kertész, Henri Cartier-Bresson, W. Eugene Smith, Robert Frank, Bruce Davidson, Dennis Stock, and

portraitist Arnold Newman. Dorothea Lange's work for the Farm Security Administration during the Great Depression, especially her beautifully composed portraits, mesmerized me. "Migrant Mother," Lange's portrait of a weary woman enclosed by her three children in a California farm labor camp, is a gritty and yet elegant summation of a time when many Americans were on the road, with their pasteboard suitcases and patched-up tires, fleeing the Dust Bowl, looking for work and a new life.

As one who wanted to write as well as photograph, I was deeply impressed by the collaborative efforts of Walker Evans and James Agee in their extraordinary *Let Us Now Praise Famous Men,* a book that brought to life the faces and lives of Alabama sharecroppers in the 1930s. All those early influences were photographers of people, some of them magnificent portraitists. And they all worked in black and white.

When I arrived at the Geographic I was faced with having to work exclusively in color. At that time, it's fair to say, *National Geographic* was the only major magazine in the United States, if not in the whole world, that was published *entirely* in color. But I had *never* photographed in color. Although I probably didn't realize it then, all of the paintings I'd looked at in art school and after were to have a major and continuing influence on

the way I would intuitively see color photographically. From the Flemish masters to the Impressionists, from Degas to Matisse to Edward Hopper, the American master of solitude, I would absorb much about color and light, grace and balance in the division of space; painters were probably a greater subconscious influence on me than other photographers were.

IN MY FAVOR AS I BEGAN MY PROFESSIONAL CAREER that summer was that my favorite photographic subject was—and continues to be—people. When the Geographic sent me to photograph the Amish who lived and farmed in Lancaster County, I was somewhat better prepared for that quest than I was for the sudden switch from black and white to color.

In college I had tried to force myself to select story subjects I might not be totally successful in completing, stories that required me to gain the acceptance of my subjects in order to work—an interracial marriage and a high-intensity black church congregation, for example. They challenged me psychologically because, if you want to photograph people intimately, you must first gain their permission.

I drove the back roads of Lancaster County, scanning the landscape for the approach of black Amish buggies, stopping at times to listen to the hollow staccato clopping sound of a buggy horse pacing its way across one of the covered wooden bridges common then in the county. Using a straightforward approach—who I was, for whom I worked, what I wanted to do, and why I thought it should be done—I was able to convince some members of the Amish community to allow me to photograph them in their daily lives.

My way of working then, as now, is often a matter of pure serendipity: no plan, simply making myself available for whatever comes along. The boy in my portrait and his little sister, both barefoot, were riding on a horse-drawn wagon while their father strung a wire fence along a piece of their farmland that bordered a country road I'd been driving one gray-skied afternoon. I stopped and explained to the farmer that I was trying to photograph the Amish for a story the Geographic wanted to do that would explain their way of life. Although I'm not at all sure he was familiar with the magazine, he agreed to let me ride along for an hour or so.

I photographed the girl in her pale blue summer dress, beneath the huge draft horses that towered over her. Sometime along the way the father stopped to remove a splinter from the boy's foot, and later, after we came out of the field and while the farmer unharnessed the horses, the young boy insisted that I go with him to the barn, where he

kept his pet guinea pig. And there, in the softest of light, with the dark recess of the barn interior behind him, I made a few simple portraits as he stood looking at me from what seemed to me to be another era. There are small details in the published portrait that are subtle but revealing: the safety pins replacing the buttons connecting the boy's suspenders, the tattered and dirty bandage enclosing one of his fingers. The color is very limited, mostly browns and black, with some white and a little yellow. The picture has a simplicity derived from both the subject and the photographer's approach. I wasn't trying for anything unusual—no clever angle, no attempt to elicit any expression beyond what the boy was offering on his own. He was just showing me his guinea pig. It's a picture that precedes the decades this chapter covers, and although it may not be the best portrait I've made in my career, it taught me that the simple truth of a situation is usually more than enough. It was the first portrait of mine published; I believe it still holds up, and it led me to all the others.

I know that of my work from the 1970s and '80s, a lot of the pictures I care most about (and it's impossible, so don't ask, for a photographer to pick one "favorite") are portraits of different kinds. From the farmlands of Lancaster County, Pennsylvania, I gravitated, in the late 1960s and through the '70s, to the American West, seeking assignments that would allow me to wander across that great landscape and photograph those who lived and worked there.

HENRY GRAY LIVED IN A RANCH HOUSE THAT SAT LIKE an island in the vast Organ Pipe National Monument country in Arizona's Sonoran Desert. I was photographing and writing about the U.S.-Mexican border in 1970, traveling by motorcycle, and I'd heard of this rancher out there in the middle of the desert and decided to go look for him. When I found his home, Henry was there, 72 years old, living alone on a place he'd ranched for 50 years. He invited me in for a glass of cold water. In that desert heat Henry wore a fairly new denim shirt like a second skin, cuffs down and secured around his wrists, his collar buttoned tightly at the throat. His straw hat, tipped back as if to cool his brow, was darkly stained from sweat that had crept halfway up the crown, bleeding out beneath the brim on one side. As we talked in his kitchen, I noticed a framed picture of the famous prizefighter Jack Dempsey; it was a picture taken from the cover of a long-ago *Police Gazette,* a magazine you don't see around anymore. We moved from the kitchen to a room that seemed to be a combination living room and bedroom. The head of a long-horned steer, its hide dried and cracked, loomed out from the wall above a mirrored dresser that reflected a diminished Henry, smaller than life in perspective. A black-and-white photograph of a young woman, perhaps a granddaughter or maybe a niece, I didn't ask, was tacked to the wall near the dresser, and above it all, directly behind where Henry stood at that moment, hung an American flag. A 48-star American flag.

We stayed there in that room and I made some portraits of Henry as he told me some facts of his life, how, for instance, he had pulled his own teeth with pliers when they went bad, and how, "That last one, God, I thought it would about take my head off." He told me the government was pressing him to take his cattle off the land, a move that would force him to give up his ranch life.

"All I know is cattle," he said. "Guess I'd have to quit ranching. I've never lived in town. I go in for supplies about every two weeks or so, but I never seem to do no good there. Sitting around gets the best of me. I don't believe I'd last long in town." He paused then, as if to think about the gravity of what he'd just told me, and looked down at the floor in silence. His hands, freckled with age spots, rested on his narrow hips in a posture somewhere between defiance and resignation. I made one or two pictures of him that way, when he was gazing down at the floor. All told, I think I used one roll of film. I don't remember reloading the camera, but that was a long time ago.

I think of good photographs as puzzles, with many pieces and many ways of putting them together, and at that moment, as we passed time on a warm afternoon in the desert, all the pieces seemed to come together, the picture almost out of balance, but not quite, and there is no doubt who this man is. He is 72-year-old Henry Gray and his life is changing more than he wants or perhaps can accept.

IN THE EARLY 1980S I GAVE UP THE AMERICAN WEST AS a motif and headed south, in 1981, down to South America, to Peru. On a brilliant spring afternoon near Puno, I was driving back toward town after a day of wandering the *alto plano* in search of pictures. The air was as clear as crystal, the sky a rich blue untouched by clouds. A boy was standing by the edge of the road and he was crying. Below where he stood, down in an open area next to a furrowed field, were the bodies of a half dozen sheep, their forms hunched and broken in death. The boy appeared to be about nine or ten years old. His blue sweater bore a large white patch at the elbow and the seat of his pants was crudely crosshatched with stitched repairs. A dark blue stocking cap was pulled down tight over the tips of his ears, and the late afternoon sun made the tears in his eyes and on his wind-burnished cheeks glisten like diamonds. I learned later that his name was Eduardo.

Eduardo had been taking his family's band of about a dozen sheep home to his village at the end of the day. A taxi had come tearing down the road and hammered through the sheep, brutally flinging half of them off the road and down into the field below. The driver never even stopped. But we did. As the boy looked up at me with his shattered face, I made just a few pictures, because I had to. The sight of him standing before me registered in my mind as a reflection of much of what Peru can be about for many of its people. It can be cold and harsh and cruel, a country where death can come easily to animal and human alike, and Eduardo

came from a family for whom their animals are their prosperity, if they have any. And now this boy, who was responsible for his family's sheep, must go home and tell them that half of their sheep are dead. Behind the boy, a man wearing a brown hat and carrying a white bag in one hand walks past the dead animals and his shadow touches the back of Eduardo's shoulder. After a few minutes, we left. We didn't give the boy anything; I probably should have, but we didn't.

It would be almost a month before I would see that picture (pages 378-379) among all the others in my picture editor's selects when I got back to the office in Washington, D.C. When I did, I went on an immediate crusade to be sure we published this picture, because I believed it illustrated a truth about this country and about the toughness of life for so many Peruvians. We did publish it, but I wasn't prepared for the reaction from our readers. More than $6,000 in contributions came in from readers from all over America. They wanted to help. The National Geographic Society contacted CARE, and that organization was able to locate Eduardo. They had a village celebration at which his family's sheep were replaced, a water pump was provided for the village, and the rest of the money was put into a fund for Andean school children.

Over the years I know I've made pictures that have entertained people, brought them pleasure of a sort. But this picture actually changed someone's life for the better. As photographers we are always taking, sometimes giving back with pictures, but more often than not we are just taking, although with good intentions, usually. It's our nature, those of us who wander about, to respond to the visual stimuli of the moment. Within our profession we are sometimes referred to as "street shooters," a rather predatory characterization, but at times true, I suppose.

The readers' response to this picture took some guilt off my back. I hadn't given that boy anything because I didn't want to seem to be somebody who walks about the Third World handing out money and acclimating people to expect money from anybody with a camera. When I think about it now, I certainly should have given him *something,* although nothing would have been enough to relieve his dread of going home to tell what had happened. I don't think I truly appreciated his broken heart until I got back to my comfortable hotel and thought about him, his tears, those dead sheep, and just what that meant to a family that lived in a world far different from mine.

IN THE DECADES OF THE 1970S AND '80S, THE NUMBER of excellent portraits published in *National Geographic* magazine grew. Some became landmarks, icons not only for the Geographic but also for photography itself. And in the middle of the 1980s came a portrait that I believe unarguably stands as one of the finest and certainly by now the most famous of any portrait published in the history of the Geographic: Steve McCurry's "Afghan Girl," published in June 1985 (page 354). Is there a more stunning photographic examination of the human face than that picture? This is a face that is *in your*

*face*. What manner of question or emotion is behind the look in those eyes? She may be looking at the photographer, but she seems to be looking at all of us, and *knows who we are*.

I was in a night market in Chiang Mai, Thailand, recently, and in one area was a group of artists who did nice copies of photographs—mostly drawings, sometimes pen and ink, occasionally paintings. And almost to a man, they had created variations of Steve McCurry's "Afghan Girl." None were as good as the original and, interestingly, most were in black and white. That picture is still quite strong in black and white. Most good pictures can hold up if converted from color to black and white, and some are perhaps better that way.

But look again at McCurry's portrait of the Afghan refugee girl in her worn and torn reddish shawl, at the warm and slightly smudged skin tones of her face, at her lips and her eyes. My God, her eyes! They are green, and for some reason you don't expect them to be so green; they are so intense they seem to be almost looking through you, not at you, and once you see that picture as he made it, in color, you can never imagine seeing it any other way. At least I can't.

AFTER I HAD BEEN WORKING FOR THE GEOGRAPHIC FOR about a year, a picture editor I'd been working with said to me: "You have an awful lot of people looking at the camera." Yes, I thought, but they weren't looking at the camera. They were looking at me. Making a portrait is a two-way proposition, an exchange, if you will, of attention, a communication that is often fairly short on words, long on eye contact. Sometimes nothing is said, you just see the picture and hold your breath that it will stay long enough—the expression or the attitude—for you to shape the space around it and make the exposure. It's almost always given to you, you seldom just take it.

I have always believed that if a person isn't doing something really interesting, something that demands the main attention of the photograph, then why not say to him, "Just look at me," and try to make a picture good enough to introduce that person to all who might see the image. A fine portrait has the potential to tell something about the spirit of the subject that can be sensed by someone half a world and a different language away, something universal and simple: This is another person in our world and I'd like you to meet him or her. Maybe you will feel like you know a little bit about them, what are their sorrows, what kind of songs they might sing, what they might be like to sit with in a café and share a cold beer or a glass of wine. A picture that's good enough can do that, I believe. Often in my attempts to make a portrait I don't say, "Look at the camera." I say, "Just look at me." The camera isn't making the picture, I am. But no matter where they are looking, whether straight ahead, down, or off in some distant thought, some reverie, and you can't really see what they see, isn't a fine portrait almost always about the eyes? I think so.

— WILLIAM ALBERT ALLARD

# When the 1970s dawned *National Geographic*'s Director of Photography, Bob Gilka, was hiring a

new crop of photographers. The young hires, raised on *Life* magazine, rejected the perky, artificial smiles, the staged cheer, and the overly bright colors of the post–World War II era. They wanted unvarnished reality and believed in presenting people quite simply as they appeared. This was a return to old ideals, but with a difference: The new photographers were drawn to the most everyday of subjects—remote and exotic peoples were fine, but folks in the neighborhood were just as worthy.

In some ways, this brought the *Geographic* closer to mainstream photojournalism. But the *Geographic* continued to seek a different kind of coverage, focusing on moments more deeply behind the scenes that were of little interest to newspapers. Photographers could capture fleeting and subtle postures or gestures, like chewing on bread thick with peanut butter: Photography was fresh again.

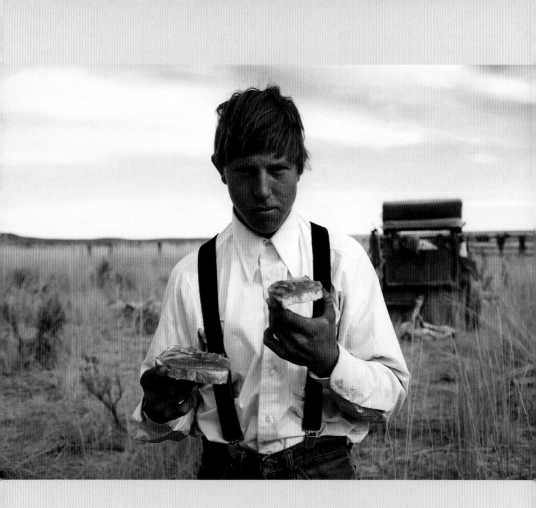

**WILLIAM ALBERT ALLARD    1979**
T. J. Symonds's father sent him from South Dakota
to work on a ranch in Nevada.

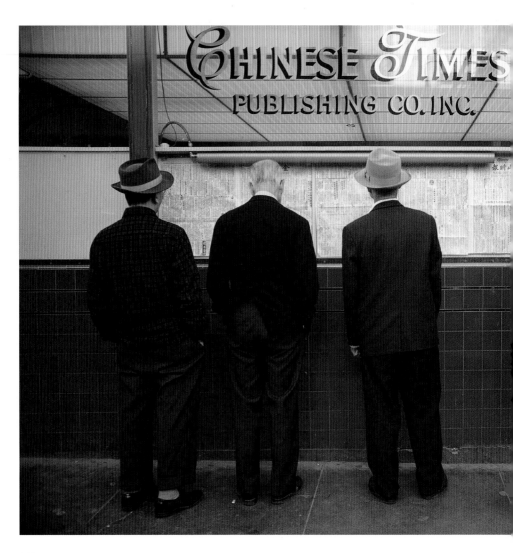

Grant Avenue in San Francisco's Chinatown

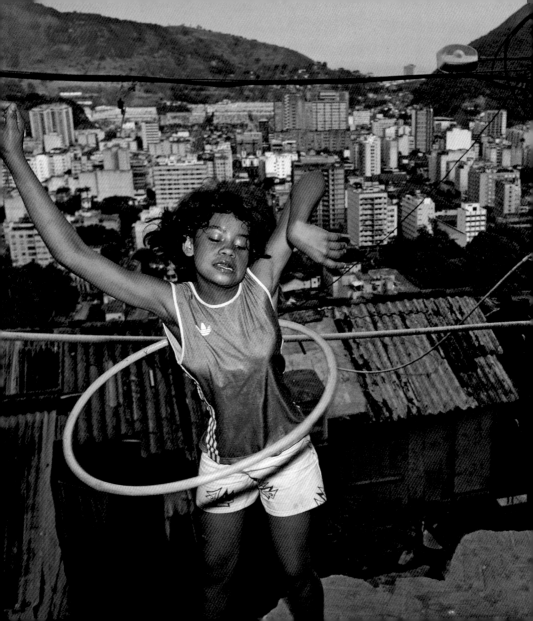

**DAVID ALAN HARVEY  1989**
Summer cruise on the Seine, Paris

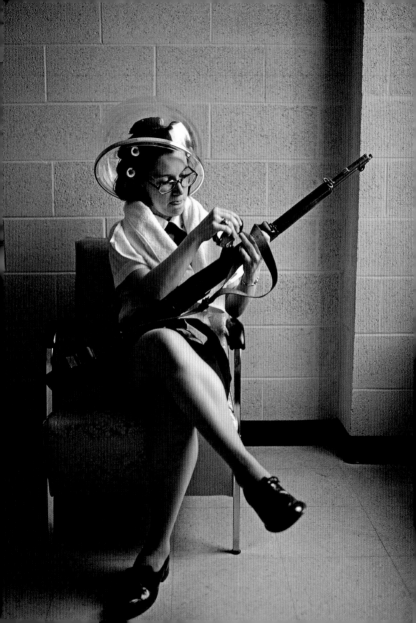

**DAVID ALAN HARVEY   1974**

In Yorktown, Virginia, one of the first women
admitted to the Coast Guard's Officer Candidate
School cleans her M-1 rifle.

## JAMES L. STANFIELD 1986

In Pineville, Virginia, a work-hardened coal miner lights up during a talk with her 15-year-old bride-to-be daughter.

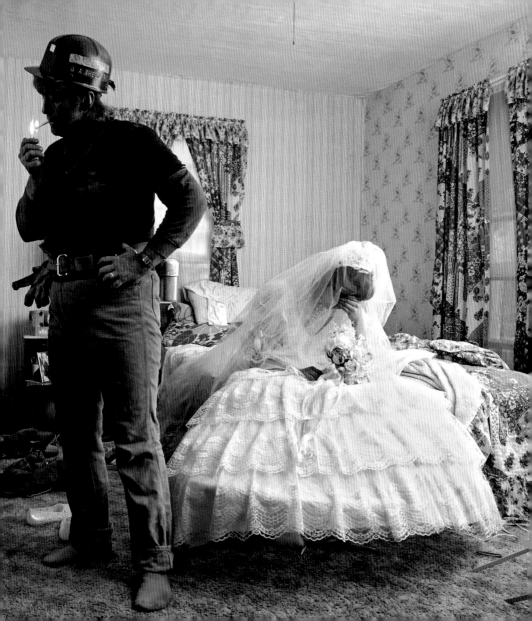

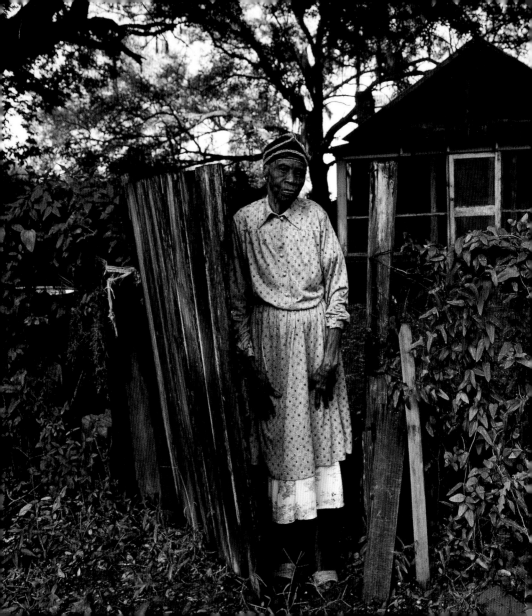

**KAREN KASMAUSKI   1987**
Virginia Bennett is determined not to sell
her one-acre lot on Hilton Head Island, where
she has lived for 40 years in a house built
by her husband.

"I made some portraits of Henry
as he told me some facts of his life,
how, for instance, he had pulled his
own teeth with pliers when they went
bad. . . . He told me the government
was pressing him to take his cattle off
the land, a move that would force him
to give up his ranch life....His hands,
freckled with age spots, rested on his
narrow hips in a posture somewhere
between defiance and resignation.
I made one or two pictures of him that
way, when he was gazing at the floor."

*—WILLIAM ALBERT ALLARD*

**WILLIAM ALBERT ALLARD    1971**
Cattleman Henry Gray, Arizona

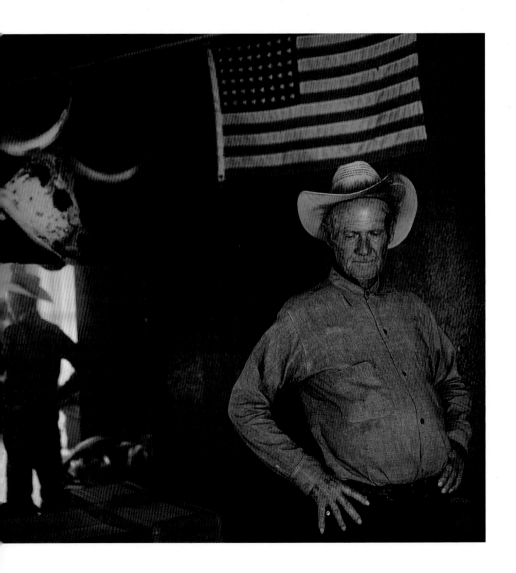

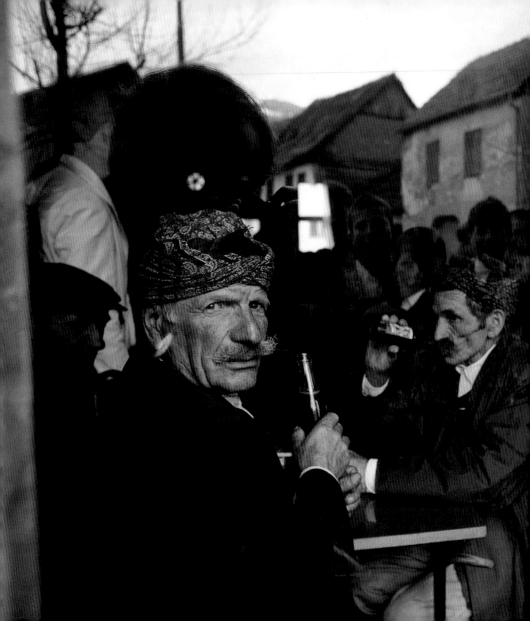

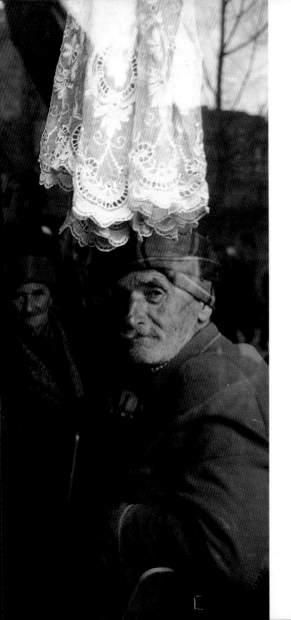

Muslim Shiptars enjoy soft drinks
in the Montenegrin village of Gusinje,
near the Albanian border.

**WILLIAM ALBERT ALLARD    1989**
Mule auction, Mississippi

**FOLLOWING PAGES:**
◄ **WINFIELD I. PARKS, JR.    1971**
Glasses of dark porter await patrons in
Inishmaan's only pub, Aran Islands, Ireland.

▶ **ROBERT W. MADDEN    1972**
Naval Academy graduates, Annapolis, Maryland

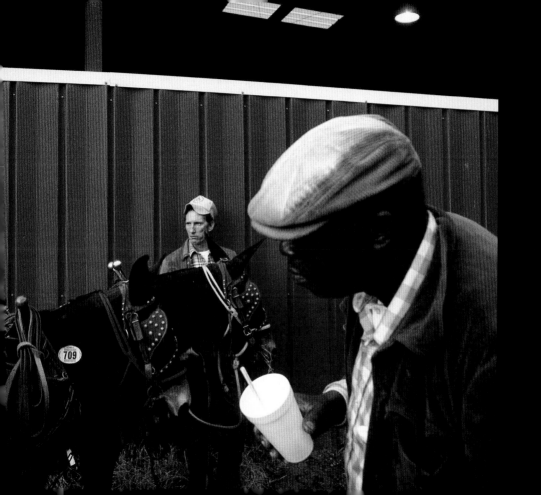

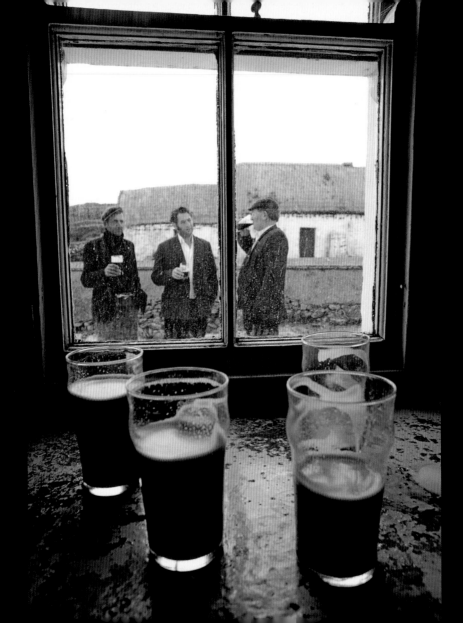

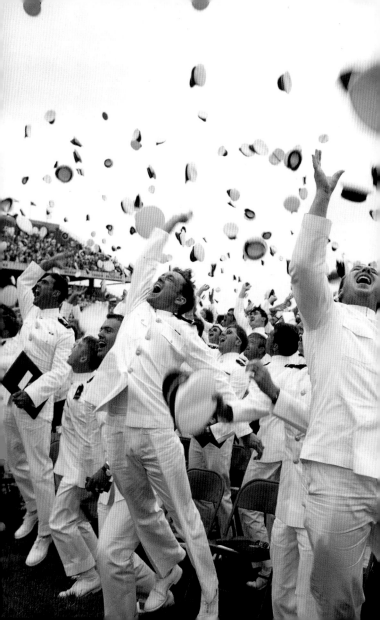

**otographers** enchanted by the ur

d quality of the passing moment still saw po

n the occasional formal portrait. Michael O'Brien posed two

Australian ladies in front of a neutral backdrop, but their faces

and stances show there's nothing neutral about their pride in

their lawn bowling accomplishments.

A formal portrait doesn't necessarily mean a neutral set-

ing: Miguel Rio Branco's perfectly balanced 1984 portrait of

Kayapo Indian chief with wife and daughter at home (page

349) and Winfield Parks's 1971 photograph of an Irish family in

their kitchen (pages 350-351) both present families surrounded

by the paraphernalia of domestic life; Dick Durrance and Eliot

Elisofon chose the outdoors for a Zulu couple (page 348) and

a rather remarkable Zaire clan (pages 346-347). But no matter

how far-flung the subjects, and regardless of style and setting,

the photographers looked for dignity and found strength in the

people they photographed formally.

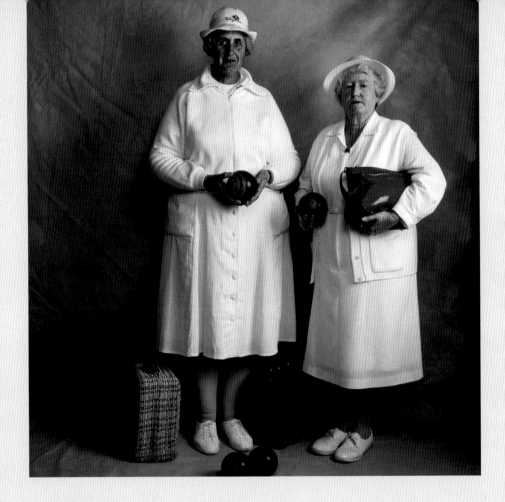

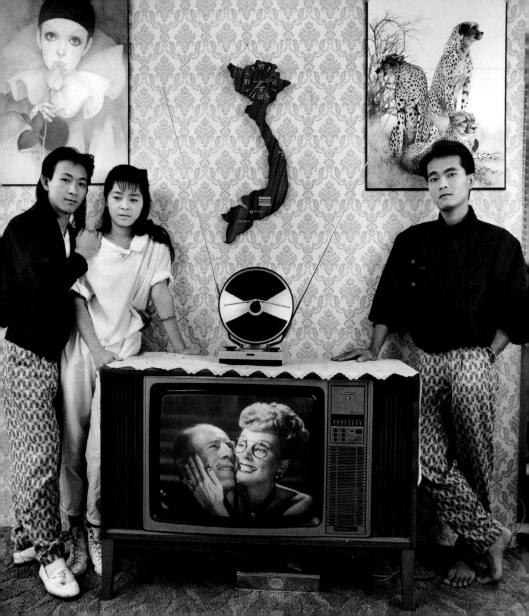

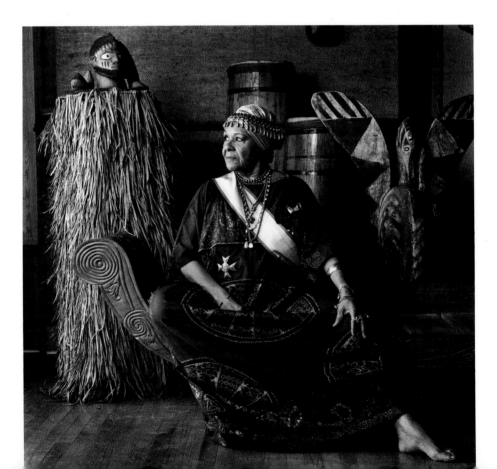

◄ **MARY ELLEN MARK** **1988**
Vietnamese immigrants, Sydney, Australia

▼ **BRIAN LANKER** **1989**
Modern dance choreographer and pioneer
Katherine Dunham poses among items of
African and Caribbean folk cultures.

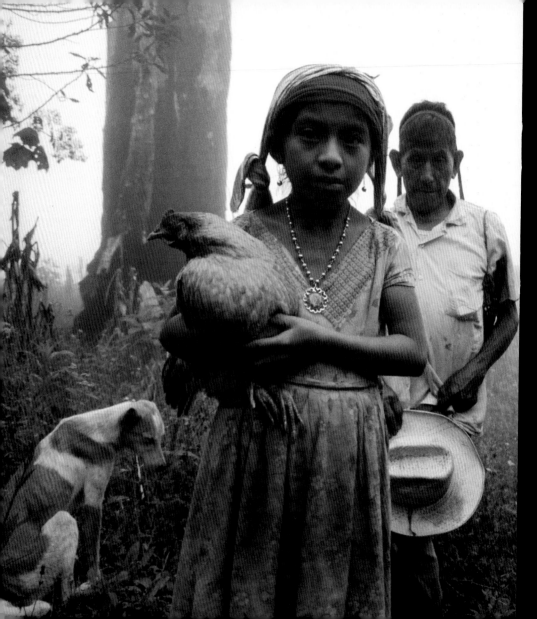

**DAVID BRILL    1975**
Maya children in the Mexican Highlands

**ELIOT ELISOFON  1973**
A portrait in Zaire of clan chief Teingu's wealth shows a partial assemblage of his 36 wives and 25 children.

**FOLLOWING PAGES:**
**◄ DICK DURRANCE II  1971**
A Zulu couple is dressed for a ten-mile walk from their kraal to market in Nongoma. The umbrella is in case of a fight, not rain.

**► MIGUEL RIO BRANCO  1984**
In Brazil, Kayapo chief Toto'i poses in a family portrait, wearing a headdress of parrot feathers representing family links.

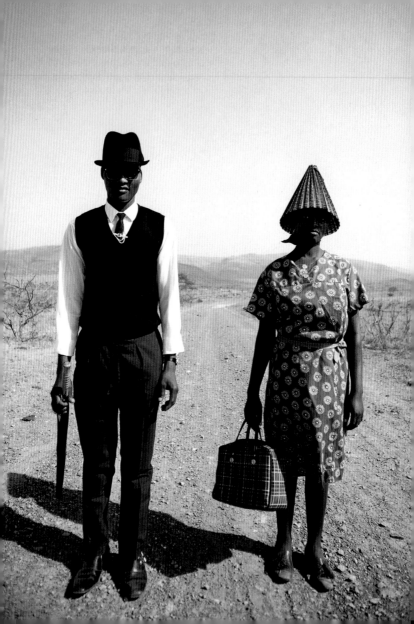

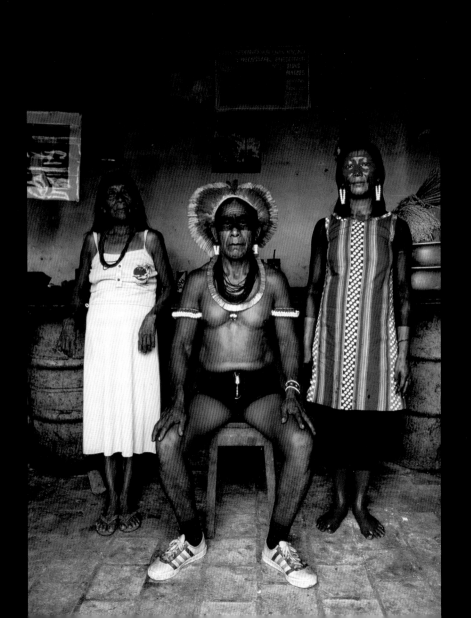

**DEAN CONGER   1977**
In Murmansk, near the Arctic Circle in the former
Soviet Union, a child gives her age in response to
the photographer's question.

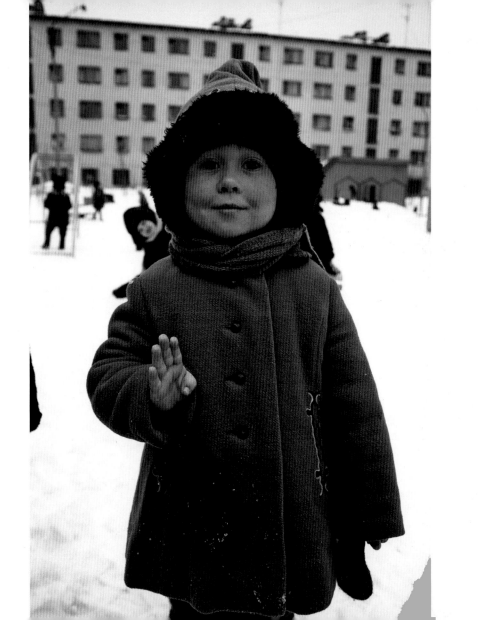

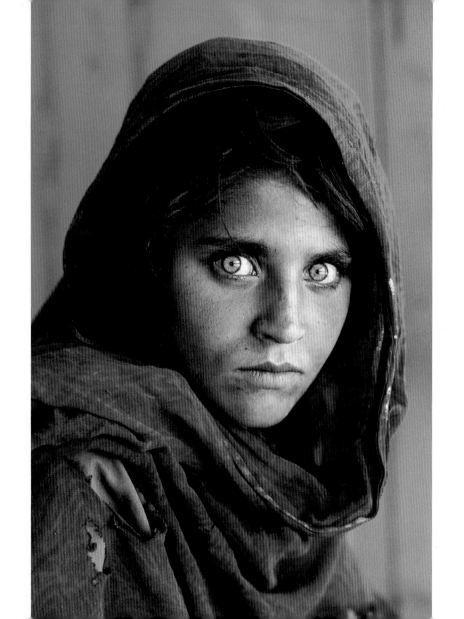

"I was in a night market in
Chiang Mai, Thailand, recently, and
in one area was a group of artists who
did nice copies of photographs—mostly
drawings, sometimes pen and ink,
occasionally paintings. And almost
to a man, they had created variations of
Steve McCurry's "Afghan Girl." . . . Most
were in black and white. . . . But look
again at McCurry's portrait of the girl
in her worn and torn reddish shawl, the
warm and slightly smudged skin tones
of her face, her lips, and her eyes. My
God, her eyes! They are green, and for
some reason you don't expect them to
be so green . . . and once you see that
picture as he made it, in color, you can
never imagine seeing it any other way."

—*WILLIAM ALBERT ALLARD*

**STEVE MCCURRY  1985**
Afghan girl, refugee camp, Pakistan

**FOLLOWING PAGES:**
**STEVE MCCURRY  1984**
Monsoon floods, Java

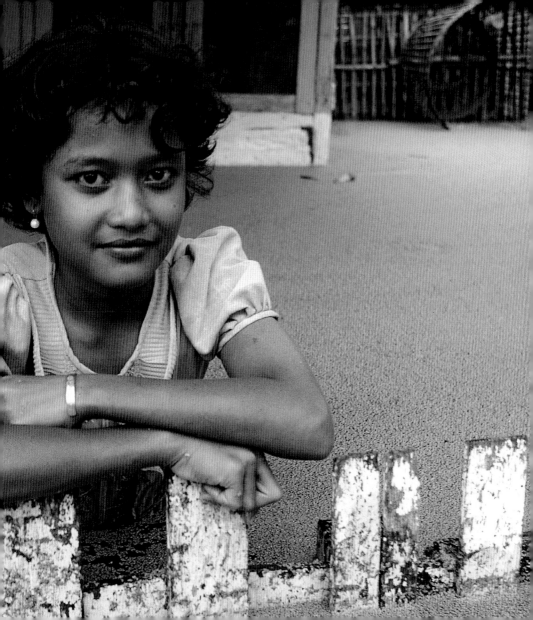

**STEPHANIE MAZE   1984**
Preparing the bride, Mexico City, Mexico

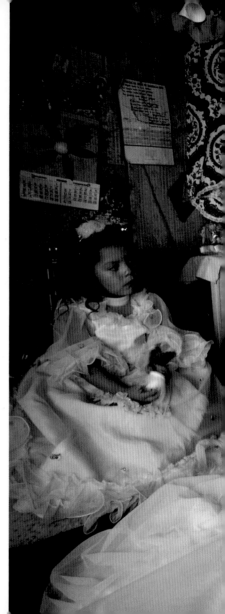

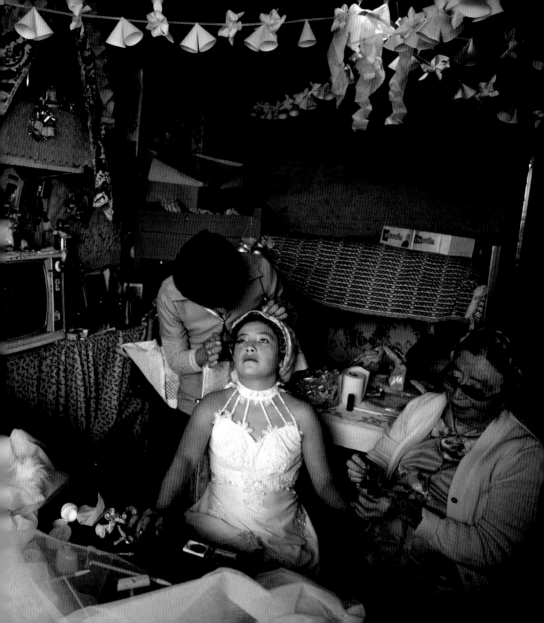

WILLIAM ALBERT ALLARD    1988
Model Debbie Chin at home, Paris

FOLLOWING PAGES:
◄ COTTON COULSON    1984
Carnival, Venice

► MALCOLM S. KIRK    1969
Mud-smeared man from the Asaro River
Valley prepares to portray an evil spirit
in a New Guinea tribal dance.

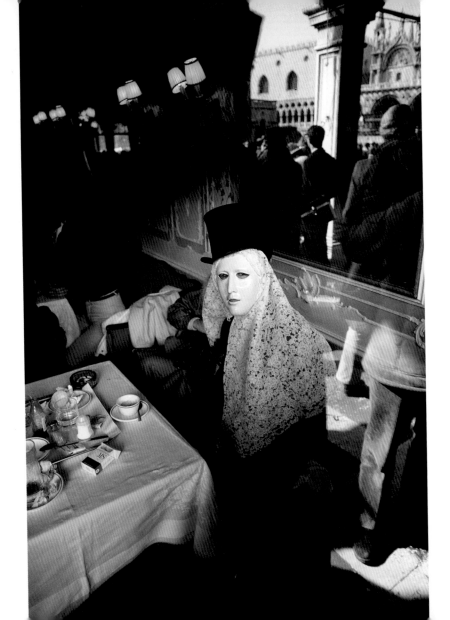

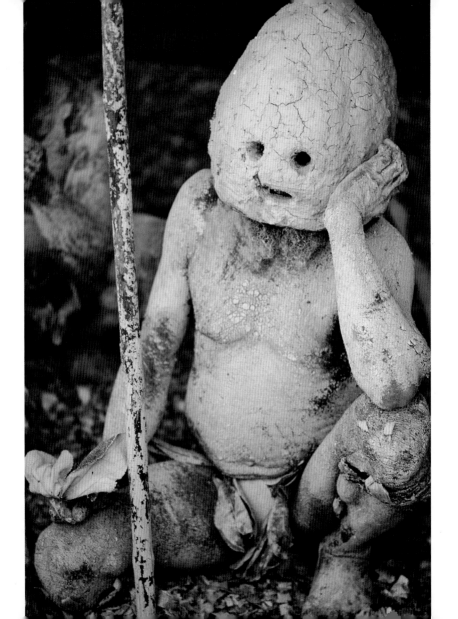

# David Alan Harvey's Nicaraguan girl would look like a coquettish teenager with

no care in the world if she were in a different setting. Jim Blair's young Haitian mother (page 368), if she were somewhere else, could be an aristocratic woman on a Sunday outing. The environments these women are in present central facts about them—they are poor, their burdens are large and basic.

In contrast, photographers like Yousuf Karsh and Richard Avedon attempt to penetrate the essence of their subjects with few environmental hints, desiring instead to portray them entirely through facial features and nuances of expression. National Geographic photographers usually intend to present an entire cultural situation. The clues the backgrounds give to the identities of the Nicaraguan girl and Haitian mother are significant, but the women also transcend their particular circumstances. They flirt and worry like people everywhere. Turn the page and you'll see another example of this: People, whether they live in Canada or Central Asia, are proud of their babies.

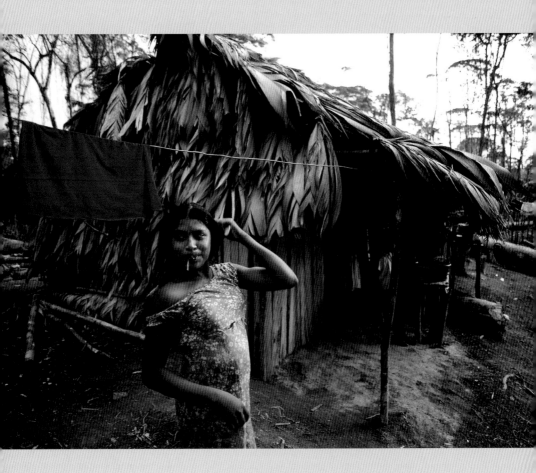

**DAVID ALAN HARVEY    1983**
A Miskito Indian girl from Nicaragua stands near
her new home in a refugee settlement in Honduras.

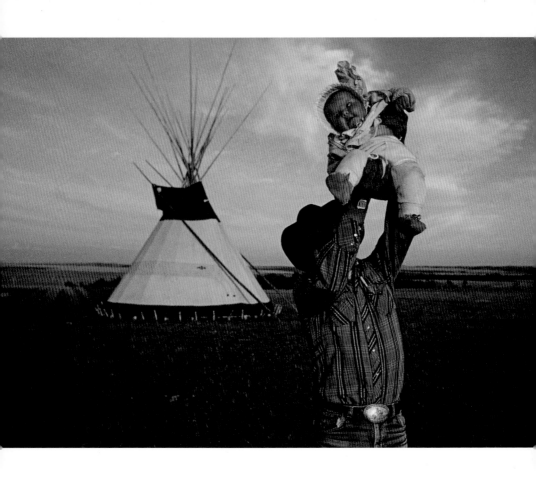

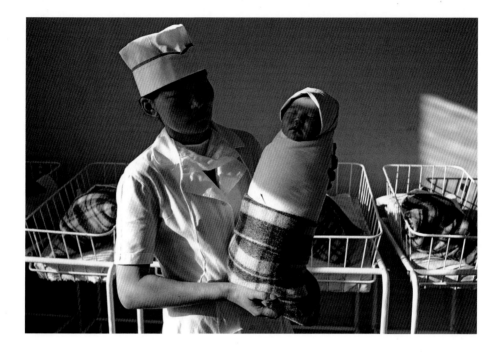

◄ **SAM ABELL    1984**
Pete Standing Alone, a Blood Indian, lifts his
six-month-old godchild into the air on the tribe's
reservation, Alberta, Canada.

▲ **DEAN CONGER    1985**
A tightly packaged infant is shown off at a
maternity hospital in Ulan Bator.

367

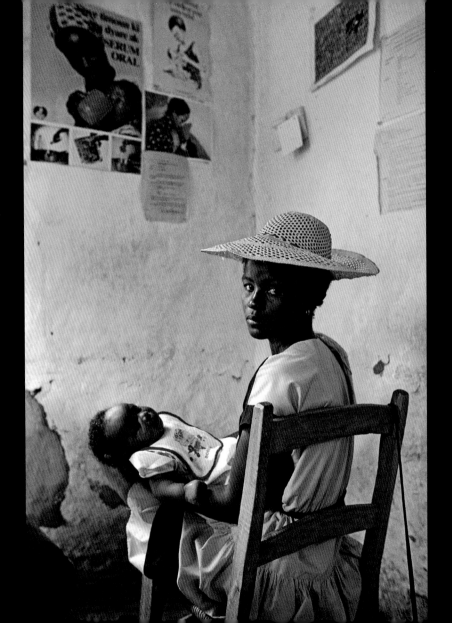

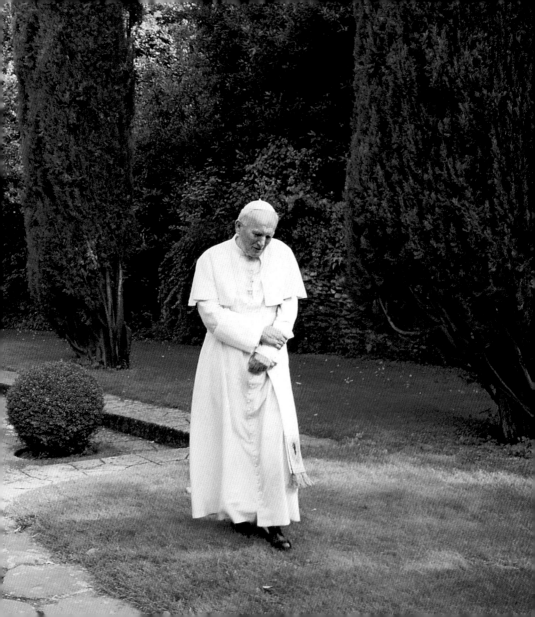

**TOMASZ TOMASZEWSKI 1988**

The Anderson family of Independence,
California, are proud of their more than
20 shotguns and rifles, and don't mind
being called rednecks.

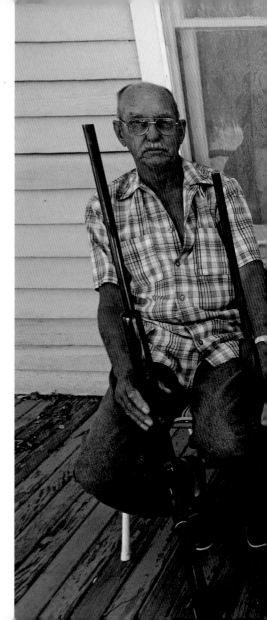

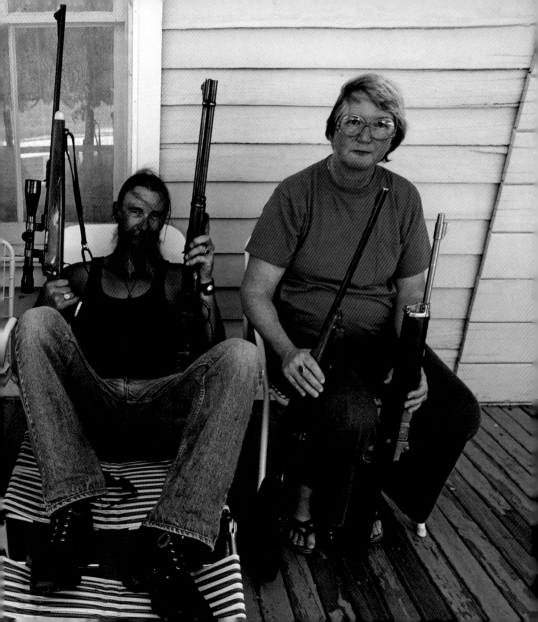

**WILLIAM ALBERT ALLARD    1988**
Model Tanya Pohlkotte with her partner,
who makes collages of old photographs
of Brigitte Bardot, Paris

**FOLLOWING PAGES:**
**◂ GERD LUDWIG    1981**
Artist Wolf Vostell, one of the founders
of the Fluxus Movement in Germany

**▸ SISSE BRIMBERG    1978**
After a pantomime performance at the Tivoli
Theater, Copenhagen, Denmark

"A taxi had come tearing down the road and hammered through the sheep, brutally flinging half of them off the road. . . . The driver never even stopped. But we did. As the boy looked up at me with his shattered face, I made just a few pictures because I had to. . . . More than $6,000 in contributions came in from readers from all over America. They wanted to help. The Geographic contacted CARE, and that organization was able to locate Eduardo. . . . His family's sheep were replaced, a water pump was provided for the village."

—*WILLIAM ALBERT ALLARD*

**WILLIAM ALBERT ALLARD    1982**
Peru

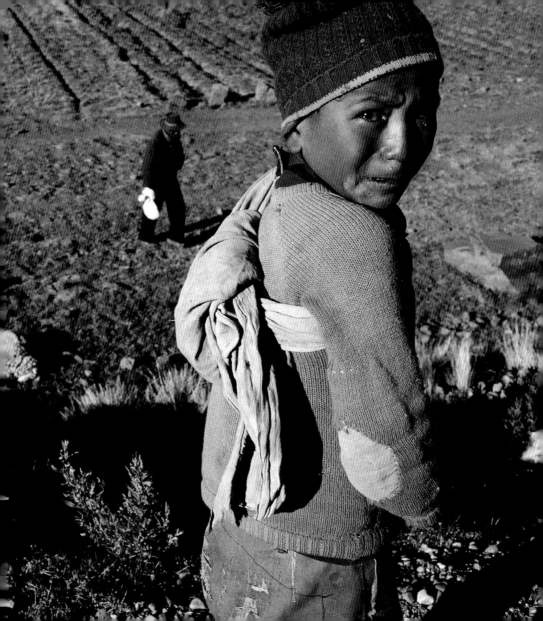

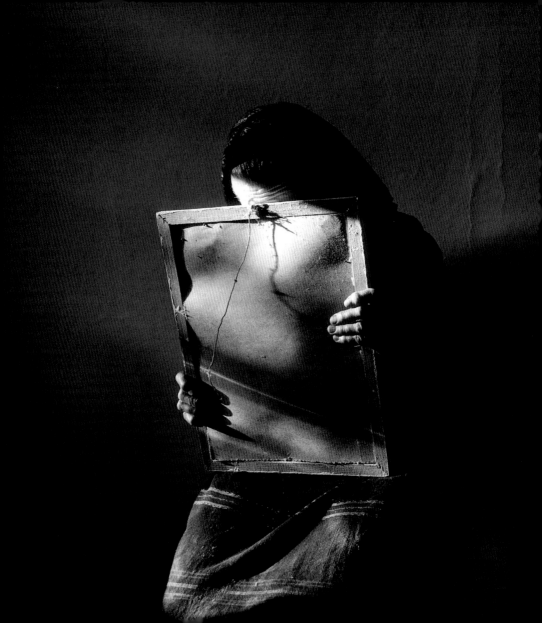

**FOLLOWING PAGES:**
**ELI REED    1989**
Medicine man, Malawi

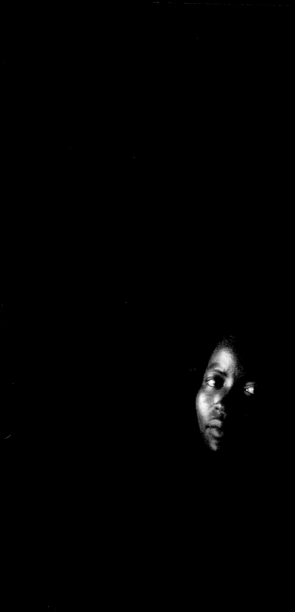

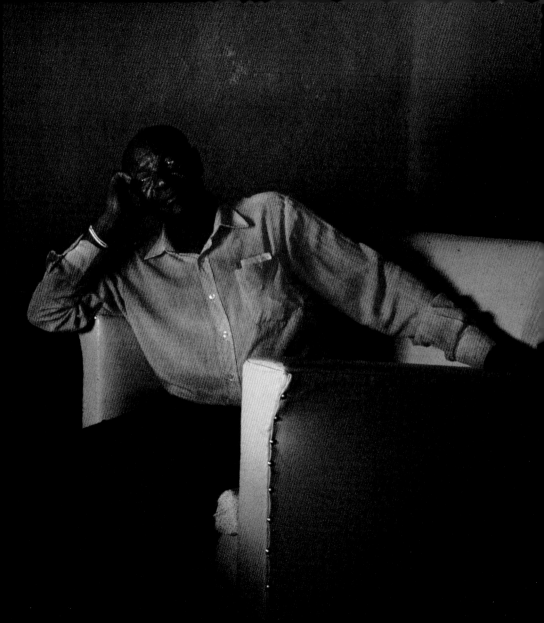

# People's everday outfits announce who they are, or would like to be. And special occasions and perform-

ances allow people like these gauchos to dress up even more. Through the years Geographic photographers have continued to seek out costumed subjects for the stories they tell—Penny Tweedie's pictures of Aboriginal boys wearing tribal makeup during their circumcision ordeal (pages 388-389); Carol Beckwith's Wodaabe tribesmen elaborately dressed to show off male beauty (pages 392-393); Sam Abell's more restrained but suggestive boy made up for a Japanese festival (page 391)—all exotic and informative.

But in unfamiliar cultures people clothed for daily life are often compelling enough. A veiled mother with her children at a local Saudi playground (pages 386-387) or an Ethiopian woman with lower lip stretched by clay plates were irresistible to Geographic photographers passing through. Paradoxically these declarations of identity can mask individual uniqueness, but the photographs stylishly deliver the cultural information National Geographic is famous for.

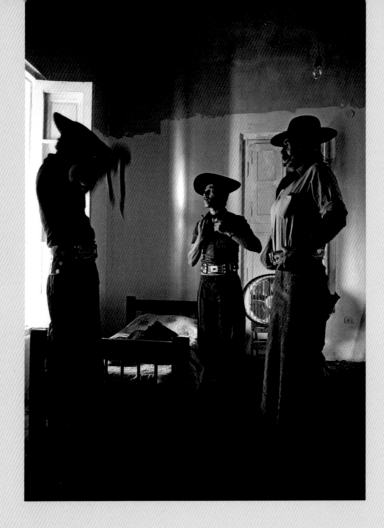

**O. LOUIS MAZZATENTA   1980**
Gauchos prepare for a rodeo in Argentina.

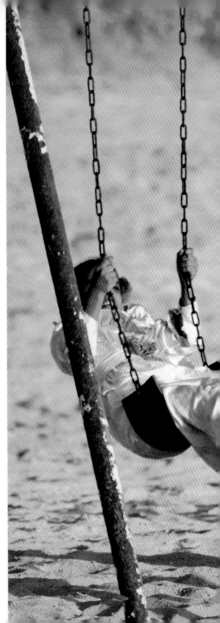

**JODI COBB    1987**
Arab girls and their mother on the
beach at Jiddah, Saudi Arabia

**FOLLOWING PAGES:**
**PENNY TWEEDIE    1980**
Aboriginal boys during circumcision rituals,
Arnhem Land, Australia's Northern Territory

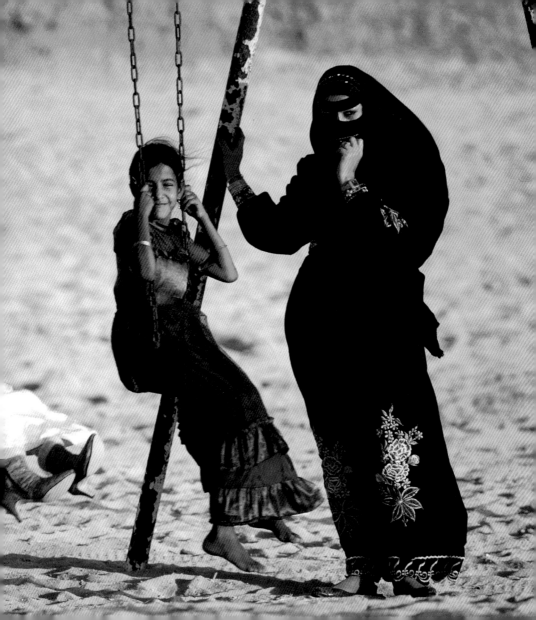

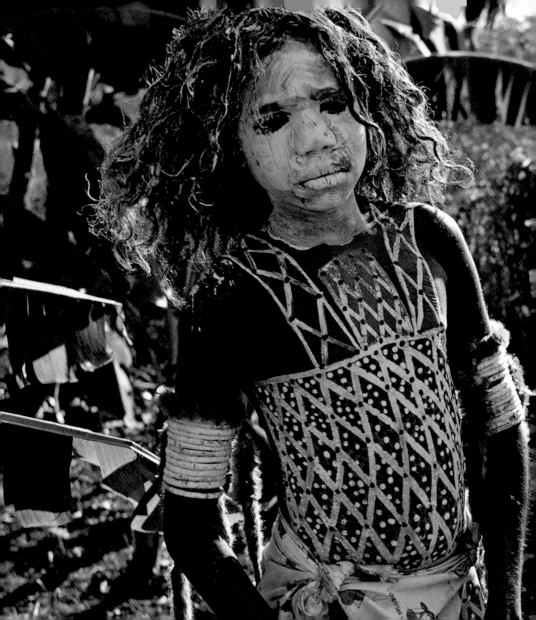

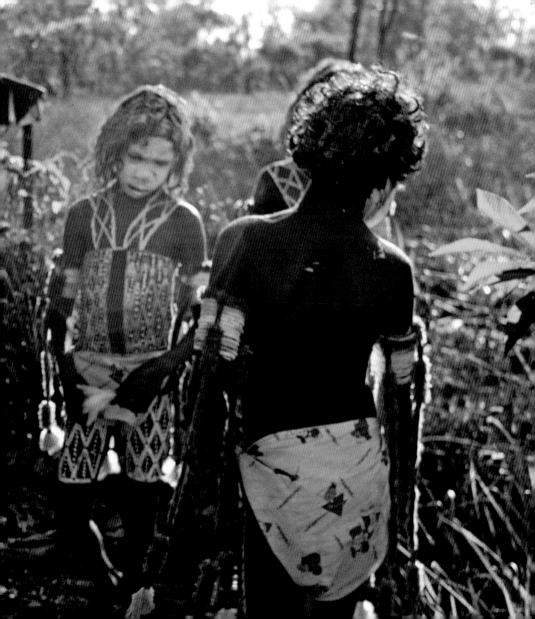

**SAM ABELL   1980**
Boy preparing for festival, Tamae Shrine,
Haji, Japan

**FOLLOWING PAGES:**
**◄ CAROL BECKWITH   1983**
Wodaabe tribesmen, Niger

**► CAROL BECKWITH   1983**
Wodaabe man in courtship dance

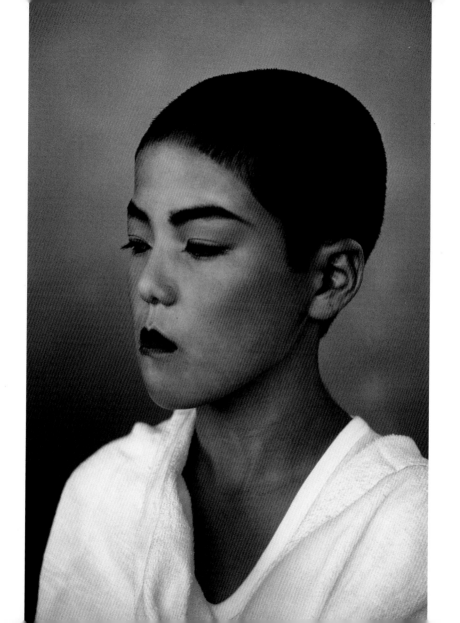

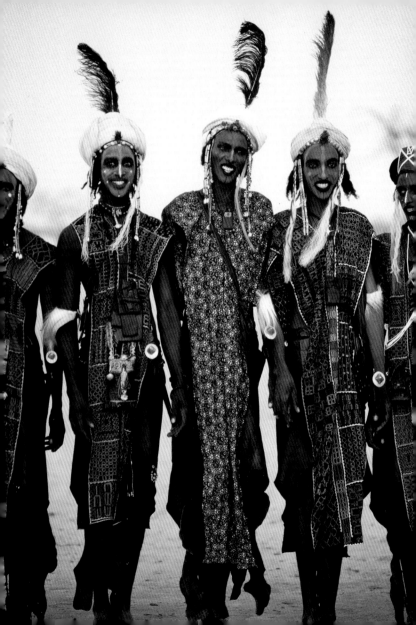

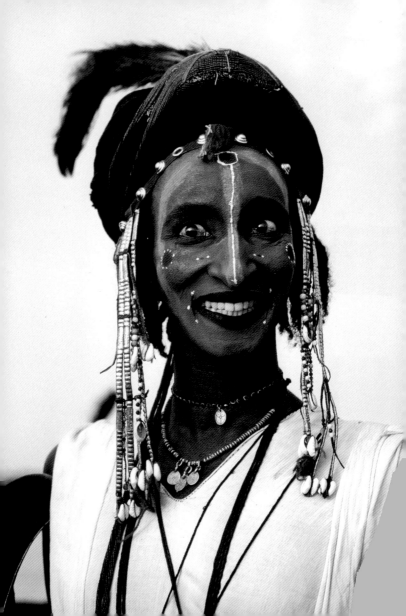

**CARY WOLINSKY   1979**
Wax busts of famous people are retired and stored in Madame Tussauds Wax Museum repository in Wells, England.

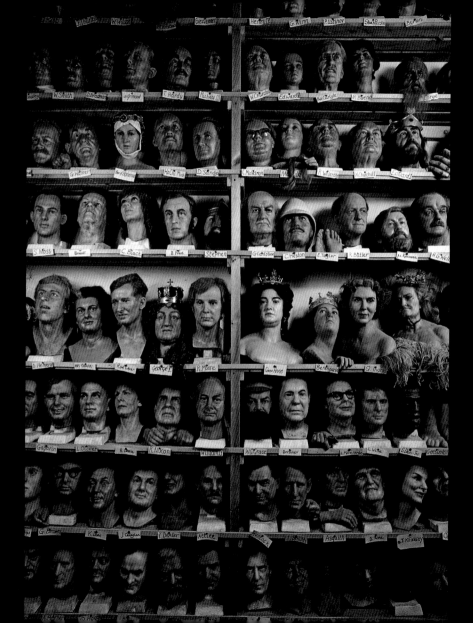

# This chapter finishes with portraits of two artists. Each is engaged in a pleasant, solitary activity.

The architect, César Manrique, reads at his home on Lanzarote, one of the Canary Islands off the coast of Africa. The colors and angular composition suggest something about Manrique's personality and work. He was not only an architect, but also a painter, sculptor, ecologist, and urban planner, a frugal man who wished to make the planet more beautiful.

Friedensreich Hundertwasser, soaking in his outdoor tub (page 398), claims it takes more than three days to walk the perimeter of his New Zealand property. Like Manrique he is a painter, but his paintings, no matter what the subject, are richly colorful. How very different Hundertwasser seems from Manrique. The way they are photographed tells us how to think about them and also makes the viewer almost forget that a photographer is present.

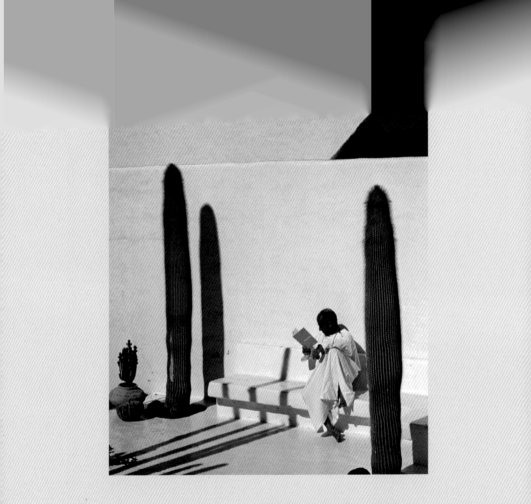

**GERD LUDWIG 1980**
Sculptor and architect César Manrique at his
house on Lanzarote, one of the Canary Islands
off the coast of Africa

# 6
# Photography and Ambiguity
## THE 1990s TO THE PRESENT

MY MOTHER TELLS ME A STORY ABOUT THE DAY MY father returned to San Francisco after surviving World War II, and walked into our living room. I was scared to death, and I cried. I was only two, but the large man with big hands who wanted to hold me wasn't really my father. Who was this man? I had been misled. For two years my mother had told me something else: fiction, a different story. She had told me a story about a little black-and-white photograph in a black wooden frame. She told me this picture was my father. It was a framed studio portrait of a young man in Navy uniform, a representation of reality, but in fact my only reality. My mother says I took this portrait to bed with me every night. To me, Alan B. Harvey was a picture. The big man back from war hovering over me was something else or someone else.

As I look across my living room right now, I see my father—the same picture. My father has gone again, this time never to return. He looks warmly out to me as I have my morning coffee—a representation, a portrait. From the time my father first tried to hold me and I cried, until he passed away three years ago, I photographed him many times: around the house, mowing the lawn, blowing out birthday candles, getting the mail, hugging my brother Gary on his wedding day. But it is this simple portrait, not artfully executed, that sits on my hutch and occupies a special place. On my walls are works of photographic masters: Allard, Abell, Nichols, Karsh, and Korda—great photographs by great photographers. But the little portrait of my father has a special place, because a portrait is very often an emotional trigger, which can be pulled to bring back the vignettes of memory. This picture is personal, a family portrait, with meaning only for the family.

FAST FORWARD 50 YEARS FROM THE DAY MY FATHER returned. I see another portrait, this time on the cover of *National Geographic* magazine. This time, of someone I have never known and will never know, someone with whom I have absolutely no emotional connection, someone known and photographed by William Albert Allard, but unknown to me. But I love her. She has beautiful red lips and a sad sensuality. She is in mourning, or, as it turns out, only represents mourning, for she is an Italian actress. A black veil partially obscures her features, adding to the mystery. Her porcelain skin intensifies because of her red lips, which provide the only color in the photograph. She is at once beautiful, sad, and longing, and she pulls me in. How can I become so emotionally attached to a portrait of a woman who is so many layers away from any reality or connection with me personally? For just that reason alone. Portraiture pulls us in, leads us, leads

us into ourselves by being a reflection, a mirror into ourselves—strangers but friends. Is it the eyes? Why do we want to look at faces? What do we see? Are we looking into a mirror or looking at a map? Is it curiosity, or do we want to create our own fantasy with the person we are "viewing"?

FOR THE PHOTOGRAPHERS AT NATIONAL GEOGRAPHIC the world is a kaleidoscope of sights, smells, feelings, emotions, formidable barriers, and personal nuance. Like everyone else, in a lifetime surely we all have seen literally millions of faces. We probably have made eye contact with many thousands of people, studying for a moment their faces, fascinated in a way, trying to figure something out about the person in a millisecond. Taking a picture in our mind. People-watching. Usually discarding the mental image quickly, but often hanging on for some time. When police interview the witness to a crime it is considered concrete and damning evidence if a person can identify the face of someone he or she saw only for a second. Unbelievably, we usually do remember faces. Not names, just faces. Each of us must have thousands of faces catalogued in our brains. The photographic portrait takes this one step further and locks it down for all time.

National Geographic photographers document landscapes, industrial scenes, science labs, religious ceremonies, daily lifestyles, and often most memorably, people. Not famous people or politicians, which are the lifeblood of most magazines, but just ordinary people: unknown people, the family next door, the family next door to the family next door. So why do the readers of *National Geographic* want to see a portrait of someone they do not know, will never know, and who isn't famous or movie-star beautiful or handsome? Because in the lines of a face, in the twinkle of the eye, in the graceful flow of the hair, we see the most incredible thing on Earth: recognition of ourselves and of our species, confirmation of our own human beauty and identity. We experience a visual dialogue within our own minds about the special nature of mankind.

Look at the little girl in the red jumper, sweetly sleeping on a flower-patterned sofa (pages 424-425). There is no event taking place here. There is nothing "happening." There is no journalistic significance. Most of us would see the girl asleep, perhaps smile at the innocent serenity, and move quietly past. For National Geographic's Sam Abell, there was a picture to be made. Once Sam made the photograph, we all see it as a photograph, but until his unique vision motivated him to actually pick up the camera and compose and make a photograph, there was no photograph. There wasn't necessarily even the subject for a photograph.

Even another master photographer might have passed this particular moment by. A photograph of this little girl is significant only because Abell made it significant with his style, his light, his composition, and his insight. This is obviously very different from a portrait of John F. Kennedy taken by an amateur, which would have power just because of JFK's fame. His personality would "carry" the picture. It would be a different kind of portrait, powerful for a different reason. A picture of Kennedy by Abell would have theoretically even more power. The now famous portrait of Winston Churchill by Yosuf Karsh has the power of the subject and the photographer rolled into one.

So which is more important, the skill of the photographer or the subject represented? For National Geographic photographers, for sure, it is singularly the skill of the photographer. For they photograph the "unknown" personalities. For world-renowned photographer Annie Leibovitz, surely it is the fame of her subjects combined with her own artistry. We love a photograph by an Abell or an Allard because of what they bring to the subject. We love a Leibovitz photograph because she brings her vision to an already famous person. Could Leibovitz bring her vision to the ordinary person, and could Allard bring his vision to the famous? Probably. But the sensibilities are different for different photographers. As with all artists, the motivations are unique to the individual. The reasons that photographers are all different from each other are as varied as the people they photograph.

In all of the arts, the leading edge of sophistication moves forward. In the arena of publishing for a mass audience, what may have been considered a "good" portrait ten years ago may fairly or unfairly be considered old-fashioned today. A mass audience is a fickle audience. In the world today, where imagery literally bombards us, it often takes something truly unique to catch our eye. Magazine editors constantly have to try to adjust their magazine both for what they feel their readers want and for what they feel their readers ought to know or see. It is, quite simply, responsibility combined with gut instinct. But it is always the fire-in-the-gut instinct that makes a great photographer or a great editor. For any artist who puts something down for others to witness—musician, filmmaker, painter, writer, or photographer—the sensibility for creation has to come more from the heart than from the intellect. The portrait artist must intellectualize the situation to some degree, but the essence of the actual creation comes from instinct. Abell knew nothing about the story, but it was his artistic sensibility that drove him to make the simple, but forever in our minds, picture of the little girl on the sofa. Could anybody have taken that picture? Yes, anybody could have. But only one person did.

IN MY OWN WORK, I RARELY SHOOT CLASSIC PORtraiture. I have never considered myself a portrait photographer. There was even a time when I disdained the classic studio portrait. I had worked in a portrait studio as a high school student, and

realized early on that being a professional portrait photographer was not for me. Later, when I became familiar with the portraiture of Karsh, Avedon, Penn, and other masters, I came to realize that portraiture, like other forms of photography, totally depended on who was doing the work. The masters added something, brought something to the table, put themselves into it, just like portrait painters da Vinci, van Gogh, and Gauguin.

But I prefer instead to meet people and personalities in an environment, what we call street photography. I love people. I love photographing people most of all, and in their natural, familiar setting. My subjects are often not expecting to be photographed at all. I want something spontaneous, something natural, something revealing.

IN 1995 I DID A STORY ON THE WYETHS, THE FAMOUS family of American painters. My assignment was to capture the essence of each personality in the family, with Andy as the central figure. I wanted to shoot the Wyeth piece in black and white, for two reasons. One, to set apart the Wyeth family portraits from their paintings, since I felt that my normal slide-film color palette would clash with the Wyeth brush tones on the printed page. Two, I thought that black and white would give the story a "look," and prop up the paintings in their monochromatic splendor.

The Wyeth family, in addition to to being influential painters, have a strong theatrical streak. Andrew, always a practical joker, would show up at social events wearing a variety of costumes. So did the rest of the family. Andy always wanted to play. Photographing him became a game. He loved it. Once I realized I was part of a game, my pictures became better. The picture of Andy in the window with his hand up (page 414) is a total set-up, a set-up by Andy. He moved toward the screened barn window. As soon as he did this, I knew he expected me to take a picture. And I did. I was inside, but I quickly saw the picture was from the outside. I ran outside, out of breath. Focus, focus. Andy, don't move now. A few frames, and Andy was gone.

I love getting "inside" another person or another culture, finding out what "makes them tick" and then using photography to reflect or interpret their being. It is, of course, always subjective. But my wish is to make it subjective with heart.

SO WHO TOOK THE PORTRAIT OF MY FATHER? SURELY IT was an unrecognized "crank 'em out" portrait photographer in San Francisco. Would I value the picture more if Allard or Abell or Leibovitz or Karsh had taken it? No, of course not. So in the end, a portrait is mostly about the person in the picture. My father lives on in many ways, mostly for his deeds, his life, his influence. The small framed portrait is an object that had little value when it was taken and is priceless now, perhaps just for me. The portrait in my disheveled living room is just the key to the door of memory.

—DAVID ALAN HARVEY

405

# Photographers, editors, and the public long assumed a photojournalist's job is to show up

and record what's there. Yes, some see more than others and are more talented with a camera, but facts are facts, and even if we know photography is subjective we can't help relying on photography's eyewitness reports to form our judgments about the world. Today's photographers question the possibility of objectivity and hint at their working methods by showing us how their pictures do both more and less than deliver data.

The choice of what to photograph and how to present it starts in the field, and photographers may come back with different stories about the same subject. A photograph begins with the act of framing, and the choices of what to include in each frame are infinite—as uncountable as human activity and shifts of camera position allow. On these pages the framing of pictures is thoughtfully considered by Jim Richardson in Scotland, Lynn Johnson, Sisse Brimberg, and Gerd Ludwig in Russia, Sam Abell in Ireland, and David Alan Harvey in the United States.

**JIM RICHARDSON    1995**
A street performer makes a call, Edinburgh, Scotland.

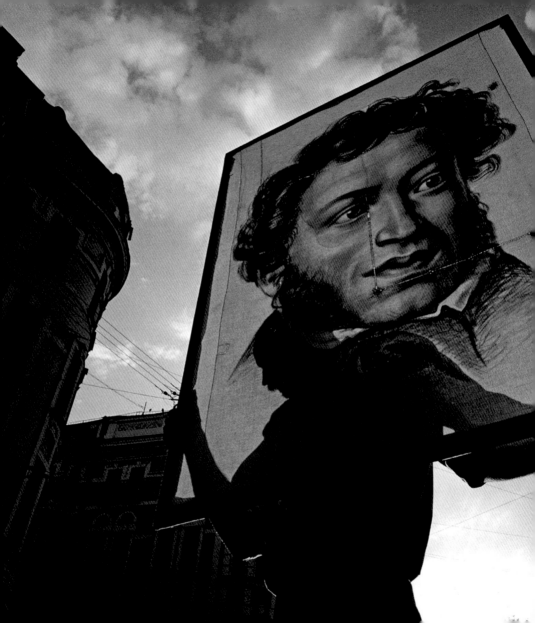

**LYNN JOHNSON 1992**
A portrait of the beloved Russian poet Pushkin in St. Petersburg

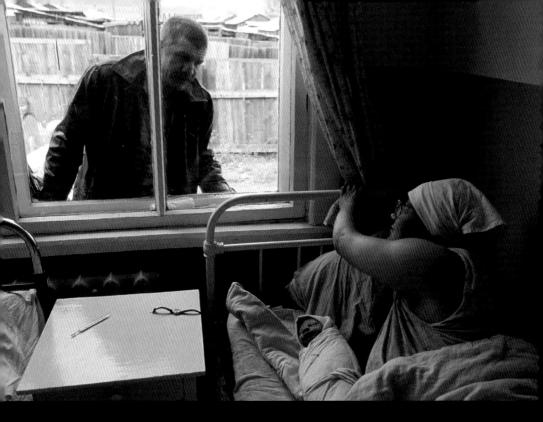

410

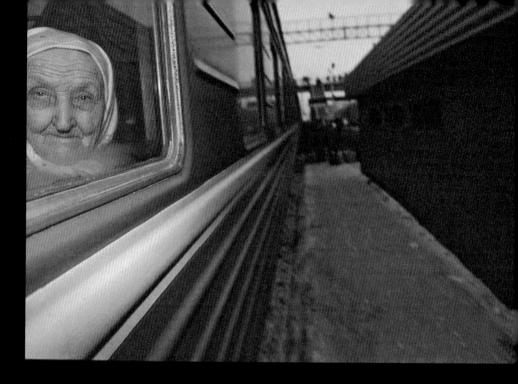

◄ **SISSE BRIMBERG** **2002**
In Siberia, a father speaks to his wife through a window
because men are not allowed into the maternity ward.

▲ **GERD LUDWIG** **1997**
Trans-Siberian Railroad

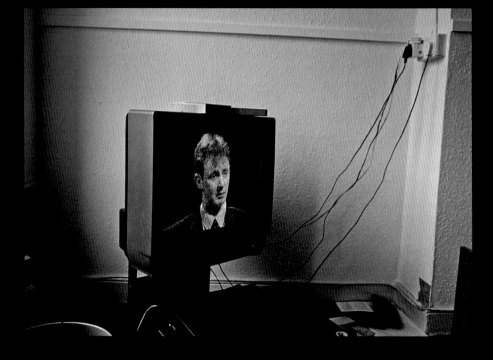

▲ **SAM ABELL   1993**
Husband and father of IRA bombing victims is
interviewed on television, Belfast, Northern Ireland.

▶ **GERD LUDWIG   1991**
Communal apartment in Moscow

412

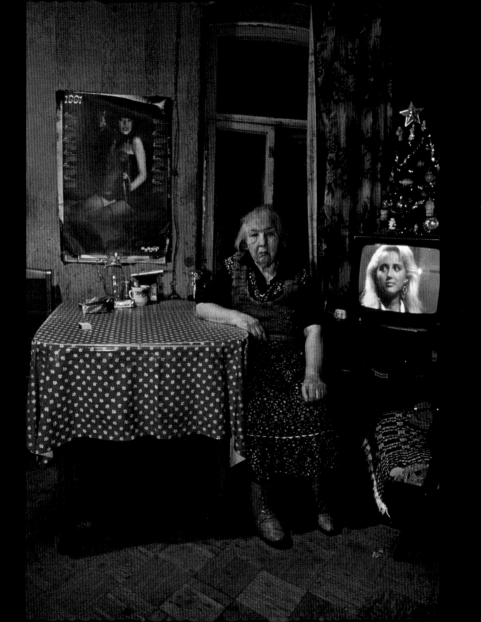

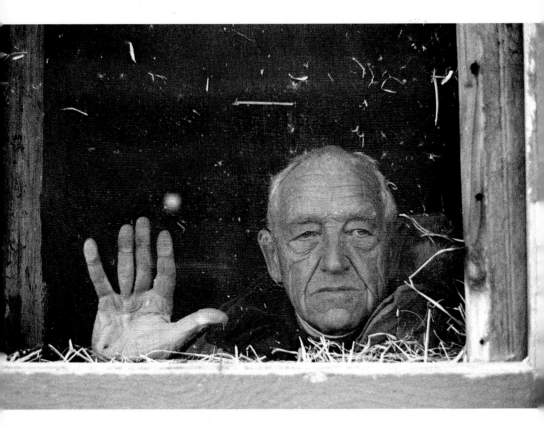

**DAVID ALAN HARVEY    1991**
Artist Andrew Wyeth, Chadds Ford, Pennsylvania

414

"Andy always wanted to play. Photographing him became a game. He loved it. Once I realized I was part of a game, my pictures became better. The picture of Andy in the window with his hand up is a total set-up, a set-up by Andy. He moved toward the screened barn window. As soon as he did this, I knew he expected me to take a picture. And I did. I was inside, but I quickly saw the picture was from the outside. I ran outside. . . . A few frames, and Andy was gone."

**—DAVID ALAN HARVEY**

# Can a portrait reveal the essential character of a person? Can a photograph deliver the full

fact of any matter? The picture by Nicolas Reynard, in addition to showing a man in Brazil's Amazon Basin trying on a ceremonial mask made from strips of bark, seems to be a not-so-subtle statement that the camera conceals at least as much as it reveals.

By blending foreground with background and lingering on paint, masks, screens, and veils, photographers skillfully and playfully make the point with enchanting results—Reza's monumental woman sitting in a Tripoli airport shrouded in white, Joel Sartore's masked waiters at a wine festival in Sun Valley, and Carnival scenes by David Alan Harvey and Sam Abell live up to journalism's mandate to deliver information and then go further. There's something about the unsolved mystery in these photographs that makes us want to return to them again and again.

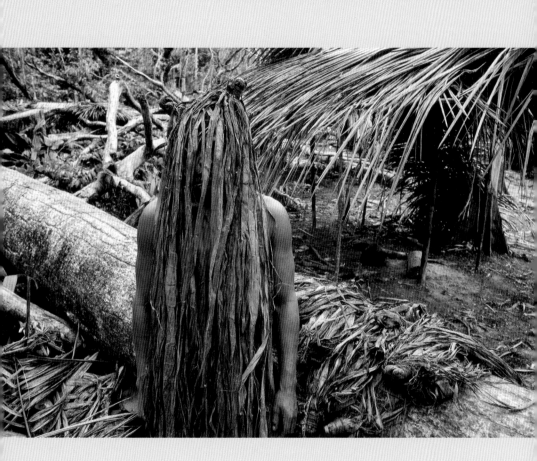

**NICOLAS REYNARD   2003**
An Amazonian tribesman tries on a ceremonial mask made of long strips of tree bark.

417

An Australian youth swims in a billabong, or water hole, in Cape York, Australia.

"One torrid day I accompanied a group of young Aborigines to a pond where they jumped and splashed, stirring the clay on the bottom of the pond. One of the young men, Trumain, spontaneously gathered a handful of the clay and began to smear it on his arms and face, as Aborigines have done for millennia. I felt the sudden revelation of looking into a face and seeing deeply into racial memory. I stepped toward Trumain and made several swift portraits before he swam off. It was only a moment but it was authentic—intense and intimate. But timeless? Only the decades will tell."

*—SAM ABELL*

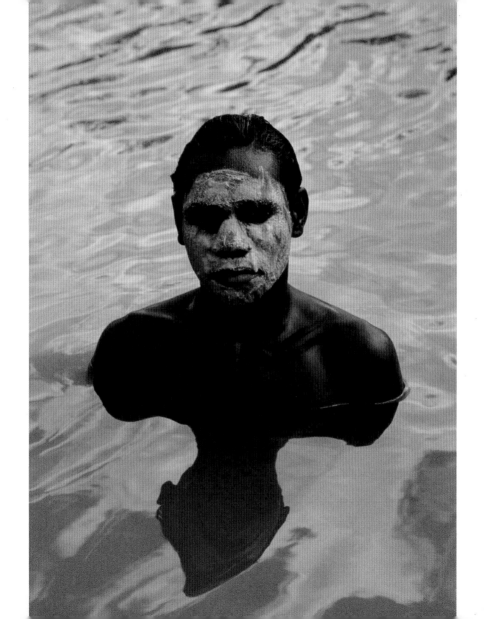

**REZA   2000**
An Islamic woman in the Tripoli, Libya, airport

**JOEL SARTORE    1994**
Schoolgirls at Deer Spring, a Hutterite
community in Connecticut

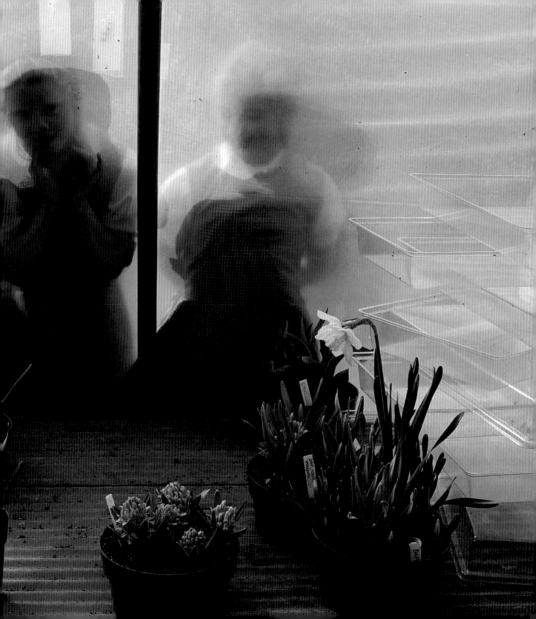

"Look at the little girl in the red jumper sweetly sleeping on a flower-patterned sofa. . . . There is nothing 'happening.' There is no journalistic significance. Most of us would see the girl asleep, perhaps smile at the innocent serenity, and move quietly past. For National Geographic's Sam Abell there was a picture to be made. Once Sam made the photograph, we all see it as a photograph, but until his unique vision motivated him to actually pick up the camera and compose and make a photograph, there was no photograph. There wasn't, necessarily, even the subject for a photograph. Even another master photographer might have passed this particular moment by. A photograph of this little girl is only significant because Abell made it significant with his style, his light, his composition, and his insight."

*—DAVID ALAN HARVEY*

**SAM ABELL 2000**
Seattle, Washington

424

**KENNETH GARRETT    1994**
Museum of Egyptian Antiquities,
Cairo, Egypt

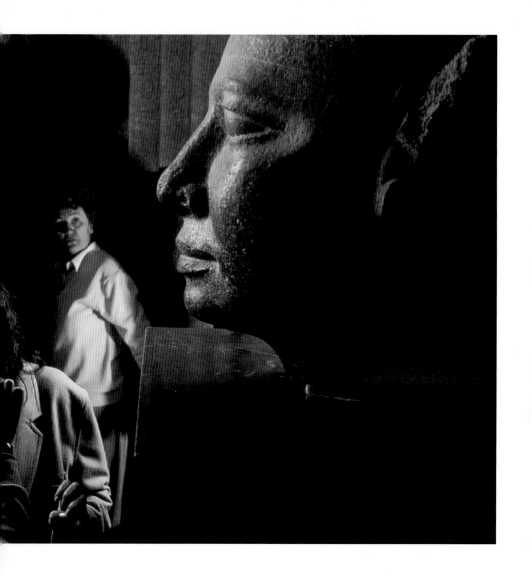

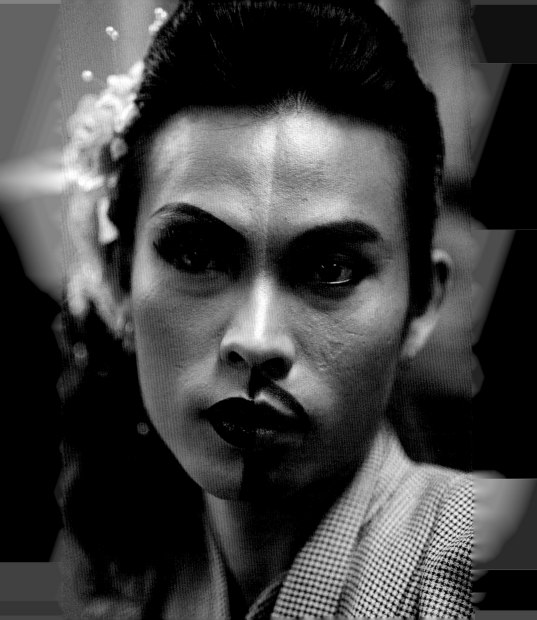

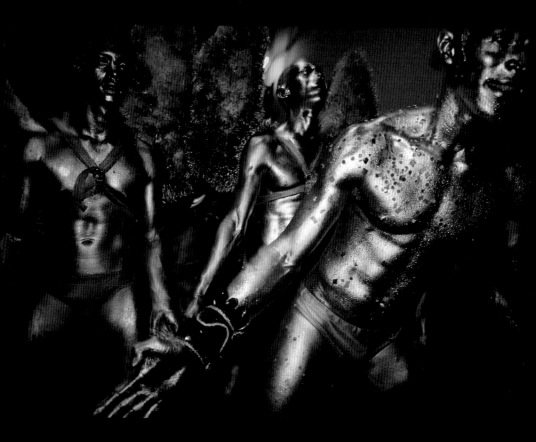

◄ **JODI COBB  1996**
A transvestite performs in a cabaret in Thailand.

▲ **DAVID ALAN HARVEY  2002**
Painted dancers in a Carnival parade, Brazil

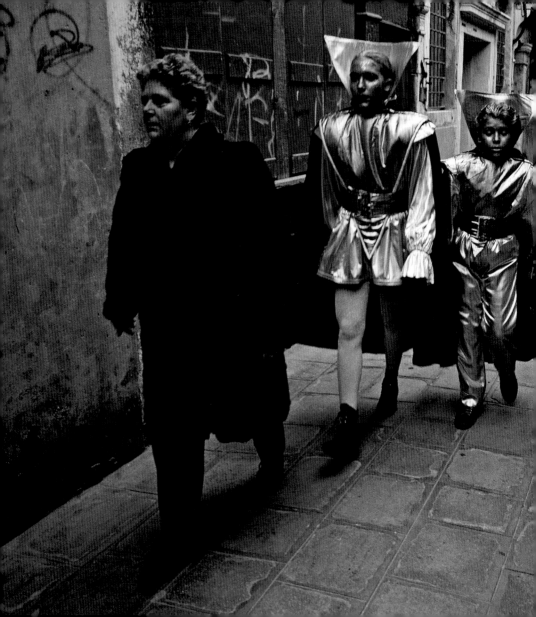

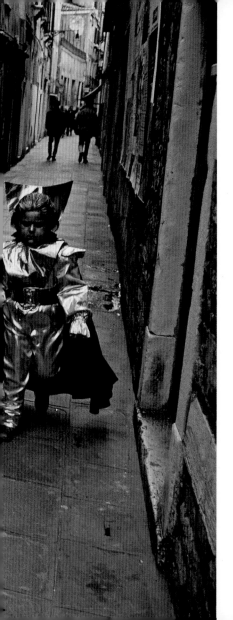

Revelers on their way to Carnival, Venice, Italy

**Attentive** viewers of portraits, noting small gestures recorded by quick photographers, sense things about the people pictured that go beyond data. A personality might be portrayed to a surprising degree by the tip of a hat, a head thrown back laughing, an unexpected touch, an erect posture or a bent one. A telling portrait, even without showing a full face, can remind us of something we already know about human nature.

Ed Kashi's woman smoking her cigarette on a Beirut beach (page 435) looks a bit tough somehow, while his picture of a Zulu mother guiding her little boy seems tender (page 459). Gerd Ludwig's Russian bather with arms raised (page 438-439) looks joyful. A gaze, a tilt of the head, and a kissed hand reveal a moment of love between a couple at a restaurant table that obliterates everything around it (page 454-455). Gestures in photographs can be adamant or barely discernable. A photographer felt it, and then we do.

**DAVID ALAN HARVEY    1991**
Dewey Williams, shape-note singer
of Sacred Harp, Ozark, Alabama

433

**JODI COBB    1998**
A family in the Omo Valley, Ethiopia

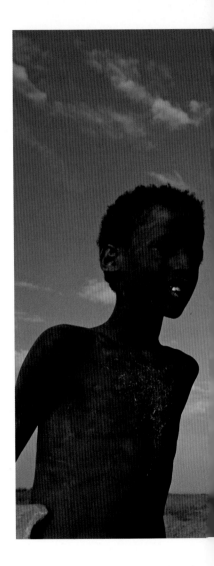

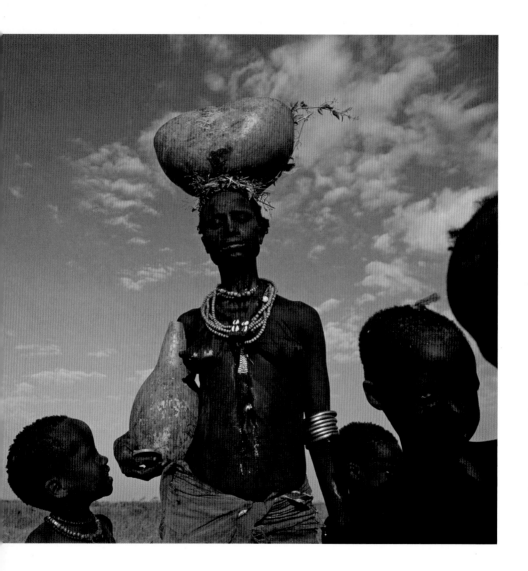

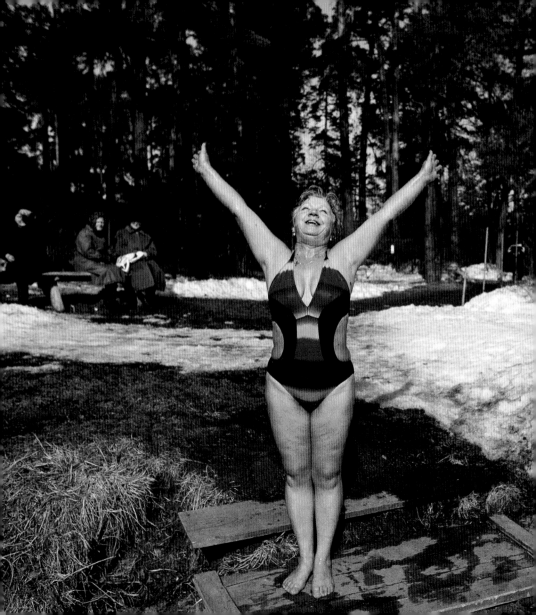

Family in Lagos, Nigeria

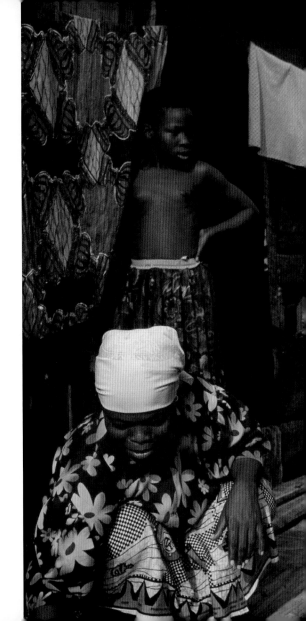

**WILLIAM ALBERT ALLARD   2003**
Amrutbhai Sarasiya earns his living cleaning
sewers in Ahmadabad, Gujarat state. He is a
Bhangi, a member of a scavenger caste—lowest
of hundreds of India's Untouchable castes.

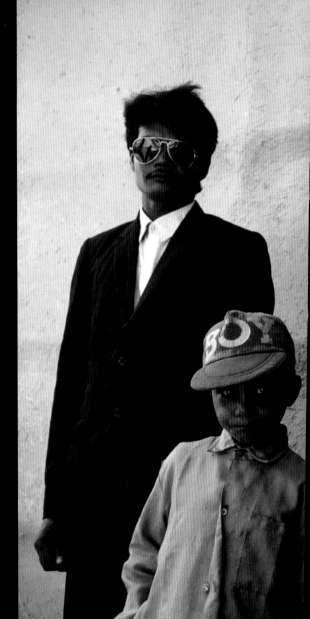

Ram Putri, like most of Nepal's Rana
Tharu women, clings to tradition,
though her husband and children
have adopted Western dress.

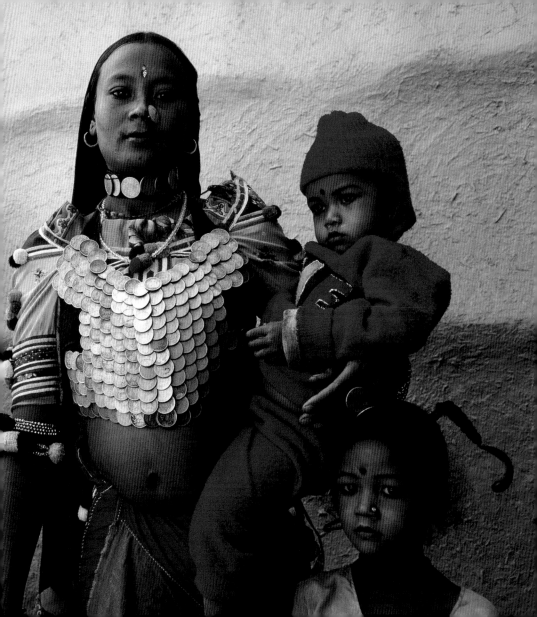

**STUART FRANKLIN   2003**

Albanian family in Greece

446

"This is Antonis Skiaou with his wife, Rosetta, and their child, Orestes. They're an Albanian family living in Koropi, a suburb of Athens. In 1995 Antonis walked to Greece from the northern Albanian town of Skodra. He has been working for eight years at a factory that equips large vans with electronics. The family lives in a room connected to the factory and are forced to endure the sound of a metal-cutting circular saw. Their dream is to get a place of their own. They calculate it would take them 30 years to save up enough to buy a small house."

—*STUART FRANKLIN*

**MAGGIE STEBER  1995**

A French tourist plants a kiss on Henry
Lambert as he poses for tourists, Cherokee,
North Carolina.

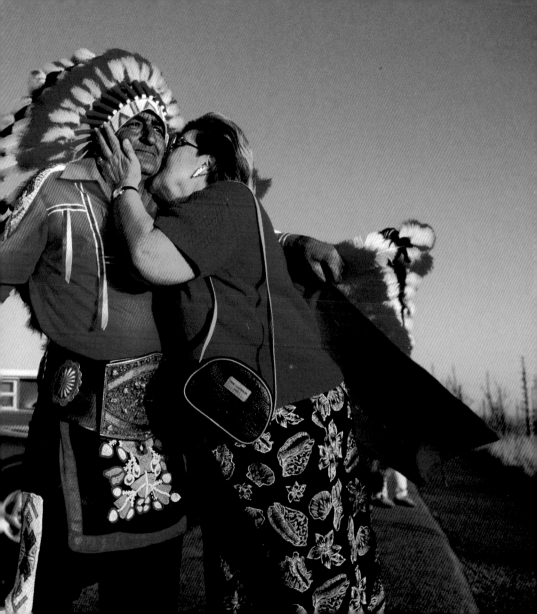

**MARIA STENZEL   1992**
Michael Esposito and his fiancée like having
not much to do in the Catskills.

**GERD LUDWIG   1994**
Teenagers hang out at the
annual Pfingstmarkt, a local
festival with rides, dances,
and food, Alsfeld, Germany.

**GERD LUDWIG   1994**
Teenagers hang out at the
annual Pfingstmarkt, a local
festival with rides, dances,
and food, Alsfeld, Germany.

**FOLLOWING PAGES:**
**SISSE BRIMBERG   1991**
Lunch at a restaurant in French
Montreal

**JODI COBB    1999**
A young woman pauses for coffee and reflection in London, Europe's magnet for the young, hip, and hopeful.

**FOLLOWING PAGES**
**◄ STEVE MCCURRY    1995**
Paduang women in Burma wear stacks of brass rings once believed to protect against tiger attacks.

**► ED KASHI    1998**
Zulu mother and child

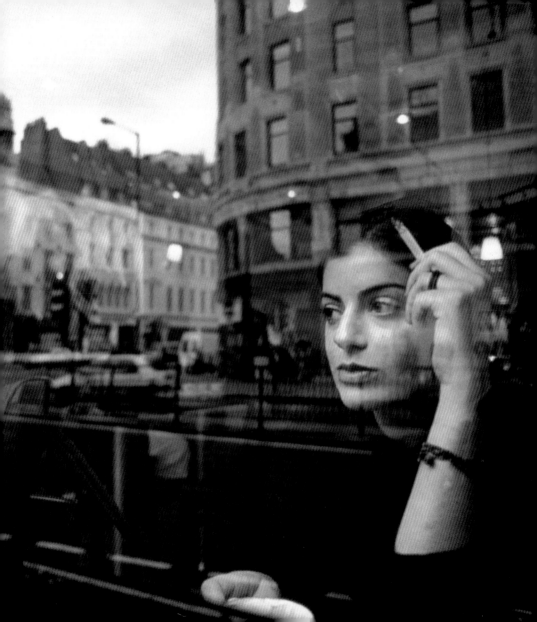

# Portraits affect us when we experience an intimacy with the subject. Photographers deliver

intimacy when they get in close physically and engage the person they are photographing directly, without inhibition as Jodi Cobb did in her portrait of a model (pages 462-463). But getting in tight isn't the only way to engage a subject. The hard-won prize of an intimate portrait comes to those with skill, patience, and talent: Jodi Cobb first had to get inside forbidden worlds to photograph Saudi women and Japanese geishas (pages 476, 477). Once inside, she had to gain the trust of her subjects. But she would not have photographs, finally, without her sensitive eye and openness to possibility.

Robb Kendrick made his beautiful portrait of freckle-faced Josh (page 469) using an old, obsolete photographic process called tintype. Because it's so slow, tintype calls for subjects who will commit almost as much time and energy to a picture as the photographer does. Kendrick spends time getting to know his subjects, telling them the history of tintype, and involving them in producing their photograph. The intimacy of their collaboration mysteriously involves us, too.

**MICHAEL NICHOLS   RECEIVED 1994**
Nemeye Alphonse worked at Dian Fossey's
gorilla research center in Rwanda for 26 years.

461

**JODI COBB   1998**
A model has her hair styled before a fashion
show in New York City.

**FOLLOWING PAGES:**
**MICHAEL YAMASHITA   2003**
The home of Wang Youshen and his wife,
Wang Yulian, was carved out of the fortifi-
cations of the nearby Great Wall of China.

462

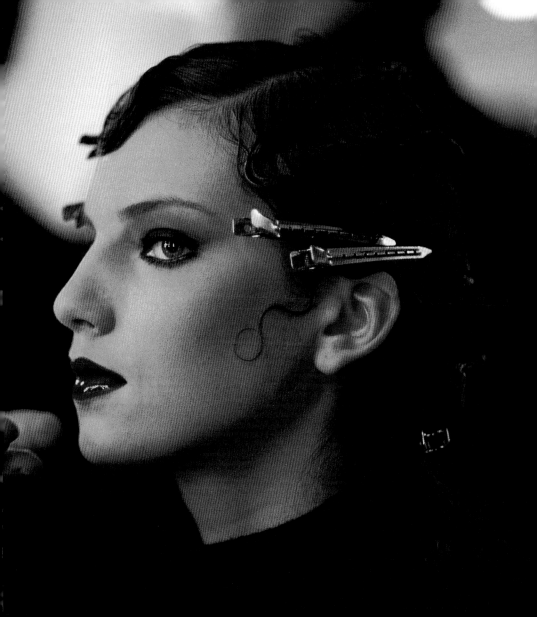

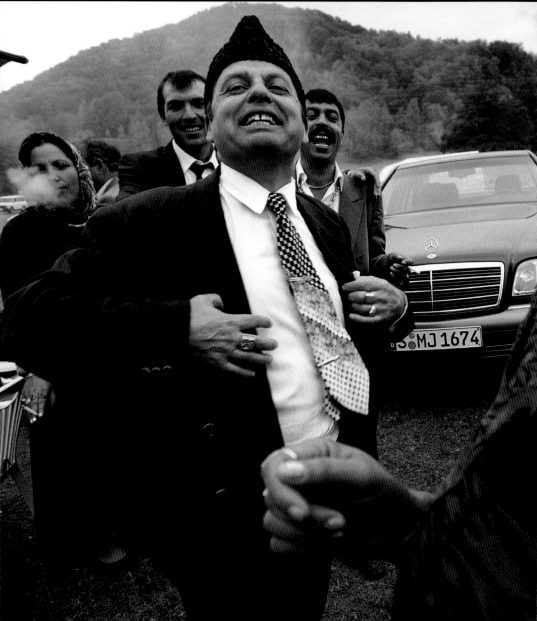

**ALEXANDRA AVAKIAN    1998**
Gypsies in Romania enjoy a hearty laugh.

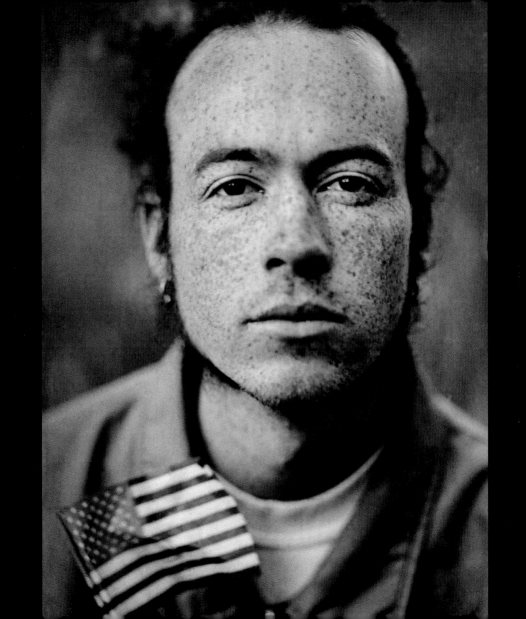

**JOEL SARTORE   1991**
Bourbon Street, French Quarter,
New Orleans, Louisiana

**FOLLOWING PAGES:**
**JODI COBB   1998**
Simbu men prepare for the dance at the
annual tribal sing-sing festival at Garoka,
Papua New Guinea.

470

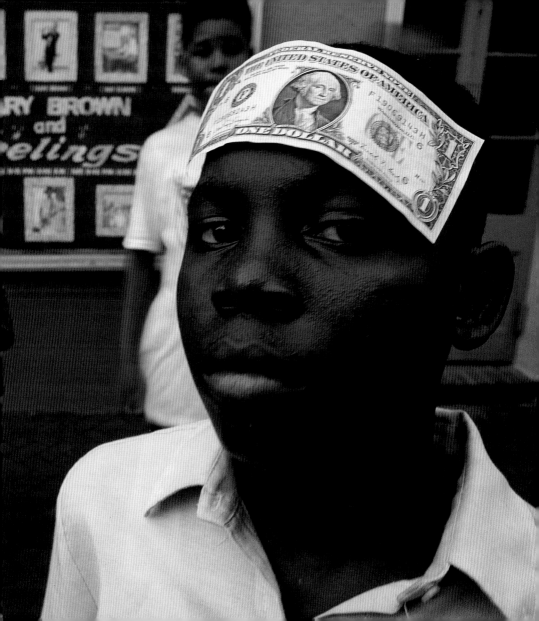

"I have never known [her] and will never know [her]. But I love her. She has beautiful red lips and a sad sensuality. She is in mourning, or, as it turns out, only represents mourning, for she is an Italian actress. A black veil partially obscures her features, adding to the mystery. Her porcelain skin intensifies because of her red lips, which provide the only color in the photograph. She is at once beautiful, sad, and longing, and she pulls me in. How can I become so emotionally attached to a portrait of a woman who is so many layers away from any reality or connection with me personally? For just that reason alone: Portraiture . . . leads us into ourselves . . . ."

*—DAVID ALAN HARVEY*

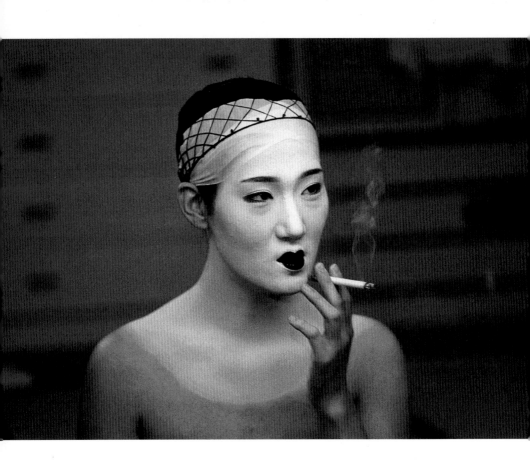

▲ **JODI COBB  1995**
A geisha takes a break during her long makeup session.

▸ **JODI COBB  1995**
Two geishas relax between performances in Kyoto, Japan.

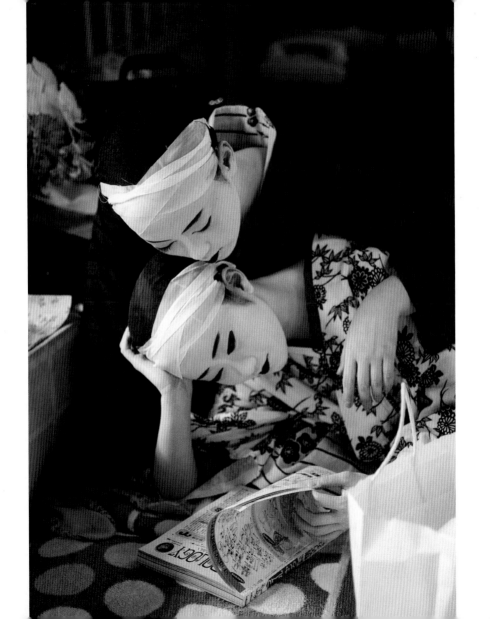

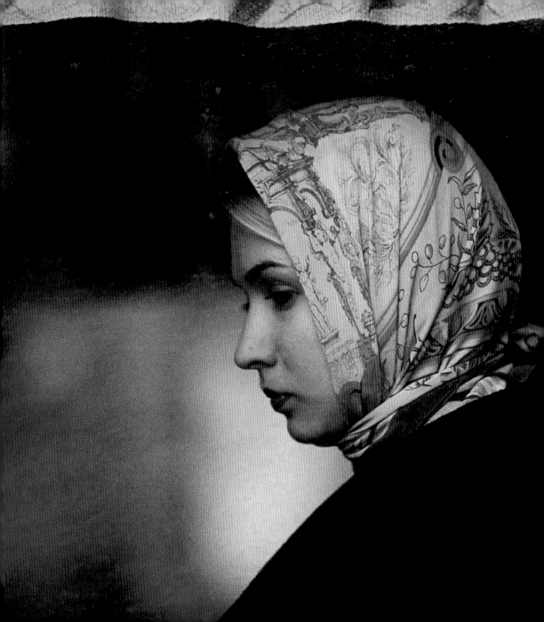

GERD LUDWIG    2002
Slavic beauty, Norilsk, Russia

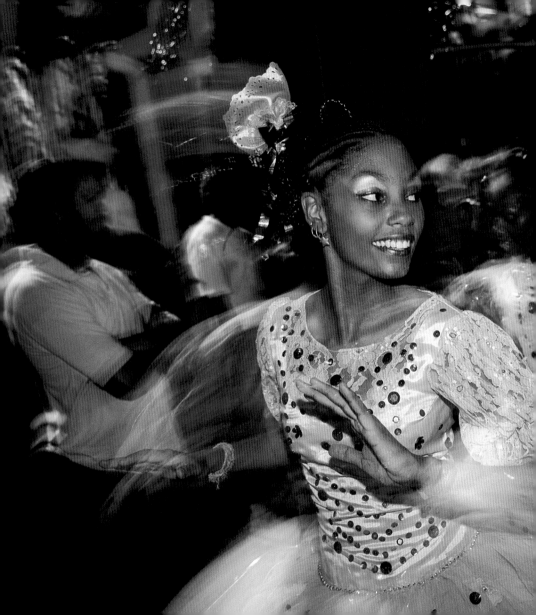

The joy and energy of Carnival inspire
a dancer in Salvador, Brazil.

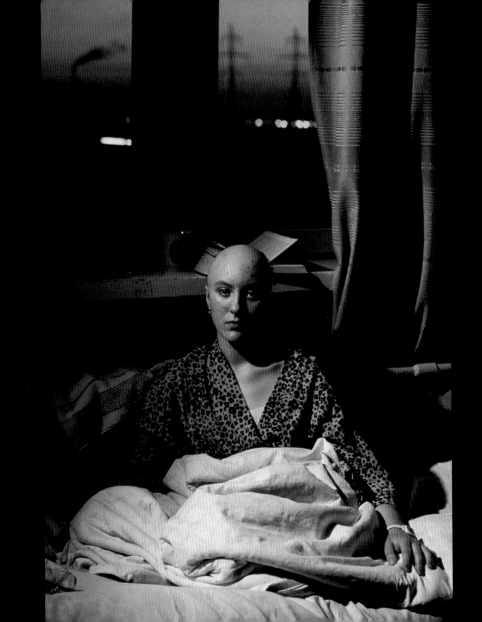

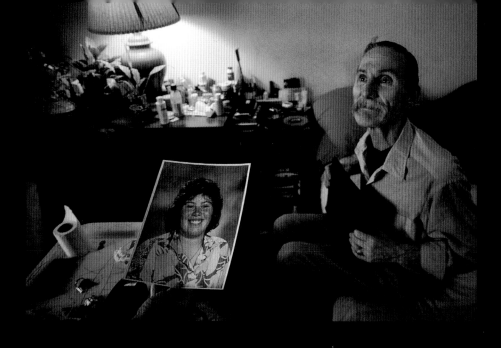

◄ **GERD LUDWIG   1993**
Cases of baldness among children leave Ukraine's
medical profession baffled.

▲ **KAREN KASMAUSKI   1994**
David Castagna, dying of AIDS, with a picture
of his daughter, San Francisco

483

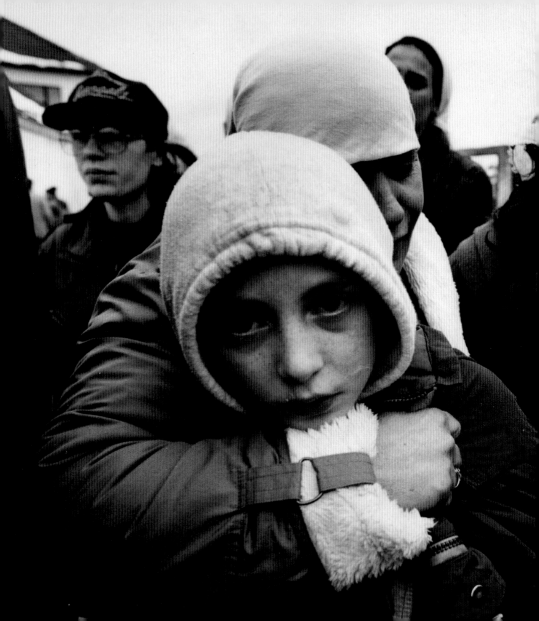

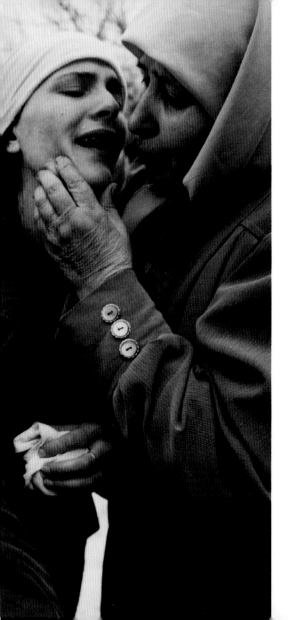

In 1999, villagers in Kosovo grieve for their dead.

**A photographer** can fall into the trap of judging a picture by the degree of difficulty it took to get it. Suppose he or she endured extreme weather conditions, hostility, rejection, pain, and exhaustion to track down an elusive or rare subject. Even if the result is mediocre the photographer might rightfully prize it. But if a picture doesn't communicate in some distinct and personal way it won't stand the test of time. Some subjects are easier to photograph than others: Cute, easy-to-photograph children ironically often yield poor portraits. Their uncomplicated sweetness, perfect for one-look greeting cards, leaves little for imagination and memory. Richard Olsenius overcomes this problem by presenting his boy on horseback in black and white, creating an elegiac mood; Joel Sartore does it by giving his two boys toy weapons (pages 488-489), a slightly surreal feeling that mildly suggests the photography of Diane Arbus. Alex Webb's complex, layered photograph of Brazilian children playing on an Amazon boat (pages 490-491) masterfully and deeply conveys the exuberance of childhood. Identical twins in identical postures (pages 494-495) offer Sartore a successful, ready-made situation, and he chose to photograph it straight on.

**RICHARD OLSENIUS 2000**
Jake Hinnenkamp lies on Vandy's back, Minnesota.

487

Boys play with space-age weapons in a historic
neighborhood of Lincoln, Nebraska.

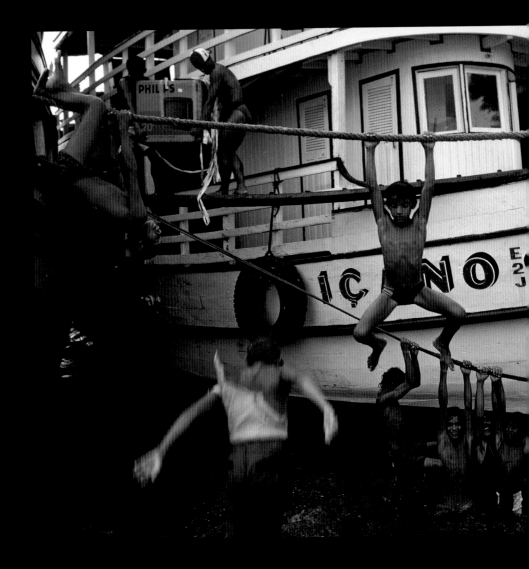

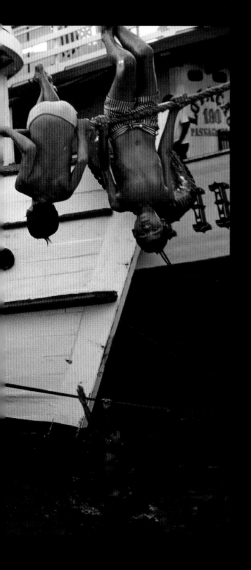

**ALEX WEBB   1995**
Young Brazilians rope together their own
entertainment along the Amazon River.

**RANDY OLSON    1998**

Earl and Versie Henry make their living selling
homemade molasses, Hasty, Arkansas.

492

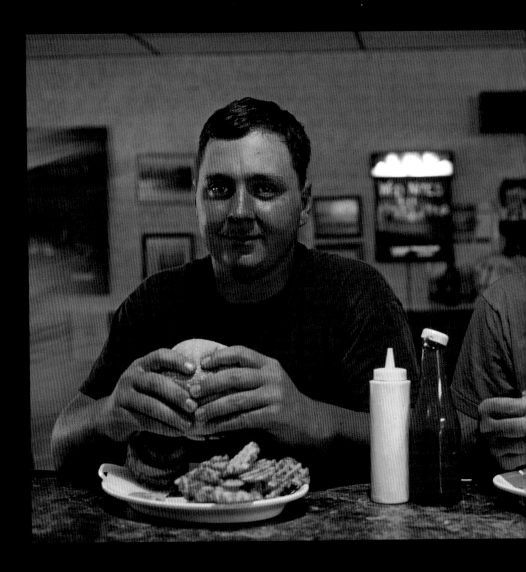

**JOEL SARTORE   1998**
Twin farmhands eat a hearty meal at the
Mule Skinner Saloon in Oxford, Nebraska.

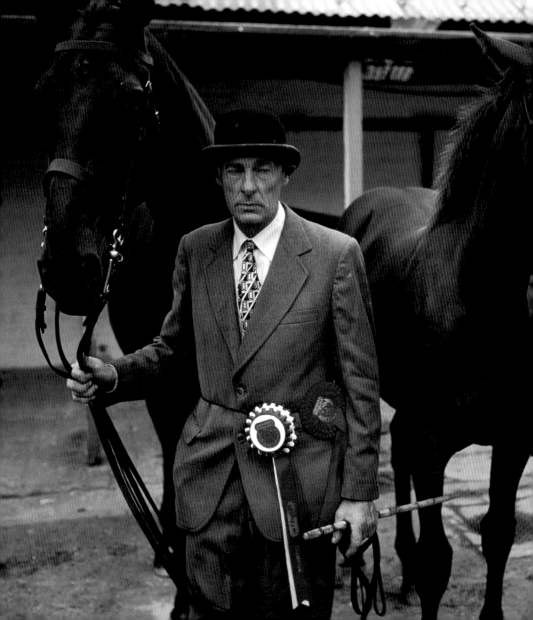

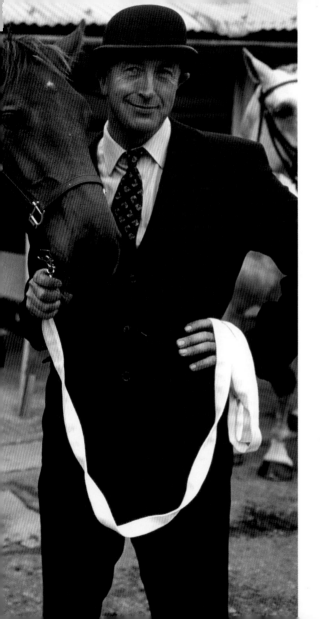

Preparing for the course at the
Dublin Horse Show, Dublin, Ireland

**Photography** has permitted us to look at each other in new and ever changing ways over the last 165 years. Jodi Cobb's photograph of numerous posters of Taiwanese leader Sun Yat-sen demonstrates that portraits may galvanize large populations. Pictures, if we let them, can tell us what to believe about today's world and about history. Now, in an uncertain decade, National Geographic photographers and their colleagues use photography to express the relativity, ambiguity, capriciousness, and unknowability of things.

Reza's photograph of Chinese soldiers patrolling a border between China and Mongolia (pages 500- 501) is about looking. It may remind us that looking doesn't always result in seeing. The Aboriginal boy in the last picture in our book (pages 502-503) spontaneously mimics the look on photographer Sam Abell's face as he lifts his camera and focuses, suggesting that a photograph, in addition to so many other things, is always a self-portrait.

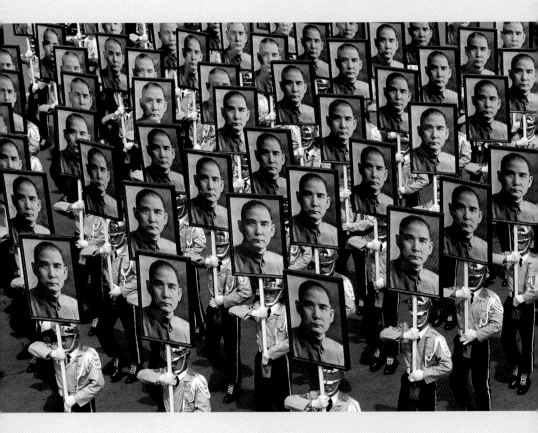

**JODI COBB   1993**
Posters of Sun Yat-Sen are paraded on Taiwan's
National Day, which celebrates the 1911 revolution
that overthrew China's last dynasty.

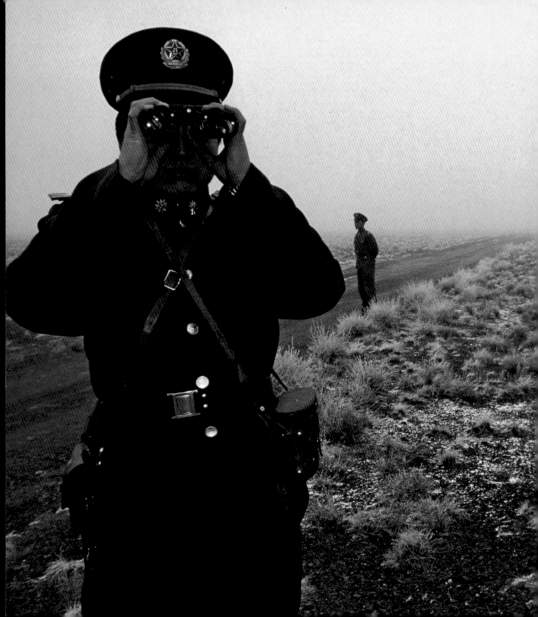

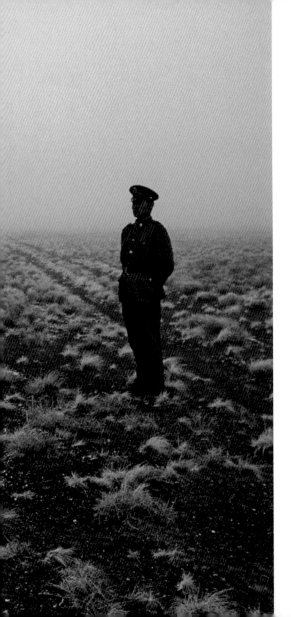

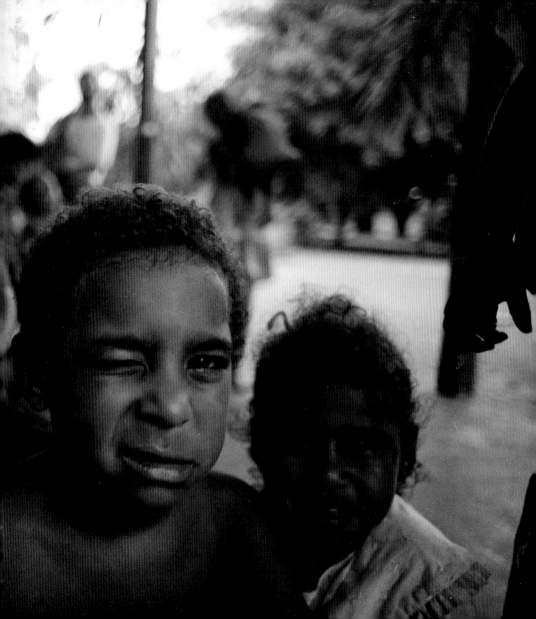

# In Focus
NATIONAL GEOGRAPHIC GREATEST PORTRAITS

## Published by the National Geographic Society

John M. Fahey, Jr., *President and Chief Executive Officer*

Gilbert M. Grosvenor, *Chairman of the Board*

Tim T. Kelly, *President, Global Media Group*

John Q. Griffin, *Executive Vice President; President, Publishing*

Nina D. Hoffman, *Executive Vice President;
    President, Book Publishing Group*

## Prepared by the Book Division

Barbara Brownell Grogan, *Vice President and Editor in Chief*

Marianne R. Koszorus, *Director of Design*

Carl Mehler, *Director of Maps*

R. Gary Colbert, *Production Director*

Jennifer A. Thornton, *Managing Editor*

Meredith C. Wilcox, *Administrative Director, Illustrations*

## Staff for This Book

Leah Bendavid-Val, *Editor*

Rebecca Lescaze, *Text Editor*

Vickie Donovan, *Illustrations Editor*

Peggy Archambault, *Art Director*

Melissa Hunsiker, *Assistant Editor*

Anne Moffett, *Researcher*

Marshall Kiker, *Project Manager*

Mike Horenstein, *Production Project Manager*

Al Morrow, *Design Assistant*

Allison Gaffney, *Design Intern*

## Manufacturing and Quality Management

Christopher A. Liedel, *Chief Financial Officer*

Phillip L. Schlosser, *Vice President*

Chris Brown, *Technical Director*

Nicole Elliott, *Manager*

Rachel Faulise, *Manager*

ISBN 978-1-4262-0647-4

The Library of Congress has cataloged the 2004 edition as follows:

In focus : National Geographic greatest portraits.

    p. cm.

    ISBN 0-7922-7363-X

    1. Portrait photography—United States. 2. National Geographic Society
(U.S.)—Photograph collections  I. National Geographic Society (U.S.)
II. National geographic.

    TR 680.I495 2004

    779'.2—dc22                2004044953

Printed in China

10/PPS/1

The National Geographic Society is one of the world's largest nonprofit scientific
and educational organizations. Founded in 1888 to "increase and diffuse geographic
knowledge," the Society works to inspire people to care about the planet. It reaches
more than 325 million people worldwide each month through its official journal,
*National Geographic*, and other magazines; National Geographic Channel; television
documentaries; music; radio; films; books; DVDs; maps; exhibitions; school publish-
ing programs; interactive media; and merchandise. National Geographic has funded
more than 9,000 scientific research, conservation and exploration projects and sup-
ports an education program combating geographic illiteracy.

For more information, please call 1-800-NGS LINE
(647-5463) or write to the following address:

National Geographic Society
1145 17th Street N.W.
Washington, D.C. 20036-4688 U.S.A.

Visit us online at www.nationalgeographic.com

For information about special discounts for bulk purchases,
please contact National Geographic Books Special Sales: ngspecsales@ngs.org

For rights or permissions inquiries, please contact
National Geographic Books Subsidiary Rights: ngbookrights@ngs.org

## Acknowledgments

The editors of *In Focus* want to thank, most of all, the photographers who contrib-
uted to this volume. The five who wrote essays, in addition to offering their own
one-of-a-kind pictures, shared their ideas and imagination, enlarged our understand-
ing of their work, and made producing this book a joyful enterprise.

We are also indebted to the National Geographic Image Collection, Image Sales,
Digital Imaging Lab, and National Geographic Archives, especially Bill Bonner,
Renee Braden, Brian Drouin, Charles W. Harr, Andrew Jaecks, Masako Jennings,
Ashley Morton, Lisa Mungovan, Susan E. Riggs, Patrick Sweigart, Paula Washing-
ton-Allen, Sanjeewa Wickramsekera, and Warren Wilson.

Finally, our appreciation goes to our colleagues in National Geographic's Inter-
national Licensing and Alliances, especially Robert Hernandez, Declan Moore, and
Howard Payne, for their support and involvement in this project.

**Note on dates:** Date of first publication appears with previously published pictures;
date of acquisition appears with unpublished photographs; when exact dates are
unknown, approximate dates are given.

## Also by the writers of IN FOCUS:

**Sam Abell** is the author of *The Photographic Life* (2002), *Seeing Gardens* (2000),
and *Stay This Moment* (1990). He has photographed over 20 stories for *National
Geographic* magazine.

**William Albert Allard** has published five books, including *Vanishing Breed* (1982)
and *Portraits of America* (2001). His photographs and text have appeared in
*National Geographic* since 1964.

**Leah Bendavid-Val** is the author of *Propaganda & Dreams* (1999), *Stories on Paper
& Glass* (2001), and *National Geographic: The Photographs* (1994). She has edited
more than two dozen books for National Geographic.

**Jodi Cobb** is the author of *Geisha: The Life, the Voices, the Art* (1995). Cobb has
photographed 24 magazine stories and has contributed to six National Geo-
graphic books.

**David Alan Harvey,** a member of the Magnum Photo Agency, is the author of *Cuba*
(1999) and *Divided Soul* (2003). He has photographed over 35 articles for *National
Geographic* magazine.

**Stuart Franklin,** also a Magnum photographer, has published two books: *The Time
of Trees* (2000) and *The Dynamic City* (2003). His photographs have appeared in
*National Geographic* magazine since 1994.

**SAM ABELL    1995**
An Aboriginal boy mimics
the photographer's squint,
Queensland, Australia.